POP ART

CONTEMPORARY PERSPECTIVES

PRINCETON UNIVERSITY ART MUSEUM

Preface by John Wilmerding
Introduction by Hal Foster
Essays by Johanna Burton, Kevin Hatch,
Suzanne Hudson, Alex Kitnick,
Julia E. Robinson, and Diana K. Tuite

Roy Lichtenstein, Andy Warhol, Claes Oldenburg, Tom Wesselmann, Robert Indiana, and Alex Katz have all come to define the revelatory and controversial Pop art movement that emerged in America in the 1960s. This handsomely illustrated book focuses on more than forty understudied and rarely seen late paintings, works on paper, and sculptures by these influential artists in the collection of the Princeton University Art Museum.

Pop Art: Contemporary Perspectives offers fresh insights on the ways in which artists radically transformed the mediums of painting and sculpture and pointed revisions of the movement's relationship to art history. For example, Lichtenstein is positioned as a classical "studio artist"; Wesselmann is shown to be playfully preoccupied with academic genres; and Indiana is interpreted less as a Pop artist than as a folk artist in a mass-cultural context. This important book also features an engaging introduction by Hal Foster that places these new interpretations in the context of the history of Pop art and its critical literature.

This volume is the first in a new series of Princeton University Art Museum Monographs, in-depth explorations of the museum's rich collections. These beautifully designed and produced books by leading and emerging scholars will offer new insights and perspectives on a single work or group of works from Princeton's distinguished permanent collection.

POP ART

CONTEMPORARY PERSPECTIVES

PRINCETON UNIVERSITY ART MUSEUM

POP ART

CONTEMPORARY PERSPECTIVES

PRINCETON UNIVERSITY ART MUSEUM

Preface by John Wilmerding

Introduction by Hal Foster

Essays by Johanna Burton, Kevin Hatch,
Suzanne Hudson, Alex Kitnick, Julia E. Robinson,
and Diana K. Tuite

Princeton University Art Museum

Yale University Press
New Haven and London

Pop Art: Contemporary Perspectives is published
by the Princeton University Art Museum, Princeton,
New Jersey 08544-1018, and distributed by
Yale University Press, P.O. Box 209040, New Haven,
Connecticut 06520-9040.

The publication has been supported with funds from
the Publications Committee of the Department of Art
and Archaeology, Princeton University, and by the
Kathleen C. Sherrerd Program Fund for American Art.

The exhibition *Pop Art at Princeton: Permanent and
Promised*, on view at the Princeton University Art
Museum from March 24 through April 12, 2007, has
been made possible by a grant from Merrill Lynch.

Managing Editor: Jill Guthrie
Assistant Editor: Mary Cason
Copy Editor: Sharon R. Herson
Designer: CoDe. New York Inc.,
Jenny 8 Del Corte Hirschfeld and Mischa Leiner
Indexer: Kathleen M. Friello
Printer: Conti Tipocolor, Florence, Italy

Library of Congress Control Number: 2006933065
ISBN: 978-0-300-12212-1

Cover illustration:
Roy Lichtenstein, American, 1923–1997
Still Life with Red Jar, 1994, detail
Screenprint on Lanaquarelle watercolor paper;
54.3 x 48.9 cm.
Princeton University Art Museum, promised gift

The book was typeset in Berthold Eurostile and
Berthold Weidemann and printed on Scheufelen
PhoenixMotion Xenon 150 gsm.

Printed and bound in Italy.

CONTENTS

6 Foreword
 Susan M. Taylor

8 Preface
 John Wilmerding

10 Introduction
 Hal Foster

14 Robert Indiana: "A People's Painter"
 Suzanne Hudson

36 Grounding the Figure, Reconfiguring the Subject: The Cutouts of Alex Katz
 Diana K. Tuite

54 Roy Lichtenstein: Wit, Invention, and the Afterlife of Pop
 Kevin Hatch

74 Claes Oldenburg: Monumental Contingency
 Julia E. Robinson

96 Andy Warhol: Surface Tension
 Alexander Kitnick

112 "Like a Rousseau among the Cubists": Tom Wesselmann's Un-Pop Procedures
 Johanna Burton

137 Checklist of the Collection

155 Selected Bibliography

FOREWORD

The Princeton University Art Museum has always been energized and enriched by its close relationship with the exceptional students and distinguished faculty of the university's Department of Art and Archaeology. Each collaboration presents the opportunity to forge new relationships, advance new scholarship, and enhance our ways of working together. In this volume, *Pop Art: Contemporary Perspectives*, we introduce the fresh viewpoints of accomplished young scholars from the Department, advanced candidates for the doctoral degree and one recent Ph.D. recipient. Their essays contribute impressively toward establishing a new framework for critical perspectives on Pop art. With the advantage of temporal distance, this generation of scholars is able to address, and correct where necessary, conventional understandings of six important figures of the 1960s: Robert Indiana, Alex Katz, Roy Lichtenstein, Claes Oldenburg, Andy Warhol, and Tom Wesselmann. Readers will have the all-too-rare pleasure of encountering novel and perhaps surprising analyses of artists whose work has been widely researched and exhibited but by no means exhaustively investigated.

For over twenty years, the study of Pop art at Princeton University has been shaped by the distinguished research and teaching of John Wilmerding, who will retire in 2007 as Christopher Binyon Sarofim '86 Professor in American Art. His respected scholarship, curatorial expertise, and thoughtful guidance of students have been the foundation of the Department's program in American art. This book and the exhibition that accompanies it are lasting tributes to his distinguished career at Princeton as scholar, educator, and curator. We are grateful to John for the direction he has provided to the authors of *Pop Art: Contemporary Perspectives*, and we acknowledge the important role that his vast experience and exceptional scholarship have played in the development of the museum's collection and exhibition program, most recently in this important project. He will be sorely missed, but we will continue to call on him for the advice and insights that have come to characterize our relationship with him.

We also are indebted to the authoritative editorial oversight and elegant introduction of Hal Foster, Townsend Martin '17 Professor of Art and Archaeology, whose extensive and respected contributions in contemporary art and criticism have provided the authors with a touchstone for their own critical and historical inquiries. As colleague and chairman of the Department of Art and Archaeology, he has actively supported the museum's commitment to developing exhibitions around the curriculum, exploring the opportunities presented by the collection to enhance the teaching of art at Princeton.

Pop Art: Contemporary Perspectives marks the launch of the Princeton University Art Museum Monographs, a series whose goal is the publication of research that advances scholarship on the museum's collection, in a format that invites general readers to delve more deeply into the complex narrative of art history. Appropriately, this first volume of the series is dedicated to Pop art, marking the museum's enhanced collections in twentieth-century art and its commitment to the establishment of a new department of modern and contemporary art.

The idea for the monograph series originated in the publications department and, like all inspired ideas, was embraced immediately by the entire museum. The production of the book has been rigorously overseen by Jill Guthrie, managing editor, and Mary Cason, assistant editor. The book's design, by Jenny 8 del Corte Hirschfeld and Mischa Leiner of CoDe. New York, provides an inspired graphic context for the significance of this new scholarship and the undeniable visual power of imagery that has come to define a movement. It will serve as a template for future books in the series, in-depth explorations by leading and emerging scholars offering new insights and perspectives on a single work or group of works from Princeton's rich collection. It is our hope that the series will interest both specialists and the wider public.

It is the museum's permanent collection that forms the backbone for the exhibition that accompanies this publication. The presentation highlights the depth and breadth of the Princeton University Art Museum's collection of Pop art, fully documented in the illustrated checklist within this volume. A recently promised gift of more than forty works will significantly enhance the museum's Pop collection, and we are most grateful to the anonymous donor for his extraordinary generosity. For the handsome organization and design of the exhibition, we express our appreciation, once again to John Wilmerding, to Calvin Brown, assistant curator of prints and drawings, and to Jenny 8 del Corte Hirschfeld and Mischa Leiner.

All of the museum programs and presentations would not be possible without the generosity of many. For

Pop Art: Contemporary Perspectives, important financial support for the catalogue has been provided by the Publications Committee of the Department of Art and Archaeology and by the Kathleen C. Sherrerd Program Fund for American Art. We are delighted to be able to acknowledge Merrill Lynch as the corporate sponsor for the exhibition and the associated programming. We also extend grateful recognition to the Partners and Friends of the Princeton University Art Museum for their ongoing support. As always, we are indebted to the university leadership, particularly President Shirley Tilghman, Provost Christopher Eisgruber, and Vice-Provost Katherine Rohrer, for their encouragement and enthusiasm for this project, indeed, for all of the museum's activities.

Susan M. Taylor
Director
Princeton University Art Museum

PREFACE

Princeton University has a long tradition of interest in modern art, evident in the number of distinguished critics, art historians, and curators who have taught, collected, and promoted the field over the last half century. In recent decades, particular attention has been devoted to chronicling the rise of Pop art through coursework and acquisitions by the Princeton University Art Museum. This publication reveals that the works in the permanent collection along with promised gifts reflect unusual vitality, breadth, and variety, surpassed only in museums of much larger size.

Among the first and most influential individuals in the modern life of the Department of Art and Archaeology and the art museum was Frank Jewett Mather Jr. He joined the faculty in 1910 to teach Italian Renaissance painting, but soon introduced courses in nineteenth-century art. Named director of the art museum in 1922 (a post he held until 1946), he actively acquired modern works for the collection. In the 1950s, the artist and critic William C. Seitz taught a course in painting and was named critic-in-residence. He completed his Ph.D. at the university in 1955, and held the position of assistant professor until his departure in 1960 to assume a curatorial post at the Museum of Modern Art in New York. During the 1960s, the Pop artist George Segal was one of several visiting artists-in-residence in the growing curriculum in creative arts, formalized in 1971 as the Visual Arts Program, which from 1972 through 1974 was directed by the distinguished art historian and theorist Rosalind Krauss. In 1969 Sam Hunter, former director of the Rose Art Museum at Brandeis University and the Jewish Museum in New York, joined the faculty of the Department of Art and Archaeology. Among the

artists he knew and studied were Segal, Larry Rivers, and Tom Wesselmann.

In 1987 the Sarofim family, in conjunction with the Brown Foundation, created a chair dedicated to American art, and courses in modern American art began to be regularly offered in the department, as well as within the Program in American Studies—including "American Art and Culture: The 1960s," which is centered around the Pop movement and its relation to advertising culture, and has been taught every other year for the last two decades. In 1998 the department made a further senior appointment in the modern and contemporary field, that of Hal Foster as Townsend Martin '17 Professor of Art and Archaeology.

In tandem with this coursework, the Princeton University Art Museum over the last three decades has steadily augmented, by gift and purchase, its collection of Pop material. When the museum made its first significant purchase of a Pop piece in 1971, it was considered a controversial and speculative move. Thanks in part to Sam Hunter's familiarity with Tom Wesselmann and his work, the case was pressed to purchase, through the Laura P. Hall Memorial Fund, a monumental charcoal drawing for a classic collage painting of 1962, *Study for Still Life, No. 22*. Beginning in 1973 and continuing through the decade, the Hall Fund made possible a steady stream of important acquisitions, mostly prints, by almost all the figures associated with Pop art, including Jasper Johns, Roy Lichtenstein, James Rosenquist, and Ed Ruscha. The museum has continued to acquire Pop art, including most recently Claes Oldenburg's watercolor *Blueberry*

Pie à la Mode, Tipped Up, and Spilling (1996), purchased through the Kathleen Compton Sherrerd Fund for Acquisitions in American Art. The Jean and Leonard Brown Memorial Fund and a partial gift from the Andy Warhol Foundation for the Visual Arts made possible the purchase of Warhol's *Brillo Box* (1964). Outright gifts from the 1970s to the present have brought additional clusters of strength to the collection: a portfolio of ten prints by Jim Dine from Ileanna and Michael Sonnabend; four Robert Indiana prints; eleven prints by Johns, including one screenprint from the Albert List Family Collection and two of his lithographs from Herbert Schorr, Graduate School Class of 1963; two drawings and four prints by Alex Katz, including one print from James Kraft, Class of 1957, and one from Herbert Schorr and Mrs. Schorr; seven prints by Lichtenstein; half a dozen works by Rivers, including a print given by Mr. and Mrs. Regan and three drawings given by Robert L. Pell, Class of 1955; seven Rosenquist prints, including two given by Mario d'Urso; a large number of works by Segal, given by Sam Hunter and others; more than two dozen prints by Warhol, gifts of Paul F. Walter, Herbert Schorr, Ileana and Michael Sonnabend, James Kraft, and others; and nearly thirty prints by Robert Rauschenberg. Two especially prominent alumni in the arts have also prompted key gifts. From Alfred H. Barr Jr., Class of 1922, and Mrs. Barr came the donations of Warhol's silkscreen painting *Blue Marilyn* (1962) and Oldenburg's drawing *B Tree (For Alfred Barr)* (1969). Following William Seitz's death, a number of gifts in his honor were presented by artists, including two significant Pop works: *Decoy II* (1971–73), from Jasper Johns, and *Wall Relief: Torso* (1972), from George Segal.

Supplementing this generous record are over forty promised gifts of Pop art, which will greatly augment the museum's representation of lesser-known works from the later careers of several artists, particularly Lichtenstein and Wesselmann. Finally, although not documented in the current project, recognition should go to the extensive long-term loans of Pop material from the collection of Ileana Sonnabend and the Schorr Family Collection. These have made available for teaching and exhibition purposes often major works by Dine, Johns, Lichtenstein, Oldenburg, Rauschenberg, Rosenquist, and Warhol. Altogether, Princeton is fortunate and proud to be able to present such a rich and extensive range of works from the Pop era as an integral part of its collections in modern art.

John Wilmerding
Christopher Binyon Sarofim '86 Professor of American Art

INTRODUCTION

The essays in this book take as their point of departure the permanent collection of American Pop art in the Princeton University Art Museum, with an eye to a promised gift of significant objects by the six prominent artists discussed in the texts—Robert Indiana, Alex Katz, Roy Lichtenstein, Claes Oldenburg, Andy Warhol, and Tom Wesselmann. That the collection can support such substantial essays speaks to its overall quality; at the same time, the texts stand on their own, and can be read independently with great profit.

This is an opportune time for a critical review of American Pop. First, the arc of the six oeuvres under study here is now clear, if not complete in each instance (three of the six artists continue to practice), and this knowledge of the scope of the work has led to some pointed revisions (a few of which I anticipate below). Second, the authors—all of whom have recently received their Ph.D. or are current doctoral candidates in the Department of Art and Archaeology at Princeton University, with most at work on postwar subjects— are positioned to deliver new perspectives on Pop, for they operate well after the period not only of its initial reception by critics, both pro and con, but also of its later revision by early scholars. In short, Pop is a historical episode for these authors, and this distance has allowed them to survey most of the literature on the six artists (the first full monographs have begun to appear only recently); it also has permitted them to benefit from the elaborations performed by subsequent artists, for today Pop devices of mass-cultural imagery, techniques of mechanical reproduction, and formats of serial presentation are treated as so many givens of artistic practice. (My own generation of such artists

as Cindy Sherman and Richard Prince work in the wake of Warhol et al. in much the way that a prior generation struggled with the precedent of Jackson Pollock et al.) Paradoxically, perhaps, this historical distance has brought our authors a new intimacy with Pop.[1]

Let me simply point to a few of the fresh insights to be found in these texts. First, with its cool look and appropriated imagery, Pop seemed to be such a bold departure from the grandiloquent gestures of Abstract Expressionism that its historical ties—not only to modernist masters like Matisse and Picasso but also to traditional forms like the nude and the still life— were often overlooked. Not here: Lichtenstein is positioned as a classical "studio artist," some of whose procedures date to the Baroque period; Wesselmann is shown to be preoccupied, in playful ways, with the academic genres just mentioned; Indiana is seen less as a Pop artist than as a folk artist in a mass-cultural context; and so on. Moreover, the specific art historical allusions that are rife in much of the work are also made evident.

Second, early commentators were distracted by the mass-cultural imagery flaunted by Pop, which many regarded not only as vulgar or banal (two key terms in the initial reception) but also as regressive—a great step backward from the high ambition and formal complexity of Abstract Expressionism. Preoccupied with the content of Pop, these analyses tended to be iconographic, a matter of source hunting and sociology, a connoisseurship of products and advertisements, comics and magazines—and this despite the insistence

by most Pop artists that the content was secondary, a pretext for the formal operations that were truly essential to the art. Our authors restore this procedural sophistication to the work. This is not to say that they are blind to the mass-cultural context or to the commercial art background of Pop practitioners (most famously, Warhol was an acclaimed illustrator, and like his peers he adapted his commercial techniques to his art). Rather, our authors attend closely to how the literal superficiality of products and people in a consumerist world, as processed by Pop artists, transformed the media of painting and sculpture radically. For instance, much Pop painting manifests an utter conflation of painting and photography, the handmade and the ready-made, in which the old opposition of abstract art versus figurative art is greatly complicated, not to say entirely undone. Moreover, for all its visual immediacy, the typical Pop image is usually produced through various transfers of images and media (usually from news photos or magazine ads to painting, collage, or assemblage) that involve still further techniques of mediation (such as projectors and silkscreens) in a complex layering of sources, formats, and effects. Historians have only begun to unpack these processes, and our authors contribute significantly to this ongoing project.

Third, even more than elsewhere in the discourse of twentieth-century art, the late work of Pop artists tends to be denigrated. Driven by the logic of the avant-garde, modernist art history privileges early breakthroughs, and very few masters are credited with strong late periods at all (the exceptions, such as, again, Matisse and Picasso, can be counted on one hand). Perhaps this low esteem for the late work is exacerbated for Pop artists on account of their apparent proximity to mass culture, as if they were expected, like James Dean, to live fast, die young, and leave a beautiful corpse (indeed, artists who do so, such as Pollock, are oddly rewarded as culture heroes after the fact). In any case, it was common until recently to insist that Warhol, for example, had gone to hell after he was shot in 1968, that there was not much new in Lichtenstein after the 1970s, and so on. Such myths are also laid to rest in these texts. Indeed, the "Pop" rubric is here questioned as an umbrella term, and in this respect, too, some of the artists finally meet with critics sympathetic to their own views.

Finally, and to my mind most importantly, this book emphasizes sculpture or (to use that odd postwar term, telling in its ambiguity) "objects"; these are also foregrounded in the promised gift, but often overlooked in the critical literature on Pop (with the exception, naturally enough, of studies on Oldenburg). There are several points to note here. The quality and quantity of Pop sculpture might surprise those of us who still think of Pop largely in terms of images that are all about *surface*—the superficiality of media images, celebrity personas, product profiles, and the like. Yet there is a way in which Pop sculpture also maintains the graphic aspect of Pop at large (the cutouts of Katz, most obviously): often these objects seem to pop, literally, from the canvases, and most exist somewhere between painting and sculpture, as though in transit from the one to the other, or as a hybrid of the two (clearly the modernist concern with medium specificity is not at issue here). If most representational painting

is a two-dimensional encoding of three-dimensional objects, Pop artists usually reverse the process, and freeze it somewhere in between; typically, they push a two-dimensional image toward a three-dimensional thing, yet retain bits of the pictorial illusion as the image-object is displaced into actual space (Lichtenstein is the master of this move, although Wesselmann is gifted here as well). The result is a mode of semi-relief, semi-trompe-l'oeil sculpture that is utterly distinctive and unjustly neglected. This book also addresses this gap.

Like the museum, the Department is grateful to the donor of such fine pieces of Pop work—all of which will greatly enrich our teaching in the postwar field in general. We also are grateful to the museum, under the directorship of Susan M. Taylor, and its publications department, for their support of our fine graduate students in twentieth-century art. It is rare that an entire book would be given over to such young scholars, however brilliant they might be, and yet it is also fitting here, as there is, among scholars associated with Princeton, a kind of tradition-in-the-making of important historians of modernist art who are also influential critics of contemporary practice, among them Alfred H. Barr Jr., William Seitz, Sam Hunter, Michael Fried, Rosalind Krauss, Thomas Crow, and John Wilmerding.

Speaking for the department as a whole, it is a special pleasure for us to honor our esteemed colleague John Wilmerding with this publication upon his retirement after so many years of enlightened leadership in teaching, mentoring, researching, publishing, and curating.

John has done more than anyone to establish the academic field of American art studies, and to bring it into productive play with programs in both American culture and modernist art at large. All of us interested in such matters owe him an enormous debt.

Hal Foster
Townsend Martin '17 Professor and Chair
Department of Art and Archaeology

Notes

1.

A brief sketch of the historiography of American Pop would include the key group exhibitions: *New Painting of Common Objects* (Pasadena Art Museum, 1962); *Six Painters and the Object* (Solomon R. Guggenheim Museum, 1963); *New York Painting, 1940–1970* (Metropolitan Museum of Art, 1969); *American Pop Art* (Whitney Museum of American Art, 1974); *Blam! The Explosion of Pop, Minimalism, and Performance, 1958–1964* (Whitney Museum, 1984); *Made in USA: An Americanization in Modern Art, the '50s and '60s* (University Art Museum, Berkeley, 1987); *Pop Art: An International Perspective* (Royal Academy of Arts, London, 1991); *Hand-Painted Pop: American Art in Transition, 1955–1962* (Los Angeles Museum of Contemporary Art, 1993); *Les Années Pop* (Centre Pompidou, 2001); and *Pop Art: U.S./U.K. Connections, 1956–1966* (Menil Collection, Houston, 2001).

Besides the catalogues of these exhibitions, the key histories and source books (again in English alone) include: Lucy Lippard, ed., *Pop Art* (New York, 1966; rev. 1970); John Russell and Suzi Gablik, eds., *Pop Art Redefined* (New York, 1969); Simon Frith, *Art into Pop* (New York, 1987); Paul Taylor, ed., *Post-Pop Art* (Cambridge, Mass, 1989); Marco Livingstone, *Pop Art: A Continuing History* (London, 1990; rev. 2000); Steven Henry Madoff, ed., *Pop Art: A Critical History* (Berkeley, 1997); Cecile Whiting, *A Taste for Pop: Pop Art, Gender and Consumer Culture* (Cambridge, 1997); and Mark Francis, ed., *Pop* (London, 2005).

BY SUZANNE HUDSON

ROBERT INDIANA: "A PEOPLE'S PAINTER"

For a 1963 issue of *Art News*, critic Gene Swenson interviewed a phalanx of "cool and tight-lipped" Pop artists in an attempt to "set the record straight" on matters of process, position, and politics. Roy Lichtenstein and other artists interviewed also dealt with the significance of the "American" in relation to their aesthetics, but it was Robert Indiana who plainly tied his work to a kind of national ethos, even as it remained for him at the level of fantasy. In spite of the biting critiques he would eventually levy—in such works as his *Confederacy* series (1965), painted in response to the Civil Rights Movement, or, more recently and in light of the escalating aggression in Afghanistan and Iraq, *Peace Escapes Once Again* (2003)—Indiana declared the American myth "the best of all possible worlds."[1]

Elsewhere in the interview, however, Indiana indicated he felt otherwise. He knew better than to blithely believe that art could provide a cure for social ills or put a stop to accelerating patterns of consumption and the loss of subjective agency such homogenizing conditions imply. Indeed, as his memento mori, *Eat/Die* (1962; fig. 1), makes clear, consumption is yoked to death.[2] When prompted as to whether he thought Pop was cynical, Indiana sharply replied: "Pop does tend to convey the artist's superb intuition that modern man, with his loss of identity, submersion in mass culture, beset by mass destruction, is man's greatest problem, and that Art, Pop or otherwise, hardly provides the Solution—

some optimistic, glowing, harmonious, humanitarian, plastically perfect Lost Chord of Life."[3]

The irony here is that Indiana has been seen, almost unilaterally since that 1963 interview, as a peddler of conciliation. From *The American Dream #1* (1961; fig. 2) to his iconic *LOVE* (1966; fig. 3), Indiana's work has prompted readings centered on his seemingly unequivocal sanguinity. This evaluation is odd given the nature of Indiana's statements, such as those staged for Swenson, not to mention the explicit content of many of his overtly political paintings, which, like the aforementioned blood-red *Peace Escapes Once Again* (fig. 4), denounce sectarian violence and war. This piece follows many others that have challenged American political administrations and their ethics and demonstrates the longevity of Indiana's commitment.

Indiana's unintentional pendants of *A Divorced Man Has Never Been the President* (1961) and *An Honest Man Has Been President: A Portrait of Jimmy Carter* (1980) represent the inequities and perceived failings of the American political system in terms akin to propaganda.[4] More subtle is *Election* (1960/61), now referred to as *Electi*, commemorating the inauguration of John F. Kennedy, whose democratic platform Indiana endorsed. *Electi* is replete with a ground of brown and black stripes, bisected in the lower register by black-and-white circles that stand for the spinning wheels of vote-counting computers; below is the word "Election." Indiana made this painting effectively to cast his vote, yet it became inadvertently and belatedly elegiac with Kennedy's assassination. It now offers a form more funerary than triumphal, and its passage from naïve faith to solemn

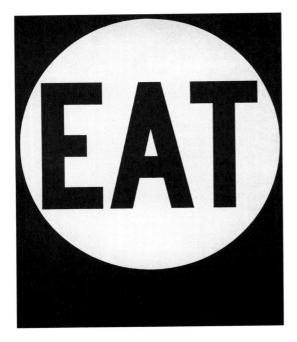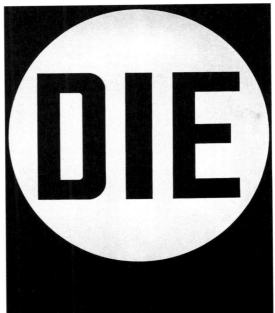

reckoning might be understood as encapsulating a like transition in Indiana's life and work more generally.[5]

Even in 1974, Indiana admitted that he had come to question the "American Dream." On the occasion of a reconsideration of Pop a decade after his interview with Swenson, Indiana fielded a query as to whether he still believed the American Dream was "optimistic, generous, and naïve." He stated:

> The American Dream has gone enormously sour. It has become the American Nightmare. The phrase "The American Dream" relates to something my father had. It wasn't something I had. He had an American Dream that turned out to be hollow. Given the war and what's happening in Washington now, I think it is very difficult to be optimistic, innocent and naïve. The dream aspect of the American character is probably all washed under now.[6]

Figure 1. Robert Indiana, American, born 1928
Eat/Die, 1962
Oil on canvas on two panels; 182.9 x 152.4 cm. each
Private collection, courtesy of Simon Salama-Caro

Strident in its critique and resolute in its position, this exchange betrays an Indiana unlike that of *LOVE*'s omnipresence. Emblazoned on everything from doormats to paperweights, ashtrays to rugs, and jewelry to dresses, *LOVE* "was as ubiquitous as the American flag, and, for a while at least, more popular."[7] *LOVE* has overshadowed much of Indiana's subsequent production to the extent that many do not realize who "coined" it. "Everybody knows my *LOVE*," Indiana once quipped, "but they don't have the slightest idea what I look like. I'm practically anonymous."[8]

Then again, when Indiana's authorship is recognized, *LOVE* is taken as the work through which to understand all others, occluding the meaning of his project as a whole. In short, *LOVE* smacked of a sellout—so much so that John Canaday even slurred in the *New York Times* that Indiana should make *MONEY* his next project[9]— and its popularization abetted Indiana's reputation as the ultimate Pop entrepreneur, loved by the masses but reviled by the art world (circumstances that, as the story goes, precipitated his exile to the Star of Hope manse on Vinalhaven Island, off the coast of Maine, and hence

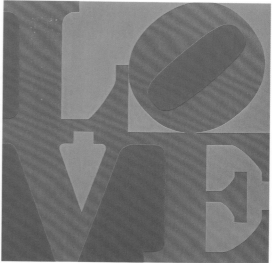

at a safe remove from the vicissitudes of the New York scene).[10] This claim for Indiana's mercenary objectives would be a truism verging on cliché were it not for the fact that he never copyrighted the work, and received no royalties from its innumerable applications.

Indiana's lack of proprietary control enfranchised widespread exploitation, diluting the efficacy of the original gesture, which was first exhibited in 1966 at the Stable Gallery in New York and was meant for dissemination in a fine-art setting, alongside other paintings and sculptures. But even before its gallery installation at Stable, *LOVE* was known as a Christmas card designed for the Museum of Modern Art, unveiled in 1965. Bearing not Indiana's signature but a museum copyright notice, *LOVE* was "delivered to untold numbers of recipients via U.S. mail."[11] In this way, *LOVE* is actually "a work with no real original, only a group of paintings, prototypes for the museum's card commission."[12]

It could be annexed for other intents and purposes without fear of compromising the "original," and in fact the U.S. postal service later made *LOVE* into a stamp that was issued in Philadelphia, the City of Brotherly Love, on Valentine's Day in 1973 (an honor for which Indiana received a flat fee of one thousand dollars).[13] Consequently, we must ask what effect this passage into the culture at large has had on the artist's objective and whether, in the end, *LOVE*'s omnipresence paradoxically reveals something particular about the nature of Indiana's heraldic visual and verbal propositions.

Indiana's work should be seen within the framework of authorship and reproduction, acknowledging the level of saturation his images have achieved but challenging the applicability of the Pop appellation to his practice by arguing that he could be more appropriately designated a folk artist than a purveyor of Pop. This classification of folk art abides in Indiana's disregard for optical realism

Figure 2. **The American Dream #1**, 1961
Oil on canvas; 182.9 x 152.7 cm.
Private collection

Figure 3. **LOVE**, 1966
Oil on canvas; 182.6 x 182.6 cm.
Indianapolis Museum of Art, James E. Roberts Fund (67.8)

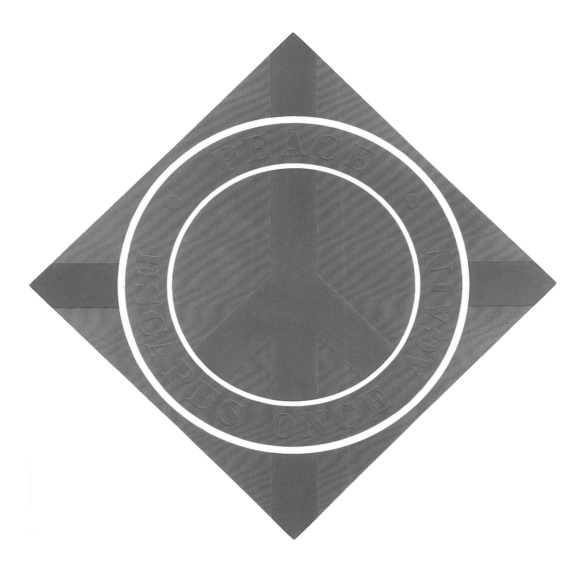

Figure 4. **Peace Escapes Once Again**, 2003
Oil on canvas; 128.3 x 128.3 cm.
Princeton University Art Museum, promised gift

in favor of emblematic design, his independence from academic traditions, his commingling of the decorative and the utilitarian, his courting of mass appeal and direct interpolation, his privileging of ornamental signs (once common on taverns, but now found on highways), his rural origins, and his "anonymous" status. A claim for Indiana's folk cataloguing obtains despite the fact that his categorization has evaded neat art historical retrospection. Aprile Gallant has noted that "he isn't detached from his subject matter, he handpaints every-thing and there's a lot of personal content in his work. But the art world likes movements, and that's been part of Bob's problem. No one knows where to put him."[14]

Indiana's America, culled from billboards and advertising culture, constitutes its own vernacular, tampering with the once-policed modernist bifurcation between art and kitsch. As he remarked in the 1963 interview with Swenson, his work "is not the Latin of the hierarchy, it is vulgar."[15] Indiana's linguistic and representational vulgate abets a circulation of contingent, temporally and culturally specific meanings that belong as much to the culture from which they emerge as to the artist; in this process of circulation from private meaning to public participation, Indiana's art nullifies distinctions between high and low, autonomous and democratic (or even populist). Like much Pop art, Indiana's art, too, hinges on tone, and what we make of surfaces either blank in affect or oversaturated with meaning.[16] In almost inverse relation to the waning visibility of the artist, his work has assumed a flexible myth of its own.

Indiana was born Robert Clark on September 13, 1928, in New Castle, Indiana, the state he would assume as his surname in 1958 as an index of his nascent identity as an artist.[17] Adopted by Earl and Carmen Clark, Indiana had a peripatetic childhood. The family's precarious finances during the Depression resulted

in almost constant relocations within and around Indianapolis. Earl Clark worked for the gasoline company Phillips 66, and many writers have claimed the company's red sign seen against a blue sky as the foundation for Indiana's later sign-based work and his range of chosen hues. Clark deserted the family when Indiana was ten, and Carmen Clark took jobs in cafes to support herself and her son. By the time he had graduated from high school and completed three years in the U.S. Air Force, Indiana had decided to pursue his longstanding desire to become an artist, enrolling in the School of the Art Institute of Chicago on the G.I. Bill. He graduated in 1953 and traveled to the University of Edinburgh on a fellowship. When Indiana moved to New York in 1954, he met the artist Ellsworth Kelly, who helped him secure studio space in Coenties Slip, a compound of abandoned nineteenth-century wharves and warehouses in lower Manhattan, near the East River and in view of the Brooklyn Bridge.[18] The latter was the inspiration for the painting *The Bridge* (1964) and the subsequent print *The Bridge* (1983; fig. 5), both of which show the structure's Gothic arches bisected with unfurling banners of light, as if divine in conception.

His New York neighborhood provided a community for Indiana; Jasper Johns, Agnes Martin, Robert Rauschenberg, James Rosenquist, and Jack Youngerman lived there as well. Duly influenced by the forms of abstraction he saw his friends producing, Indiana slowly relinquished a figurative aesthetic for a form of hard-edged, color-field painting that has since been compared to that of Kelly. Like Kelly, Indiana introduced broad, matte swaths of sharply delineated and flatly applied pigment and pared-down compositions that play figure/ground games against ambiguous pictorial spaces. Kelly's works, though, eschew representation to a greater degree than do those made by Indiana (fig. 6). Further, Indiana began to insert text into the visual field, thereby allowing for verbal or linguistic signification if not mimetic picturing.

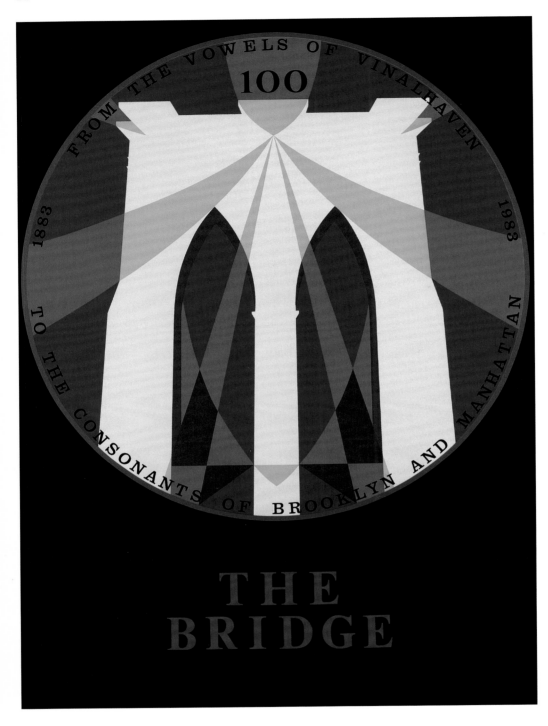

Figure 5. **The Bridge**, 1983
From the portfolio *New York, New York*, 1983
Color screenprint on white BFK Rives paper;
89.9 x 62.9 cm. sheet
Princeton University Art Museum, promised gift

Language soon appeared splayed across canvases and stenciled on early upright, four- to six-foot-tall sculptures that Indiana calls "herms."[19] Comprised mostly of scarred, patinated materials taken from demolished buildings, these assemblages of wooden beams and columns also included masts from old ships. Words such as "soul" in *Soul* (1960), "hole" in *Hole* (1960), "Ahab" in *Ahab* (1962; fig. 7), and "Chief" in *Chief* (1962) attend distinct functions that allow the works to be read in multiple ways. *Soul* raises the specter of religious iconography, omnipresent in Indiana's pre-Coenties work, while also rendering the pole anthropomorphic. *Ahab* references Melville's *Moby Dick* and, self-consciously, the ships of New York that are the material constituents of Indiana's sculpture, while *Chief* exhumes Longfellow's epic poem "The Song of Hiawatha" and commemorates its heroic protagonist. The herms are also marked by the presence of numbers, as in *Two* (1960–62), with the number 2 appearing twice (in red on a green circular ground and in yellow

on a blue circular ground) and the word *two* spelled out once at the sculpture's base. This use of numbers is a harbinger of Indiana's later iconographic lexicon.

As a series, the herms have much in common with broader tendencies exhibited in the watershed exhibition *The Art of Assemblage* at the Museum of Modern Art in 1961, where Indiana's works were on view with those of Johns and Rauschenberg (among others), both of whom were using quotidian objects as the basis for a new form of collage, obdurate in its materiality. Nonetheless, Indiana's assemblages are not derived from commercial culture, like those of Johns and Rauschenberg, but are inspired by antiquity. The moniker "herm" refers to a type of statue that originated in ancient Greece, consisting of stone pillars bearing a head and phallus; herms were at once roadside markers delineating territory as well as anthropomorphic structures bearing faux-mythological attributes and displaying overt phallic protrusions. Indiana's herms capture these mythological and phallic aspects, as evident in *Hole*, *Ahab*, and *Chief*; in their vertical bearing, they too express the totemic form of the ancient examples. William Katz has written that the herms "are absolutely the very first real statement of [Indiana's] ambition

Figure 6. Ellsworth Kelly, American, born 1923
Atlantic, 1956
Oil on canvas on two panels; 203.2 x 289.6 cm.
Whitney Museum of American Art (57.9a-b)

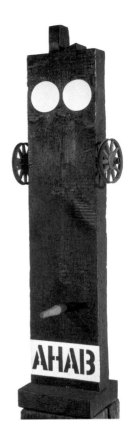

Figure 7. **Ahab**, 1962
Gesso, oil, iron, and wooden wheels on wood;
155.0 x 47.0 x 36.0 cm.
Morgan Art Foundation Limited,
courtesy Simon Salama-Caro, New York

Rome. These references indicate his burgeoning interest in naming as such and in using words in myriad ways. Indeed, language is a crucial part of the composition and meaning of these works, from the inclusion of words that are deictic in usage, as in *Hole*, with its word "hole" and arrows pointing to an actual hole in the wood, to those that are mnemonic in resonance, as is the case with *Duncan's Column*, where the lettering offers a litany of symbolically meaningful elements plucked from his neighborhood (such as his "Ship Slip," where he lived, and "Ginkgoes," found in a nearby park). More often than not, the use of language is deeply personal, with Indiana indexing places, people, or events from his past in a coded, condensed manner.

As Susan Ryan has maintained, autobiographical material in Indiana's work is not made figurative or descriptive, nor is it annexed to depict vignettes from his life. Instead, Indiana engages repeated episodes of his past that "deal with childhood memories and ground the paintings' words, numbers, symbols, and even colors, within allegories of triumph and timelessness or failure and loss."[22] Themes of origins, interpersonal relations, and mortality are inscribed in a formally stylized visual language in Indiana's art and writing. He obsessively recasts his sense of place in works like *The Slips* (1960), *Ahab*, *Duncan's Column*, and similar instances that pay tribute to his urban residence. Similarly, in *Terre Haute* (1960), Indiana paints an homage to his home state, with the Wabash River arcing at the bottom of the composition next to the number 40, a local highway.

to be an artist. And what he did was to make them like surrogates of himself."[20]

The projection of himself onto the means of his representation was the basis of Indiana's becoming "Indiana," which happened around the same time he began producing the herm sculptures.[21] Present to varying degrees on most of Indiana's herms proper are autobiographical fragments, names, locations, and symbols; these are most obvious on the related sculpture *Duncan's Column* (1960), which with its commemorative text in black lettering, red oil paint, and white gesso spiraling around its central mast resembles Trajan's Column in

Indiana's self-penned "Autochronology" presented similar autobiographical material. First introduced in 1968, in the context of an exhibition catalogue published by the Institute of Contemporary Art in Philadelphia, his contribution mines the form of a standard institutional chronology meant to deliver an artist's biography, exhibition history, and critical reception.[23] Indiana's "Autochronology" supplies the requisite dates (birth,

years of education, and so forth), genealogies (friends and neighbors figure prominently), synchronic events (the day of Franz Kline's death, for example), proclamations (Alfred Barr calling the Museum of Modern Art acquisition *The American Dream* "spellbinding"), and excerpts from relevant discursive commentaries on contemporary art movements (frequently on the then-codifying Pop aesthetic by writers including Max Kozloff, who would call the artists assembled under this collective rubric the "new vulgarians").

Markedly unlike an informational repository, however, the "Autochronology" fictionalizes and comments upon biographical and historical information. Ryan describes Indiana's move away from concrete particulars to their licensed recapitulation as "storytelling," because he narrates and renders less than wholly factual the items under discussion. The "Autochronology" is therefore an artist's statement more than a literal chronology (although it is that, too), in that it identifies Indiana's role in the company of other artists and styles. By designating his place, Indiana then seeks to make it so, on the model of what J. L. Austin has referred to as "performative speech acts," whereby an expression serves to state, as a nominal phrase, an intention rather than to convey information.[24]

Speech acts are at the core of Ryan's Indiana in her appropriately titled book *Robert Indiana: Figures of Speech*, published in 2000. She argues for understanding Indiana and his performative acts in many media— sculpture, painting, writing, and interviews—by means of his self-articulation through storytelling, nominating himself into being. Important here is that Indiana's naming, writing, and works of art all assist in the construction of Indiana, while Clark and his forthright, unvarnished biography are displaced. At stake in the "Autochronology" as much as in Indiana's art is the coalescence of personal mythology and communal meaning, whereby fragments from Indiana's past are abstracted to evidence broader concerns of identity,

lineage, and transience. When Clark became Indiana, he opened Pandora's box, with meaning at once everywhere and nowhere: as legible as a hazard sign, as tangible as a wooden pole, and as vague as someone else's memory, telegraphically recounted.

In the early 1960s, Indiana's formal play extended from words to numbers. A few years before, Johns had begun to explore similar compositions with stenciled numbers. Along with flags, maps, and concentric targets, as in his seminal *Target with Plaster Casts* (1955), Johns utilized depersonalized signs as things corresponding to their representations. These signs were items that the mind already knew, and Johns rendered them clear in association but uncertain in signification. They became equally images and objects, as Johns worked with encaustic, a viscous wax, over newspaper supports. This process is important in that the medium (and literal support) for Johns's thickly factured images encourages multiple tiers and valences of meaning, wherein the textual grounds are largely concealed but still surface amidst mummified, gestural globs of wax. The encaustic gives these works a deeply sculptural presence and permits analysis of submerged content without allowing the shards of text to be altogether decipherable.

Importantly, the subjects of Johns's compositions are often at odds with their formal properties. A modular repetition undercuts the falsely emotive resonance of the "expressive" strokes and complicates the seemingly explicit denotation of much of his subject matter, most notably in *Flag* (1954–55; fig. 8) and *White Flag* (1955). Stars and stripes make for a holistic, dynamic composition, but their plastic nature cannot be cleaved from their cultural resonance, so that a flag is a flag, but it may not be just a flag. As Fred Orton has written: "*Flag* is made of two main messages or two utterances. As a work of art it embodies a set of ideas and beliefs about art and aesthetics and as the American flag it

embodies a set of ideas and beliefs about citizenship, nationalism and patriotism."[25] The crux of Johns's proposition was that politics — personal or collective — cannot be sequestered from representation, and representation, in turn, cannot be thought of apart from mediation by and through mass media.

But the nature of Johns's commentary is equivocal on these very terms, and was seen as such in the 1950s. Claims of "neo-Dada" abounded in the wake of Johns's show at the Castelli Gallery in 1957, with Robert Rosenblum leading the charge and many others following suit. Was *Flag* a flag or a painting? And was it, whatever it was, blasphemous or affirmative, hostile or domesticated, iconoclastic or iconic, anti-art or art? For Hilton Kramer, the answer was easy. Johns's work was "mock-naïve… a kind of Grandma Moses version of Dada." Where "Dada sought to repudiate and criticize bourgeois values… Johns, like Rauschenberg, aims to please and confirm the decadent periphery of bourgeois taste."[26]

Such was the anxiety that attended *Flag*'s importation into the Museum of Modern Art. When Alfred Barr met with the acquisitions committee in 1958 to discuss purchasing the work, he was at pains to reassure the deliberating body as to its positive value. As Orton recounts, Barr's ultimate recourse was not to the work but to the person of the artist; he provided a character reference of Johns as an "elegantly dressed Southerner" who had "only the warmest feelings toward the American flag."[27] Evading *Flag*'s meaning in favor of supplying the artist's supposed purpose did not help matters, because, as Orton summarized, "biography and intentionality were not the issues. Effect was."[28] And effect prevailed. Although *Flag* was purchased by the museum, an internal memo warned curators that the work was not to be installed in the main lobby, where it would be broadly accessible and in plain view, for fear of the controversy it might provoke and the anti-American sentiment it might imply.[29]

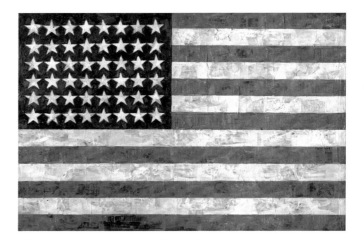

This problem of indecipherability bears directly upon the works Indiana was producing during these years, as he too navigated the fault lines of intentionality and effect and the junction between public and private meaning. Even more explicitly, Indiana's numbers bear a formal similarity to those used by Johns; Indiana has openly acknowledged Johns as a source and has ceded priority to him. Nevertheless, more interesting than precedent or influence, especially in view of the number of other artists (from Thomas Cole to Charles Demuth, Walt Whitman to Edward Curtis) to whom Indiana's works pay homage, is how the numbers actually work, which is to say, how to regard *their* effect. If Johns played a game of cat-and-mouse where subjective affect was invoked but disavowed to maintain all kinds of ambiguity, Indiana's comparable forms were straightforward but laden with allegorical conceits.

Numbers had been used as concrete texts *and* symbols in the herms and *The American Dream*, but they began to dominate Indiana's compositions in the early 1960s, soon overwhelming them entirely and resulting in a separate body of work. Perhaps taking a cue from

Figure 8. Jasper Johns, **Flag**, 1954–55; dated on reverse 1954 Encaustic, oil, and collage on fabric mounted on plywood; 107.3 x 154.0 cm.
Museum of Modern Art, New York, gift of Philip Johnson in honor of Alfred H. Barr Jr. (106.1973)

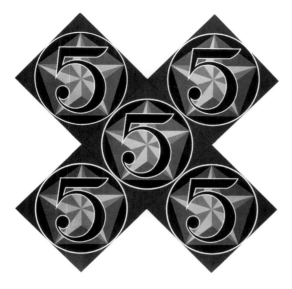

The X-5 (1963; fig. 9) does not seem to propose a specific point of reference, but it too proposes a narrative of the family romance, albeit in a divergent way. The work grew out of a series of related paintings pertaining to Johns's *The Figure 5* (1955) and Demuth's earlier canvas *I Saw the Figure 5 in Gold* (1928), itself a symbolic portrait of William Carlos Williams's poem about a fire engine, which he wrote en route to Marsden Hartley's studio.[32] This infinite regress of personal reference and artistic pedigree (into which Indiana's work is thereby projected or retrospectively assigned) is the ostensible subject in *The Figure Five* (1963), *The Small Demuth Diamond Five* (1963), and *The Demuth American Dream #5* (1963).[33]

Kelly's optical gestalts, Indiana additionally engaged the impossibility of the mutual recognition of the forms as numbers and as words. Indiana's *The Big Four* (1964) is a radiating force field that rotates four images of the number 4 in a continuous forty-five-degree rotation; the work is striking in its bold graphic sensibility and red, yellow, and black palette, with one numeral allocated per panel. Ryan has noted that 4 also stands for the "archetypal family" of mother, father, sister, and brother as part of Indiana's emergent numerology.[30] She also describes such numbers isolated on individual panels as "central portraitlike images," avowing their anthropomorphic basis.[31] This reading can apply to other number works from the same period, such as *Exploding Numbers* (1964–66), which also comprises four panels that expand in size (from twelve square inches to twenty-four to thirty-six to forty-eight) as they spread across the wall laterally. These differently sized panels can be read even more literally as the "archetypal family" than can the four panels of *The Big Four*, which all feature the same dimensions.

Lest this (or any other) equation become too fixed, the numbers never cease to be numbers *and* formal patterns, even as they, like Indiana's words, solicit a range of interpretations. With the monumental *The Cardinal Numbers* (1966), Indiana embraced a mode of seriality that took its relation to signification as its very subject. The stark simplicity of the work is owed to a reduced palette and a condensed graphic scheme (notably so, relative to *The X-5*'s numbers on hexagonal, illusionistic star grounds, encased in circles), and could be discussed exclusively in terms of its formal ingenuity and design properties. *The Cardinal Numbers* has ten compositional units, with one number per panel as in *The Big Four*, *Exploding Numbers*, and *The X-5*. If read horizontally, the panels form, in aggregate, a list charting 1 to 9 and back to 0, as though the enumerated sequences were akin to lines of language on a page. Indiana encourages this linguistic mode of engagement with the sequence by spelling the numbers below each numeral. As a clean graphic system, it also sets cursory spectatorial apprehension against sustained looking or reading; the whole can be read quickly, as a totality, or parsed thoughtfully.

It becomes clear that as the numbers extend from 1, they further stand in for and even portend a cycle of life, where the act of counting—not unlike that of naming

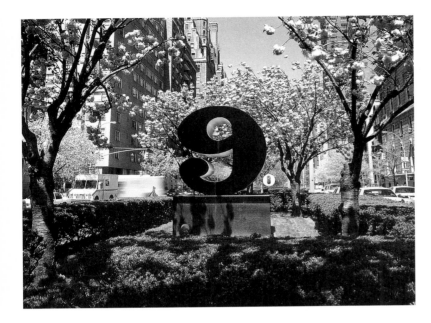

and ushering into existence a before and an after—expresses the passage of time. From Cole's *Voyage of Life* (1840 and 1842) to Thoreau's *Walden* (1854), the theme of the ages of man has been a mainstay in American art in many media, but in Indiana's paintings it is paradoxically concretized and rendered oblique. Each number corresponds to a stage of life in a way that is perhaps most obvious in Indiana's later large-scale numbers.

Beginning in 1980, Indiana made numbers reaching nearly six feet tall, and a decade later, he translated them into a more diminutive suite (about eighteen inches high). Then, in 2003 (from February 3 through May 3), he exhibited along Park Avenue in New York a series of works in polychrome aluminum on steel bases (fig. 10), erecting one number per traffic bank, analogous to the single number assigned to each panel of the related paintings. In the installation, the numbers—instead of cascading across the plane of a wall—unfolded through

space as one approached them from the side when crossing the street, or drove parallel to them in a car.

As may be seen in *Two* (1980–2001; fig. 11) and *Six* (1980–96; fig. 12), maquettes for the larger numbers, each has different colors, and the color combinations solicit disparate emotions. John Wilmerding has noted that *One* is red and blue, "carrying associations of blood and a first view of the sky. The green and blue, a subdued linking of adjacent hues on the color wheel, for number *2* are the tones of spring. The combinations for most of the middle numbers introduce far more vibrant color complements and opposites, such as red and green for *6* and blue and orange for *7*." The mood changes markedly near the end, as "*9* introduces black, and the final *0* is absent of color (and life) in gray and white."[34] For the emotional implications to register, even in a passing glance from the window of a speeding taxi, one need not be aware of any arcane references.

Figure 10. **Nine**, 1980–2001
Polychrome aluminum on steel base; 198.1 x 188.0 x 96.5 cm.
Installation on Park Avenue, New York, February 3–May 3, 2003
Private collection

Figure 11. **Two**, 1980–2001
Polychrome aluminum on steel base; 44.5 x 45.7 x 25.4 cm.
Princeton University Art Museum, promised gift

To be sure, one need know nothing about the history of art or about Robert Indiana.

Writing in 1962, Dorothy Gees Seckler discussed Indiana in conjunction with James Rosenquist, under the sign of Johns. "For both artists," she stated, "the example of Jasper Johns was important, especially his way of presenting commonplace objects without implying any judgments as to their beauty, desirability or morality. Typical was his bronze casting of two ordinary beer cans, perhaps the wellspring of a folk-lore of the banal—which is attaining more and more prominence today."[35] In proposing that Johns was seminal for Pop artists, who were also trafficking in "the folklore of the banal," Seckler rendered this interest generational. She also moved the terms of analysis from Pop culture to folk culture. Even if modernist art had long been implicated in a world of mass culture, the new work grouped together in Seckler's article refused the possibility of autonomy that had been championed for decades by Clement Greenberg.

In his 1939 essay "Avant-Garde and Kitsch," Greenberg famously described the avant-garde as independent from the masses insofar as it was an artist's imperative to sustain culture in the face of its imminent dissolution.[36] Even so, the avant-garde—"a kind of research and development arm of the culture industry," as Thomas Crow put it—was still connected to elite sources of patronage by means of "an umbilical cord of gold."[37] When Kozloff echoed Greenberg, lamenting in 1962 that "galleries are being invaded by the pin-headed and contemptible style of gum chewers, bobby soxers, and worse, delinquents,"[38] he was upset that Pop

made kitsch legitimate or, more to the point, that galleries made kitsch legitimate in championing Pop and securing its economic validation while debasing "high" culture in the process.

Insofar as Indiana's work is concerned, appraisal within the terms of folk art is a useful corrective, because the genre ignores the dialectic of a critique based upon high versus low that is still maintained in variant threads of Pop (Andy Warhol is exemplary here). Indiana's work forgoes associations with commodity culture even as it necessarily circulates within it. A self-proclaimed "people's painter,"[39] he engages in a kind of liberal pluralism that renders binary divisions moot.

A case in point is Indiana's broad series of Art works, including *The American Art* (1970), *Colby Art Tondo* (1973; fig. 13), *Art* (1992; fig. 14), and *Art* (2000; fig. 15). As in *LOVE*, where the four-letter word fills the canvas without remainder, two letters stacked upon two letters dividing the square into equivalent quarters, the Art pieces divide compositional space according to the word's three letters. Ryan notes, in relation to *LOVE*, that "word and image are equal, and figure and ground coextensive,"[40] and the same can be said for *The American Art* and its successors.

In this series, a large triangular form—the letter A—dominates the optical field. It is cut into two sections, red and white in the case of *The American Art*, to demarcate the form, next to which is a white R crowning two volumes of color (blue and red) that become legible as the missing T. These building blocks of language are the nestled constituents of the image, syncopated in pattern, vivid in color, and unified in structure to become "art." In its various forms, whether a color etching or, in the case of the polychrome aluminum *Art* (fig. 15), Indiana transmogrifies a single imaged word into material incident and in so doing questions the singularity of art. The application of "art" as an insignia—redoubled in form and reproduced in various media—raises questions

Figure 12. **Six**, 1980–96
Polychrome aluminum on steel base; 44.5 x 45.7 x 25.4 cm.
Princeton University Art Museum, promised gift

4/50

R Indiana

Figure 13. **Colby Art Tondo**, 1973
Color screenprint on white wove paper;
diam. 70.5 cm. image, 88.9 x 88.9 cm. sheet
Princeton University Art Museum, promised gift

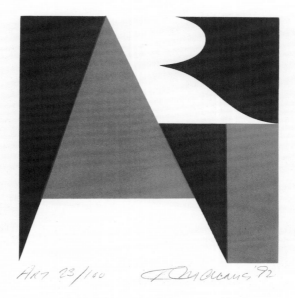

Figure 14. **Art**, 1992
Color etching and aquatint on white wove paper;
40.6 x 38.1 cm.
Princeton University Art Museum, promised gift

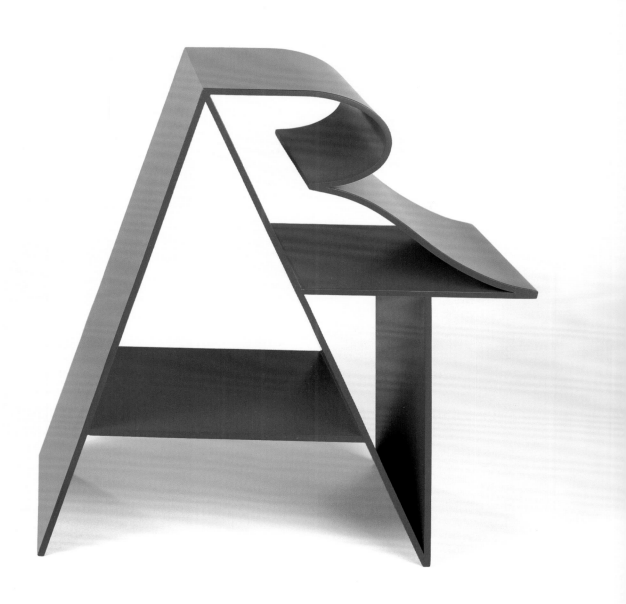

of meaning and interpretation akin to those engendered by Indiana's deployment of words and numbers. Since it is as declarative as it is representational, *Art* nominates or performs itself as such. Like Indiana's other speech acts, *Art* marshals itself into meaning. But is *Art* then the "art" proposed by its title, which is to say, is this particular sculpture the art to which its text cum title refers? Or does the work function as a sign announcing "art" as elsewhere, thereby acting as a signboard (*The American Art*) or, like the herms, a corporeal marker (*Art*), pointing to—and wryly advertising—art as somewhere or something else?

Partaking of the tradition of folk signage while operating as conceptual and aesthetic propositions, the Art pieces tolerate a wide range of meanings that are solicited but neither circumscribed nor delimited by the work itself. Nor are meanings determined by the author's intention, which, so to speak, remains outside the frame. As Seckler first deadpanned in a pithy remark that returns us to the issue of tone in Indiana's work: "We do not ask whether Cézanne enjoyed eating apples."[41] Instantiating a latitude of meaning, inside and outside the gallery, Indiana participates in an economy of exchange that establishes his generative offer as no more important to the meaning of the "art" than the responses offered by its addressees.

In this regard, *LOVE* is a crucible, granting a leeway of analysis: like *Art*, it is open in linguistic (and extra-linguistic) signification. Like a shifter—a word that slides from meaning to meaning, depending on who is speaking and what pronouns are invoked—*LOVE* might be by Indiana (even if few know it) but, irrespective, it is not exclusively, or even primarily, for Indiana. As Ryan has argued, "It is an utterance from personal experience and rendered with an investiture of labor,

but these are both denied, masked by the image's anonymous and hard-edged appearance and endless reproduction."[42]

Ryan elsewhere avers that Indiana "gave *LOVE* away,"[43] a point corroborated by the work's afterlife. Although it had begun with Indiana's exploration of his childhood roots in Christian Science Sunday School—an early version reads *Love Is God* (1964)—it was next elaborated as *FUCK* (produced about the same time, in relation to a break-up, and never exhibited), contaminating any sacred overtones with the flesh of the profane. Regardless of its origins or Indiana's intentions, within a short period following *LOVE*'s emergence, it had been annexed by more groups (including the New Left, hippies, the Berkeley Free Speech Movement, and the 1980s artists/activist collectives General Idea and Gran Fury to commemorate New York's Stonewall riots and raise awareness about AIDS) and politics than can be efficiently summarized, which seems to have become the point.

As a sardonic riff on branding and corporate logos, like those exploited by Lichtenstein, *Art* (and its permutations) serves as a rejoinder to *LOVE* and the interpretive free-for-all it precipitated, and as such it may be, somewhat ironically, the best response to the earlier work.[44] Rather than reclaiming a reified position, Indiana threw out for public consumption another erratic interpretive variable. Displacing the thorny matter of "what is art" in favor of just nominating it as such, Indiana's answer to those who doubted that *LOVE* fit the bill does not take the form of a question. It productively implies it, still.

Figure 15. **Art**, 2000
Polychrome aluminum; 45.7 x 45.7 x 25.4 cm.
Princeton University Art Museum, promised gift

Notes

1.

Robert Indiana quoted in G. R. Swenson, "What Is Pop Art?" *Art News* 62, no. 7 (November 1963): 64.

2.

Eat/Die also relates to two frequently recounted episodes from Indiana's life: his father died unexpectedly while eating breakfast, and his mother's last words urged him to make sure to eat.

3.

Indiana quoted in Swenson, "What Is Pop Art?" 27.

4.

The former highlights the position of Nelson Rockefeller, who was favored for election before his 1961 divorce, while the latter was conceived in support of a candidate who lost the election for which the work was produced.

5.

This reading is partly occasioned by the work's material form, which was damaged by a falling sculpture in 1961 and consequently cut down from its original dimensions. Its truncated form now reads "Electi," and suggests Kennedy's uncompleted term in office. See Aprile Gallant, "An American's Dreams," in *Love and the American Dream: The Art of Robert Indiana*, exh. cat., Portland Museum of Art, Maine (Portland, 1999), 49.

6.

Indiana quoted in Phyllis Tuchman, "POP!" *Art News* 73, no. 5 (May 1974): 29.

7.

Scott Sutherland, "Exiled in Maine, The Creator and Prisoner of 'Love'," *New York Times*, June 27, 1999.

8.

Indiana quoted in Susan Elizabeth Ryan, *Robert Indiana: Figures of Speech* (New Haven, 2000), 235.

9.

John Canaday, "Aesop Revised, or the Luck of Orthopterae," *New York Times*, December 3, 1972.

10.

This perception of Indiana was not the case at the beginning of his career, as the first *American Dream* was purchased for the Museum of Modern Art in New York and he was, in short order, included in the exhibition *Americans 1963* (along with other "Pop" artists, including Claes Oldenburg, Marisol, and James Rosenquist) and in many other shows and institutional arrangements. For a discussion of the *Americans* shows at the Museum of Modern Art, see Lynn Zelevansky, "Dorothy Miller's 'Americans', 1942–1963," in *The Museum of Modern Art at Mid-Century: At Home and Abroad*, ed. John Elderfield (New York, 1994), 57–107, esp. 83–87.

11.

Susan Elizabeth Ryan, "Eternal Love," *Love and the American Dream*, 85.

12.

Ibid., 211.

13.

Ibid., 235.

14.

Aprile Gallant quoted in Sutherland, "Exiled in Maine," 32. Even in those shows and attendant publications that have taken as their theme a reconsideration of what constitutes Pop, Indiana is often downplayed in significance or altogether omitted as out of place. A salient example is Indiana's position in *Hand-Painted Pop*, where his work was illustrated only twice among 235 illustrations and hardly occasioned a mention in the text. See *Hand-Painted Pop: American Art in Transition, 1955–62*, ed. Russell Ferguson, exh. cat., Museum of Contemporary Art (Los Angeles, 1992).

15.

Indiana quoted in Swenson, "What Is Pop Art?" 27.

16.

Roland Barthes and Thomas Crow argue for these positions respectively. For Barthes, "the Pop artist does not stand behind his work, and he himself has no depth: he is merely the surface of his pictures: no signified, no intention, anywhere." This analysis proposes a subject "who looks, in the absence of one who makes" ("That Old Thing, Art…," in *The Responsibility of Forms*, trans. Richard Howard [Berkeley, 1985], 202, 205). By contrast, Crow reads Pop through Andy Warhol and posits a Warhol interested in the breakdown of commodity exchange: "These were instances in which the mass-produced image as the bearer of desires was exposed in its inadequacy by the reality of suffering and death." Crow thus takes Warhol's subject matter—in the early 1960s, the "open sores in American political life"— seriously ("Saturday Disasters: Trace and Reference in Early Warhol," in *Modern Art in the Common Culture* [New Haven, 1996], 51, 62–63).

17.

With regard to this act of naming, Nathan Kernan proposes: "In choosing the state of his birth and upbringing as his name, Indiana simultaneously allied himself with Renaissance artists, such as Leonardo da Vinci, also often known by their hometowns, while adopting as his own identity a specifically American landscape, and in fact an entire culture of middle-American, 'automotive' identity. It was arguably his first Pop Art act, before he had painted any Pop Art paintings, or the term had even been coined" (*Robert Indiana* [New York, 2003], 7–8).

18.

For a detailed chronology of Indiana's life, see Ryan, *Robert Indiana*, esp. chapter 1.

19.

Indiana recovered a brass stencil along with the other debris that would constitute his early sculptures, and it was used to make many of these inscriptions.

20.

William Katz quoted in Ryan, *Robert Indiana*, 56.

21.

In 1966 Gene Swenson talked as much about Indiana's act of naming as the works he produced. He emphasized the act of self-mythologizing (tied to a geographical location and ethos of locale) implied by "Indiana," entitling one essay "The Horizons of Robert Indiana," and beginning it thus: "Robert Indiana's paintings have something of the plains in them, the country with its flat speech, matter-of-fact and sure; and there is something of the edge of the city, warehouses and artists' lofts, proximity to the center of the world's activities; and a touch of the sea" ("The Horizons of Robert Indiana," *Art News* 65, no. 3 (May 1966): 48.

22.

Ryan, *Robert Indiana*, 4.

23.

See John W. McCoubrey, *Robert Indiana*, exh. cat., Institute of Contemporary Art, University of Pennsylvania (Philadelphia, 1968), 51–59.

24.

See J. L. Austin, *How to Do Things with Words*, ed. J. O. Urmson and Marina Sbisá (Cambridge, Mass., 2000; originally published 1962).

25.

Fred Orton, *Figuring Jasper Johns* (Cambridge, Mass., 1994), 140.

26.

Hilton Kramer, "Month in Review," *Arts*, February 1959, 49.

27.

Cited in Orton, *Figuring Jasper Johns*, 144.

28.

Ibid.

29.

Ibid.

30.

Ryan, *Robert Indiana*, 154.

31.

Ibid., 150.

32.

Ibid., 136.

33.

Indiana's numbers later prompted Robert Creeley to write a series of autobiographic poems about them; thus did Indiana become fully written into the history he desired to construct.

34.

John Wilmerding, "Robert Indiana: The Shape of Meaning," in Wilmerding et al., *Robert Indiana* (New York, 2006), 261.

35.

Dorothy Gees Seckler, "Folklore of the Banal," *Art in America* 50, no. 4 (August 1962): 58. Johns's *Painted Bronze (Ale Cans)* of 1960 is reproduced in "Andy Warhol: Surface Tension" in this volume.

36.

Clement Greenberg, "Avant-Garde and Kitsch," in *Clement Greenberg: The Collected Essays and Criticism*, vol. 1, ed. John O'Brian (Chicago, 1986), 11.

37.

Thomas Crow, "Modernism and Mass Culture in the Visual Arts," in *Modern Art in the Common Culture* (New Haven, 1996), 35.

38.

Max Kozloff, "'Pop' Culture, Metaphysical Disgust, and the New Vulgarians," *Art International* 6, no. 2 (March 1962): 36.

39.

"I want to be a people's painter as well as a painter's painter"; Indiana quoted in Gallant, "An American's Dreams," 31.

40.

Ryan, *Robert Indiana*, 197.

41.

Seckler, "Folklore of the Banal," 45.

42.

Ryan, "Eternal Love," 91.

43.

Ryan, *Robert Indiana*, 216.

44.

For a discussion of logos in Lichtenstein, see Michael Lobel, "Trademark Lichtenstein," in *Image Duplicator: Roy Lichtenstein and the Emergence of Pop Art* (New Haven, 2002).

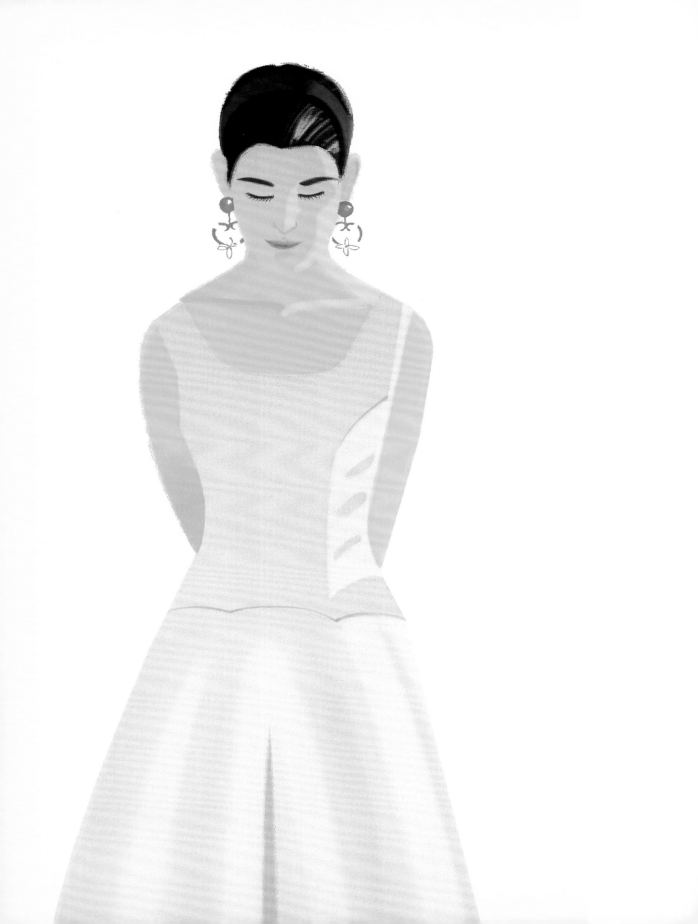

BY DIANA K. TUITE

GROUNDING THE FIGURE, RECONFIGURING THE SUBJECT: THE CUTOUTS OF ALEX KATZ

Among post-Abstract Expressionist artists in the 1950s, style had become a hotly contested topic, and the stakes were high. It is, therefore, not surprising to discover that, in the course of pursuing various possibilities, Alex Katz had destroyed thousands of canvases over the decade. As Andy Warhol said, in 1963, "How can you say one style is better than another? You ought to be able to be an Abstract-Expressionist next week, or a Pop artist, or a realist, without feeling you've given up something."[1] Depending upon whom you asked, Katz fused color-field and hard-edge painting, anchored realism in abstraction, or even anticipated Warhol's brand of Pop.[2]

In 1959 Katz inaugurated his cutout practice when he rescued two painted figures from a canvas he was intending to otherwise abandon. Persuaded that the composition was not holding together successfully, Katz impulsively cut around the two figures in the scene, hung them on his wall, and, after some consideration, mounted them onto plywood.[3] The artist has continued to produce cutouts through an array of methods and in a variety of media ever since. It is as though Katz had to physically evacuate the human figure from the context of easel painting before he could commit to representational painting with the heroic confidence it demanded in the Abstract Expressionist era. The first cutouts constituted a pivotal moment in Katz's career, something the artist himself implied when he chose 1959 as the earliest date of works to be shown in his first retrospective. In their many subsequent incarnations,

Detail of **The Wedding Dress**, 1992
Etching with aquatint on paper; 132.0 x 55.9 cm.
Princeton University Art Museum, promised gift

the cutouts deliver the artist's challenges to easel painting. Rather than functioning as the apotheosis of portraiture, Katz's cutouts rewrite nonabstract painting's rules of engagement (its qualities of size and scale, for example) while exposing its tacit assumptions in the process. In many ways engaging with issues that would become central to Minimalist and Conceptual art—for example, Robert Morris's discussion of how size and scale participate in creating the "quality" generated by a work of art—Katz uses the cutouts to examine the cognitive constants attributed to painting and sculpture.[4] In light of the implications of these investigations, the cutout should be repositioned at the center of the artist's oeuvre rather than at the periphery.

As a student at the Cooper Union in New York from 1946 to 1949, Katz was exposed to a Bauhaus-modeled curriculum that included courses in typography and graphic design. He also registered for life-drawing classes held in the evening at the Young Artist's Guild in Manhattan, where the eminent printmaker Robert Blackburn persuaded Katz to try his hand at printmaking, a medium to which he did not return until 1965. He anticipated graduation from the Cooper Union and employment as a commercial illustrator who would "paint on the side,"[5] but resolved otherwise when he was awarded two summer scholarships to paint at the Skowhegan School of Painting and Sculpture in 1949 and 1950. Somewhat enigmatically, Katz has said that he "found" his subject matter in Maine, and that "the sensation of painting from the back of my head was a high that I followed until the present."[6]

Leaving Cooper Union, Katz attempted to pass under the radar of those who were "paying lip service to Picasso" by fashioning his work as compromised "provincial modern art."[7] In so positioning himself, Katz anticipated a greater measure of freedom, assuming he would be dismissed by followers of both regional realism and advanced art alike. He was, therefore, quite surprised when Clement Greenberg, the influential critic who had championed Jackson Pollock, "went out of his way to say how lousy [Katz] was."[8]

In Maine, Katz initiated his practice of painting land-scapes *en plein air.* Whether working on portraits or landscapes, on canvas or aluminum, in real or fictive tableaux, Katz has always begun from observation. As part of his subsequent process, however, he often devotes significantly more time to working alone in the studio than to working in front of the subject. In this way, he reconciles empiricism with the high-modernist emphasis on the flatness of the support, demonstrating that the latter need not be painting's endgame.[9] Katz returned to New York in 1950, and for ten years the artist (who would abandon the frame altogether in his cutouts) derived the bulk of his income from the sale of hand-carved frames. He also supported himself as a mural painter, theatrical decorator, and art teacher at Yale University and Pratt Institute while he nursed a studio practice. Responding to works by Bonnard and Matisse, Katz eschewed modeling for solid fields of color. He began working on collages in 1955, addressing the incorporation of a three-dimensional subject into a two-dimensional composition in the most literal and self-evident way possible. Many of these collages were as small as four or five inches in each direction. With the disposition of figure and ground continuing to obsess him, Katz turned his attention to painting from photographs, subsuming the mechanically compressed planes of the image into painted space. Maintaining the affect of both collage and daguerreotype in these works, Katz painted single figures against solid grounds. In *Ada Ada* (1959; fig. 1), Katz represents his wife twice within a

compact image, but not identically, as her name is in the title. The two iterations are slightly different, and the frenzied brushwork around her feet poetically fore-tells the emergence of the cutout figure.

Executed in the greasy, faux-naïve brushwork that characterized Katz's early production but is antithetical to his mature style, the figures in works like *Ada Ada* appear both trapped and sheltered in fields of mono-chrome paint. Immobilized yet restless, they incarnate Katz's own struggle during this period. How should an artist who wanted to represent the figure now paint? What should be the disposition of figure and ground? As Katz has admitted, "I was just scared silly during those days because it didn't make any sense at all."[10] Willem de Kooning's Women series, with its revelation of the figure hovering beneath the surface of abstraction, had alarmed champions of gesturalism with the spectral

Figure 1. Alex Katz, American, born 1927
Ada, Ada, 1959
Oil on canvas; 125.7 x 127.0 cm.
Grey Art Gallery, New York University Art Collection,
gift of Mr. and Mrs. Samuel Golden (1963.13)

reemergence of the human form.[11] According to Katz, it was only after a 1959 exhibition of his paintings at the Tanager Gallery in New York, when he received de Kooning's endorsement, that he could redirect the energies he had been expending in his Oedipal struggle with Abstract Expressionist artists. De Kooning urged the young artist to persist with his investigations, saying, as if to one of Katz's cornered individuals, "Don't let them back you out."[12]

It is telling that in much of the Katz literature, the artist refrains from identifying which of his figures first lent themselves to the cutout innovation.[13] This lack of an original enhances the cutouts' status as an ongoing and collective project. Billed as "flat statues" when they were first shown at the Tanager Gallery in 1962, the cutouts have always been problematic to classify. Interpreted as occupying a liminal zone between painting and sculpture, and arriving on the scene prior to Pop art's institutionalization of the paradoxical "handmade ready-made," Katz's cutouts did not seem to fit anywhere. If their medium was yet indistinct, these works had not been "hunted back to their mediums," as Clement Greenberg deemed requisite for avant-garde art.[14]

Instead, as the responses to Katz's work suggest, non-abstract art was assigned exaggeratedly mimetic effects. One collector of the cutouts was purportedly "terrified each morning that a thief was standing beside her bed and was relieved to lend [the work] to an exhibition."[15] Upon first encountering the cutout of poet Frank O'Hara (1959–60; fig. 2), Edwin Denby was famously "fooled" and snapped to his senses only when he realized that the figure was three-quarters life-size.[16] It was thus the scale of the work rather than the quality of likeness or materiality that alerted Denby. The designation as "flat statues," a paradoxical category that is subversive yet reliant on traditional classification,

has influenced critical consideration of the cutouts ever since their inception. John Perreault most clearly registered this tension, writing: "Alex Katz's cutouts… are flat — flatter than the flattest flat painting. This is because they are not merely paintings, but works of painted sculpture."[17]

In essence, the cutouts were related to sculpture on the grounds of their suggestion of emulation or likeness, and strategically related to it so that they might not be diminished as further proof of modernist painting's aspiration to flatness. Oftentimes, reviewers of Katz's cutouts distract from these complexities by unfurling banners of hyphenated description: referred to as "free-standing," "stage-set-like," and "person-high" and viewed as having "surface-and-blankness," the cutouts register largely through analogy or contradiction.[18] In describing these "painted sculptures," such accounts appear to compound infinitely, as if trying to materialize

Figure 2. **Frank O'Hara**, 1959–60
Oil on double-sided wood cutout; 152.4 x 38.1 cm.
Private collection

the figure represented so that it might speak for itself. Such hinged phrases reveal how the hybrid art-object, so long as it is figurative, remains saddled with the expectation of replication or mimesis.[19]

In early cutouts like *Frank O'Hara*, Katz exaggerates the materiality of the support by letting his brushwork sit on top of the wood, as though it physically binds the composition together. Elsewhere, the artist retains the collage impulse and remounts several cutout figures onto a solid-colored canvas. In *Blue Series, Ada and Edwin* (1965; fig. 3), the two figures bracket yet another frontal, more formally posed cutout of Edwin that is not enumerated in the title. Although this Edwin, like Ada and the other Edwin, is obviously affixed to the surface of the blue square, one is tempted to read him as spatially recessed, since the artist has painted him in his entirety and much smaller than the others. This impulse is checked, however, by the fact that the head of the Edwin in the ostensible background, like the torsos of the others, extends beyond the blue square: he cannot be within a space whose finite dimension he exceeds.

With these cutout combinations, Katz seems to be saying that advanced painting need not expunge the human figure from the canvas, as the Abstract Expressionist generation had done; rather, it may incorporate the figurative as a formal element on the condition that it not drive the work. Katz demonstrates this contingency by extending Edwin's head beyond the frame, and so thwarting any spatial narrative among the three figures. One also cannot help but feel that Katz's choice of a square canvas painted a hue close to International Klein Blue is a direct rebuttal of the "end of painting" polemicism of artists like Yves Klein, Ellsworth Kelly, Ad Reinhardt, and Frank Stella. Katz shuns comparisons between his work and that of his contemporaries out of suspicion of the codified practices of even the most avant-garde artists. To Katz, Reinhardt's "Twelve Rules for a New Academy" only risked perpetuating academic absolutism.[20]

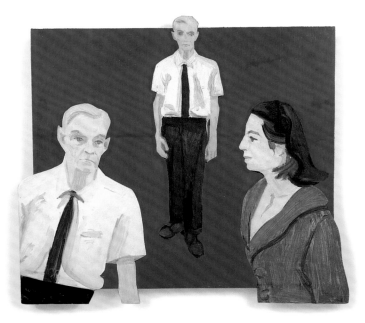

Consideration of the work of certain other artists is required, however, for an understanding of Katz's artistic choices. Just before Katz made his first cutouts, in 1958, George Segal began his synthetic experimentations with painting and sculpture, combining large-scale figurative paintings with life-size sculpture made from plastered chicken-wire frames. Although Segal, too, has been relegated to Pop-satellite status, his sculpture presents antitheses to Katz's cutouts. Segal pushed his sculptures in the direction of indexical representations, casting them directly from the human body through the use of plastered bandage molds (see Checklist). After assembling the bandages to reconstruct the figure, Segal situated them within universal settings (a movie theater, for example), driving the works into the realm of the generic in spite of the traces of portraiture struck in the casting.

Although Katz's cutouts were nothing like Segal's works, they seemed to be measured in its terms. In a

Figure 3. **Blue Series, Ada and Edwin**, 1965
Oil on wood cutouts; 48.3 x 55.9 cm.
Collection of the artist

1967 review of Katz's work, Hilton Kramer exemplified critics' willful insistence on acculturating the cutouts to the means and ends of traditional portrait painting: "[The cutouts] are free-standing, on pedestals, in the manner of sculpture in the round, but they are painted in oil in a most conventional and realistic manner, and for the most part achieve deft and often witty likenesses of their subjects."[21] Even the title of Kramer's review— "Cutouts, for the Squaring of the Circle"—suggests the aggressive transmutation of one form into another. The constituents of likeness are certainly invoked by these cutouts, but, per Katz's strategy, deliberately not fulfilled.[22] Indeed, the artist marveled at the extent to which the cutouts are construed as realist in their motivation and yet misdirected in their means: "People ask me why I don't do them in 3-D. Well, I'm an illusionist, and the minute you put them into 3-D, you ruin the illusion."[23]

For Katz, illusionism depends on the maintenance of some degree of distance in order to identify itself as such. If Robert Rauschenberg famously bridged the "gap between art and life," then Katz wavers between wanting to spill painting's bag of illusionistic tricks and being unable to do so because he performs them all too well. In recalling Rauschenberg's visit to his studio in the late 1950s and his praise for the cutouts, Katz clarified how the cutouts condensed his interest in the requisite autonomy of any single work of art: "[The cutouts] were weird because they were only four feet high.... They were life-size in an eight-foot picture but four feet high in real life...."[24] In any painting with roughly equal volumes of figure and ground, the figures would register as life-size. As Katz sees it, this perception of life-size in painting need neither correlate with real life nor with the historical conventions of how real life is represented. Just as Manet indicated the mirror behind the barmaid in *Bar at the Folies-Bergère* (1882) with scumbled white paint, interrupting the reflective surface in order to make it legible as such, Katz pursues new means to pictorial truth. If, in the cutouts, painting's

frame and its ground appear to have dropped out, and the tension between figure and ground and concomitant properties of scale are now internalized by the figure itself, then, Katz suggests, figurative painting approaches the opticality espoused by Clement Greenberg and, later, Michael Fried.[25]

Beyond reconfiguring relationships of scale, Katz underscores the cutouts' vertiginousness as physical objects by mounting some of them onto bases, and pivoting the figures' feet off the bases at dramatic angles. With one such work, *Ada (Weather Vane Model)* (1959), Katz's title appears to invoke the vernacular of both found art and folk art, inviting associations with those genres' resonance in Pop art, but he has never considered himself a Pop artist: "I was there and all of a sudden Pop art comes along and makes what I'm doing look like a compromised Pop art when the sequence is actually reversed. It was something in the air."[26]

In Katz's view, Pop posed yet another set of standards against which he was judged as coming up short. Yet critics who have argued for his relationship to Pop tender the cutouts as evidence of his kinship with Claes Oldenburg or James Rosenquist, for example, and see in them a fusion of the scale of Abstract Expressionism with a playful, acerbic treatment of the banal.[27] Critics such as Jed Perl or Lawrence Alloway, who are determined to resuscitate the history of nonabstract art, instead crown Katz a neo-Dada heir. For Perl, the cutouts function like Marcel Duchamp's "ready-mades aided" in their deviation from the tools of painting as the very means of engagement with the medium.[28]

By the mid-1960s, Katz was rehearsing the wet-on-wet painting technique that gives his works the taut finish for which he is famous. He also had established the repertoire of subjects in which he would continue to work throughout his career. Portraiture, in its myriad interpretations, became the category that painters and photographers of the 1960s began to pull apart.[29]

In the midst of this debate, Katz chose subjects—men with flinty countenances, sinewy women, dappled landscapes—that would overwhelm readings of his work. Many critics have emphasized that Katz's models belong exclusively to his own social milieu and therefore comprise a kind of autobiographical vernacular. Frequently, he has also been compared to Constantin Guys, the "painter of modern life" exalted by Charles Baudelaire but otherwise absent from the arc of art history.[30] *The Wedding Dress* (1992; fig. 4), an etching with aquatint, is one such work that might be apprehended in the tradition of Guys' modern fashion-plates.

Because Katz paints inexpressively, the men and women he depicts are necessarily construed as likenesses (even illusions, according to Denby's anecdote), but are simultaneously reduced to types that have been called "Hobbesian" in their self-interestedness.[31] On the contrary, the existence of Katz's figures as forms in fact supersedes any typology. His rarefied set of subjects, like the scale of his works, reveals itself to be part of painting's illusionism. Rather than documenting the patterned behaviors of the circles to which he belongs, Katz, like Neoimpressionist Georges Seurat, selects these subjects for the analogy between their social codes and the conventions of art.[32] Just as the individuals portrayed by both of these artists may signal their social status through their dress or the company they keep, painting likewise relies upon a network of properties in order to construct its meaning.

Katz has followed Seurat's lead in other respects. The nineteenth-century artist painted the same model three times within a single space in *Les Poseuses* (1890), and Katz has similarly resorted to seriality in his assault on the assumptions of portraiture. His sitters also exist multiple times within a single work, either on canvas or in cutout form. In these "reduplicative portraits," a term coined by Denby, Katz signals that he is not trafficking in temporally bound images, but rather running counter to the prevalent and photographic notion of the portrait.

Just as he combined two Edwin Denbys and one Ada cutout, Katz has painted two Robert Rauschenbergs, four Edwin Denbys, and anywhere from two to six Adas in a single work. There is no painterly illusion to be achieved through the inclusion of multiple versions of the same figure within a single image, and thus, in their very implausibility, the reduplicatives lay bare painting's access to imagination and persuasion. With works like *The Black Dress* (1960), Katz demonstrates how the subject of the so-called portrait is not necessarily the essence of the sitter, but rather a formal hypothesis that may perform an illusion. According to Katz, the act of painting necessarily abstracts, regardless of whether it is committed to portraying a certain subject or, conversely, to the eradication of subject matter: "If everything is described, then it isn't realistic. It's descriptive and hasn't got the life of anything realist. The realistic has to do with an illusion."[33] If one thinks of realism as having a referent in the actual world, and of illusionism as a representational system that supersedes this, then Katz in his cutouts takes full advantage of the misconception that illusion supplants the real.

On an intermittent basis, Katz has continued to produce cutouts since 1959. At times they have served as intermediary props to support his choreography of a group portrait on canvas. He would work up sketches, then paint cutout figures and arrange them, and finally draw and paint directly onto a canvas. Given the evolution of Katz's artistic practice, the early cutouts stand apart, manifesting a whimsicality that renders the mature cutouts more programmatic and more obviously influential on the rest of Katz's painting and printmaking practice.

Figure 4. **The Wedding Dress**, 1992
Etching with aquatint on paper; 132.0 x 55.9 cm.
Princeton University Art Museum, promised gift

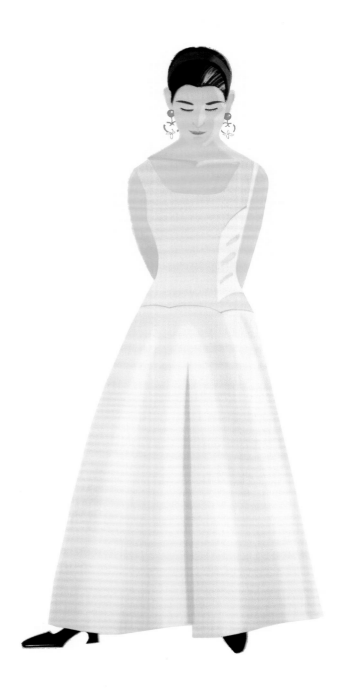

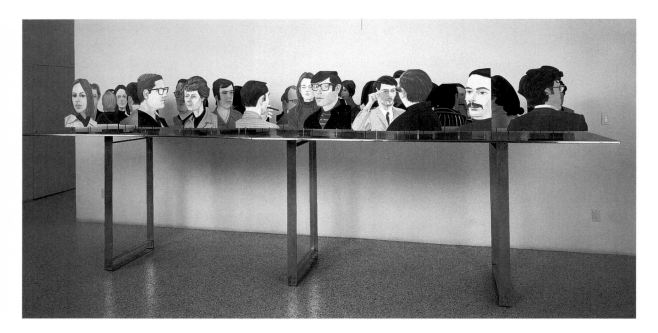

He has produced cutouts in oil on wood, masonite, and aluminum, oil on aluminum on wood, and, more recently, silkscreen on aluminum. Some of these works are gigantic, some belong outdoors, and some play with balance, but none assumes merely one of those roles.

Certain of Katz's cutouts pack their punch in the disjunction, often droll, between their front and back surfaces. Approached from either direction, *Maxine* (1959) never fails to startle viewers with her apparently backless bikini ensemble. Like Roy Lichtenstein's later Stretcher Frame paintings, which present the backs of canvases as their subjects, Katz mocks the authoritativeness of a representation by dissecting *Maxine* into two irreconcilable halves. Not only is it impossible to see both the front and back of any of these cutouts at the same time, but the extreme flatness of the support dictates that the viewer rotate in large arcs that describe obtuse rather than acute angles in order

to comprehend the presence of something, or in some cases nothing, on the reverse. While classifying the cutouts as neither painting nor sculpture, Carter Ratcliff has interpreted them as demonstrating the values of a "good gestalt" on the basis of the immediacy of their effect.[34]

Katz became increasingly aware of the potential for a mis-en-scène with multiple cutouts, in part through his experience designing scenery for the play *George Washington Crossing the Delaware*, written by Kenneth Koch and produced in 1962. Hilton Kramer observed in 1967 that painting, in its ever-expanding size, had emerged as a cultural threat, a self-reflexive space that was no longer an outlet into which society might grow, but rather a force threatening to consume it: "No longer content to be a discrete object, painting aspires to become a world.... The new scale is a scale of abstraction—the product of a consciousness that does not aspire to interest the spectator in anything but itself."[35]

As if in direct challenge to such sentiment, in 1968 Katz began to amass his cutout figures into ensembles. In *One Flight Up* (1967; fig. 5), Katz assembled thirty-nine

Figure 5. **One Flight Up**, 1967
Oil on aluminum cutouts; 170.8 x 457.2 x 119.4 cm. overall
Collection of the artist

such cutout busts, shearing the torsos just below their shoulders. He arranged this buffet of characters, all personalities from the art world, atop a semireflective metal table. Staged at eye-level, with figures painted at angles to one another, *One Flight Up* communicates the aural and visual cacophony of figures trapped in the discontinuities of felt space. At the same time, the abrupt interruptions of these figures allude to possibilities beyond the rote and requisite information contained within a framed canvas.

Even when his cutouts are not massed together, they often belong to a related series. In the 1980s, he painted the Black Stocking series, female cutouts dressed, as the title suggests, in variations on a theme. Hung on the wall, the vertical thrust and the frontal gaze of these cutouts mimic mirror images. Mounted in a stand, *Anne* (1996; fig. 6) belongs to Katz's series Women in Jackets. Like imperturbable counterparts to Robert Longo's Men in Cities series, Anne and her professionally attired colleagues gaze confrontationally at the viewer. Here, Katz's formal innovation is once again striking: he horizontally truncates the figures by removing the crowns of their heads. The act of violence caricatured in the staggered poses of Longo's figures is transferred by Katz to the artist's action upon the sheet of aluminum. With parts of the figures sliced off, Katz mocks the extent to which art's effects depend upon cognitive constants. Rather than making the viewer uncomfortable, the incompleteness of the works approximates a kind of experiential realism. Katz points to the artificiality of framing at the same time that he depicts each figure as part of a greater visual field, one that can only be comprehended in parts. Just as a person seated in a passing vehicle encounters the torsos of pedestrians through a window, or someone seated on a crowded subway is confronted with a tangle of anatomies, the torso of *Anne* registers as stable despite its abbreviation.

Katz's preoccupation with seriality prefigured strategies of Conceptual and Minimalist art, both of which used repetition as a device for exploring the relationship between part and whole and opening up questions of authorship, and led him inevitably to a hybrid of the cutout and the print. *Jessica* (2002; fig. 7) is screen-printed onto both sides of an aluminum sheet and, perhaps more emphatically than some of the other cutouts, challenges the viewer to engage with the figure. Standing at roughly 5 feet, 8 inches, *Jessica* could be approximately Jessica's height, but she is nothing like her in scale. Here height trumps proportion, since, piked atop a bronze spear much like one of Alberto Giacometti's sculptures, *Jessica* registers as a peer with whom one can make eye contact—but her head is actually slightly smaller than life-size. If Katz were to complete the rest of Jessica's body commensurate with the dimensions of her head, the viewer would easily comprehend the dissonance between her height and her scale.

"Eye level," as Katz demonstrates with *One Flight Up*, like "life-size," is a highly contingent measurement that should not dictate one's experience of art. Rhetorically asking "why can't you paint a figurative picture that's as big as … a big abstract picture," Katz has noted that "then it becomes like … little figures on a big canvas," adding that he chose to follow the scale developed by Velázquez, based upon "the proportion of the figure to the outside [of the] perimeter."[36] In other words, painting larger and larger figurative paintings merely reinstates concentric versions of the same dynamic. Dropping the frame out and assembling these cutouts establishes a new order of figurative painting. Almost a hypertrophied

Following Page:

Figure 6. **Anne**, 1996
Oil on aluminum cutout; 106.7 x 55.9 cm.
Princeton University Art Museum, promised gift

Figure 7. **Jessica**, 2002
Four-color, two-sided screenprint on aluminum cutout;
head 43.2 x 33.0 cm., stand h. 132.1 cm., base diam. 25.4 cm.
Princeton University Art Museum, promised gift

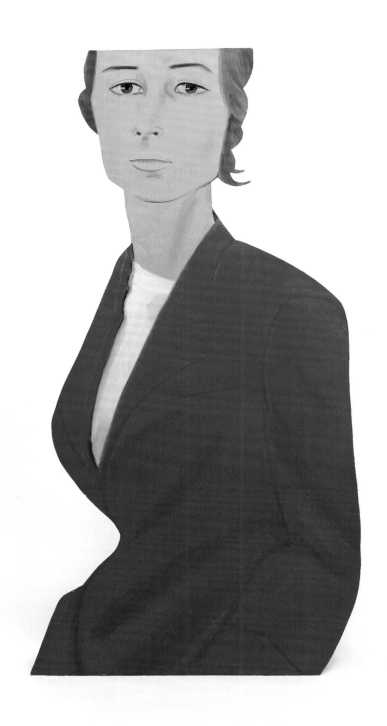

pun on the idea of the "trophy wife," *Jessica* commands attention in this way. Printing a corresponding vantage of the back of Jessica's head on the reverse, Katz puns on the totality of her screen-printed demeanor.

Katz's critics typically perceive a dissonance between landscape and figure when both elements coexist within a single work, leading to distinctions between his "pure" figure paintings and landscapes. Some writers have construed the figures within certain works as equivalent to cutouts placed in the gallery in front of a Katz landscape hung on the wall.[37] The flatness of figures that can appear coextensive with their context has led others to argue for an environmental imperative behind all of Katz's work.[38] Nevertheless, to conceive of either cutouts or landscapes as scenery is to misunderstand them completely. The artist arrives at landscape and figure through extensions of the same impulse, and asks each to be read as the other. As Katz explains: "I was working with the idea of landscape—of doing a landscape that was 'non-scenery'. I'm involved with the idea of making details or sections of things into whole paintings and in a way of seeing a landscape in an altered way. I was wondering: could you make a painting with so little in it and still have it seem like a concrete landscape?"[39]

While Katz excises, abbreviates, and recombines in his cutouts, his landscape paintings retain the traditional shape of the canvas, even if he sometimes expands the size to as much as thirty feet in width. What Katz depicts in these is only "so little" with regard to conditioned expectations of landscape. His objective is not to make "so little" become "so large," since size is merely a by-product of his engagement with form. What he offers is not simply a small detail blown up to the exclusion of all else, nor is it a matter of arbitrary cropping. If the cutouts' incompleteness aligns them more closely with antiportraits than traditional portraits, Katz's landscapes similarly depict something "so little" that they can not function as synecdoche. That which is painted can not

be read as either inductive or lacking in reference to a greater context, but must be read as finite.

Katz's landscapes train the viewers' eyes to stop seeking expansiveness, and induce a nearly myopic perception, to the extent that background details dissolve almost completely. In works like *Swamp Maple* (1968; fig. 8), he sheds any lingering Claudian perspective, that technique for unfolding a landscape painting in an almost concave fashion, with certain elements at the margins imposing depth. Viewers are unable to enter Katz's landscape, not because the tree blocks their access, but rather because the field of vision provides no anchor. Those aspects of the landscape that should logically be confined by the maple in the space behind it instead

Figure 8. **Swamp Maple**, 1968
Oil on canvas; 365.8 x 236.2 cm.
Collection of the artist

move forward and merge onto a single plane, and viewers must compensate with a new kind of attentiveness. Their ability to narrate this terrain is revoked, just as the incongruities in *One Flight Up* or the impossible proportions of *Jessica* foreclose any extrapolation and force viewers to focus on what is present rather than what is absent. The cutout *Standing Legs* (1992; fig. 9) further illustrates how Katz thrives on disorientation as he toggles between his landscape paintings and his cutouts. In this work, "so little" has become all there is. Katz paints only a portion of half of Ada's body, from her waist to her feet, onto each side of an aluminum sheet. Given his gravitation toward this myopia, it is hardly surprising that since 1996 Katz has been working on landscape paintings set at night. These works, in which night is the homogeneous surface against which fragments of information are projected, are the ultimate concrete landscapes. They are not merely scenes set at night, but rather manifestations of how one sees and how one paints when light, that crucial ingredient in figurative painting, is removed and one's sensory and representational devices reinvent themselves.

In a sense (although not a literal one), Katz's quest for the "concrete landscape" has steered him into territory usually ceded to Edward Ruscha, another artist often related to Pop art.[40] The interests of the two artists appear, on the surface, to be antithetical—Ruscha is based on the West Coast, rarely depicts the human figure, and has worked in photography and film in addition to painting and printmaking—but their concerns in fact converge. As scholars have recently noted, Katz need not be kept in art historical quarantine simply because he prefers it, but should be considered in conjunction with his contemporaries. Trained, like Katz, as a graphic artist, Ruscha has used language as the representational system on which he bases much of his work (*Mocha Standard*, 1969; fig. 10). Letters, those symbolic units of language, appeal to Ruscha for their existence outside of physical fixities; because words have abstract shapes, "they live in a world of no

size."[41] Preserving language as a formal system in his paintings and prints, Ruscha typically eliminates the human form, if not its trace, from his works.

Without the figure, that tool for bestowing scale on the panoramic expanses of nature in survey photography, Ruscha's work hits on analogous means of expression.[42] For him, the lines of words have become the de facto contours of a landscape that is not beholden to any of landscape's operative rules. Words may constitute a nonhierarchical image. Early on in his career, during a typography course at the Cooper Union, Katz similarly conceived of the way that typeface offered a visual language with lessons for painting: "[A class] led you into an area of . . . finished lettering that's very abstract;

Figure 9. **Standing Legs**, 1992
Oil on aluminum cutout; 91.4 x 10.2 cm.
Collection of the artist

just related to itself. It was quite fascinating, the whole idea of weights and what things are."[43] By cutting around the perimeter of all of *Anne*'s torso but omitting the crown of her head, for example, Katz demonstrates how excisions may in fact become irrelevant to what is present in an image.

As Katz construes his practice, "When you make paintings, it's like writing in the desert. You don't know what you've done, until someone tells you. If several people say it, it could be true."[44] With this sentiment, he perhaps unintentionally evokes both the postapocalyptic landscape of art in the wake of Abstract Expressionism, and a condition of possibility for painting. Beyond suggesting a solitary pursuit, "writing in the desert" implies urgent

Figure 10. Edward Ruscha, American, born 1937
Mocha Standard, 1969
Color screenprint on cream mold-made paper;
49.6 x 93.8 cm. image, 65.4 x 101.6 cm. sheet
Princeton University Art Museum,
Laura P. Hall Memorial Fund (x1974-8)

inscription on a monumental scale, divorced from the touchstones of "real life" or "life-size," and perhaps most legible from an aerial perspective. In his seminal text *Art and Visual Perception: A Psychology of the Creative Eye*, Rudolf Arnheim diagrammatically illustrates this principle of the generative viewing position. He includes an image of a Maltese cross drawn in black ink on a circular ground explaining that "the cross appears on a ground, that is not endless but is circular and lies in turn as a disk on the top of the surrounding empty plane. The disk is ground for the cross but figure for the surrounding surface."[45] In other words, the cross is figure to the circular ground, but the union of the cross with this ground becomes figure to the ground that is the white page. Rather than simply liberating figure from ground, Katz presents cutout figures that may be *all* ground in the sense that they dispense with the dichotomy altogether. Alex Katz's cutouts can be viewed as either ground or figure, but only as exclusively one and not the other at any given time.

Notes

1.

Andy Warhol quoted in G. R. Swenson, "What Is Pop Art?" *Art News* 62, no. 7 (November 1963): 26.

2.

Regarding the ongoing assessment of Katz's negotiation of realism and abstraction, see Arthur Coleman Danto, "Alex Katz," in *Encounters & Reflections: Art in the Historical Present* (New York, 1990), 31–35. So prevalent was the association of Katz's Ada motif with Warhol's Marilyn that even in 1976 Lawrence Alloway took pains to distinguish between the two, on the grounds that Katz's works are much larger than Warhol's and that Katz paints "visually" ("Alex Katz's Development," in David Sylvester et al., *Alex Katz: Twenty-Five Years of Painting from the Saatchi Collection* [London, 1997], 171–75).

3.

See Carter Ratcliff, "Alex Katz's Cutouts," in Zdenek Felix and Carter Ratcliff, *Alex Katz Cutouts* (Hamburg, 2003), 26.

4.

See Robert Morris, "Notes on Sculpture" (originally published 1966), in *Minimal Art: A Critical Anthology*, ed. Gregory Batcock (New York, 1968), 222–35. Morris identified a continuum between public and private: "The size range of useless three-dimensional things is a continuum between the monument and the ornament," 230.

5.

Alex Katz, interview by Paul Cummings for the Archives of American Art, Smithsonian Institution, October 20, 1969 (http://www.aaa.si.edu/collections/oralhistories/transcripts/katz69.htm).

6.

Alex Katz, "Starting Out," *New Criterion* (December 2002): 4.

7.

Alex Katz, keynote speech, Cooper Union for the Advancement of Science and Art, New York, March 9, 2006.

8.

Katz, "Starting Out," 8.

9.

See Brendan Prendeville, *Realism in 20th-Century Painting* (New York, 2000), 208. Prendeville refers to Katz's practice as "perceptualism" and associates it with the artistic strategies of Fairfield Porter and Larry Rivers.

10.

Alex Katz quoted in Robert Enright, "The Years of Figuring Restlessly: An Interview with Alex Katz," *Border Crossings* 21, no. 3 (August, 2002): 59.

11.

See, for example, Klaus Kertess, "The Other Tradition," in *The Figurative Fifties: New York Figurative Expressionism*, ed. Paul Schimmel and Judith Stein, exh. cat., Newport Harbor Art Museum (Newport Beach, Calif., 1988), 30. Kertess makes a case for the paramount significance of Katz's anxiety of influence with regard to de Kooning in particular.

12.

Willem de Kooning quoted in Enright, "The Years of Figuring Restlessly," 59.

13.

The first cutout figures were probably from a portrait of Blackie and Helen Langlais (Vincent Katz, e-mail message to author, July 25, 2006). For an example of how Alex Katz typically glosses the identity of the initial cutouts, see Ellen Schwartz, "Alex Katz: 'I See Something and Go Wow!'" *Art News* 78, no. 6 (Summer 1979): 45.

14.

Clement Greenberg, "Towards a Newer Laocoon" (originally published 1940), in *The Collected Essays and Criticism*, vol. 1, *Perceptions and Judgments, 1939–1944*, ed. John O'Brian (Chicago, 1986), 21.

15.

Jed Perl, *New Art City* (New York, 2005), 367.

16.

"As I was looking at them, I noticed out of the corner of my eye that Frank O'Hara had come in and was standing a few feet away, absorbed in the show. I quickly turned to speak to him. But he wasn't there: it was the cutout of Frank that had fooled me. A moment later with a deeper misgiving I realized that the Frank who had fooled me was only three-quarters life size" (Edwin Denby, "Katz: Collage, Cutout, Cut-up," *Art News* 63, no. 1 [January 1965]: 42–43).

17.

John Perreault quoted in Irving Sandler, *Alex Katz: A Retrospective* (New York, 1998), 26.

18.

Barry Schwabsky, "Alex Katz: Robert Miller Gallery," *Artforum* 31, no. 10 (Summer 1993): 109.

19.

As Ernst Gombrich has phrased it: "Whenever a current style is modified in the direction of realism, our mental set over-reacts" (*Art and Illusion: A Study in the Psychology of Pictorial Representation* [1965; repr. Princeton, 2000], xxxiii).

20.

Reinhardt, who had never been a representational painter, began each rule as a prohibition, forbidding, among other things, drawing, color or light, and any subject but the painting as object. See Ad Reinhardt, "Twelve Rules for a New Academy" (originally published 1957), in *The Selected Writings of Ad Reinhardt*, ed. Barbara Rose (Berkeley, 1991), 203–7.

21.

Hilton Kramer, "Cutouts, for the Squaring of the Circle," *New York Times*, January 21, 1967.

22.

Although Katz frequently speaks about likeness as a quality indispensable to his work, I would not conflate likeness with the appearance of likeness, as Irving Sandler has done (*Alex Katz*, 16–17; see n. 17 above). Denby identified the always already mediated nature of likeness in his response to Katz's cutouts of him, saying, "Looking at it I saw not a flattering likeness, but the very person I catch without warning in the mirror" ("Katz: Collage, Cutout, Cut-up," 43).

23.

Katz quoted in Grace Glueck, "A Party that Includes You Out," *New York Times*, October 27, 1968.

24.

Katz quoted in Cummings, Archives of American Art.

25.

For Clement Greenberg, flatness and "opticality" were those properties that characterized modernist painting's medium specificity. This type of painting could and must be apprehended through eyesight alone. Michael Fried extended Greenberg's ideas of opticality to a discussion of the "immediacy" of a work of art. See Clement Greenberg, *The Collected Essays and Criticism*, vol. 4, *Modernism with a Vengeance*, ed. John O'Brian (Chicago, 1993), esp. "Modernist Painting" and "Sculpture in Our Time"; and Michael Fried, *Art and Objecthood* (Chicago, 1998).

26.

Katz quoted in Enright, "The Years of Figuring Restlessly," 57.

27.

See, for example, Marco Livingstone, *Pop Art: A Continuing History* (New York, 1990), 66–67: "The free-standing painted 'cut-out' figures produced sporadically by the portrait painter Alex Katz as early as 1959 cannot properly be described as Pop, but in their flat and obdurate presence they have something of the deadpan solemnity of folk art forms such as painted sign-boards and cigar-store Indians.... The cut-outs nevertheless prepare the way both for the three-dimensional figures and tableaux made by Red Grooms from 1963 and for the enlargement and simplification of Katz's own paintings at the same time in the manner of billboards, with flat areas of strong unmodulated colour, harsh tonal contrasts and severe cropping of the image."

28.

Perl has described contemporary portraits as emerging from an "anti-painting sensibility," but also as works that have been "rescued from the end of painting and returned to its trompe l'oeil roots" (*New Art City*, 369).

29.

To demonstrate such assaults, Benjamin H. D. Buchloh pointed to Robert Rauschenberg's 1961 portrait of Iris Clert, which consisted of a telegram bearing the statement, "This is a portrait of Iris Clert if I say so. Robert Rauschenberg." Buchloh wrote: "While the photographers struggle to resurrect [portraiture] at all costs ... the artists of this generation struggle to undo this category as definitively as possible" ("Residual Resemblance: Three Notes on the Ends of Portraiture," in Melissa E. Feldman, *Face-off: The Portrait in Recent Art*, exh. cat., Institute of Contemporary Art, University of Pennsylvania [Philadelphia, 1994], 59).

30.

Charles Baudelaire, "The Painter of Modern Life," in *The Painter of Modern Life and Other Essays*, trans. and ed. Jonathan Mayne (London, 1964), 1–40. On Katz's attainment of the terms of Baudelaire's fulsome praise for Guys, see Roberta Smith, "A Unique Brand of Modernism," in Sylvester et al., *Alex Katz*, 178–81.

31.

Carter Ratcliff, "Alex Katz's Hobbesian Portraiture," in Sylvester et al., *Alex Katz*, 191–93.

32.

For the best introduction to such readings of the work of Seurat, see Norma Broude, *Georges Seurat* (New York, 1992).

33.

Katz quoted in Enright, "The Years of Figuring Restlessly," 65.

34.

"Elsewhere Katz paints the other side of the metal with a back view of his subject. The eye comes to it all of a sudden, not by degrees as with sculpture.... But which is the image? There is never an easy way to connect front and back. These free-standing but non-sculptural works generate the weight of the problematic out of their very thinness.... This creates an exquisite unease which the viewer transcends with an awareness of the contingency, even the arbitrariness of the perceptual processes by which we make sense of things" (Carter Ratcliff, "Alex Katz's Cutouts," *Arts Magazine* 53 [February 1979]: 96–97).

35.

Hilton Kramer, "Abstraction and Empathy," *New York Times*, July 23, 1967.

36.

Katz quoted in Cummings, Archives of American Art.

37.

See Jochen Poetter, "Something Hot Done in a Cool Way: On the Syncopated Compositions of Alex Katz," in *Alex Katz: American Landscape* (Stuttgart, 1995), 13. Of *Vincent and Vivien* (1995), Poetter writes: "[The figures] are not standing on the beach, but rather in front of a painting (by Alex Katz) within the white light of an art gallery: two pictorial dimensions bereft of depth." Arthur Danto likewise interprets the cutouts as indistinguishable from the figures in paintings: "The cutout so resembles the figure in a painting by Katz that one could will the problem of determining whether a given painting was of a woman or of a cutout of a woman, for the figures in the paintings have a curious flatness" (Danto, "Alex Katz," in *Encounters & Reflections*, 32).

38.

Paul Schimmel, for example, is one critic who interprets the reappearance of the figure in Katz's work as enacting a return to pictorial "environments." Schimmel extends Harold Rosenberg's idea of the "arena" in which action painters performed to the transition from Abstract Expressionism to realism and to Pop: "For classic Abstract Expressionist painting, the reality of the painting itself was its only subject For the Pop artists and the second generation Abstract Expressionists, environment began to mean something altogether different. For the second generation Abstract Expressionists (Mitchell, Goldberg, Hartigan, and Norman Bluhm), the space within the painting became landscape. For Müller, Katz, Thompson, et al., the figure reemerged in a variety of real and imagined environments, and for the Pop artists, the environment became the world outside the picture frame" ("The Faked Gesture: Pop Art and the NY School," in *Hand-Painted Pop: American Art in Transition*, ed. Russell Ferguson, exh. cat., Museum of Contemporary Art, Los Angeles [New York, 1992], 21). I would argue, however, that Katz be aligned with the second generation of Abstract Expressionist artists.

39.

Katz quoted in Jerry Saltz, "Alex Katz: Cool School," *Flash Art* 24, no. 159 (Summer 1991): 106. Although Katz's paintings resist the containment of recessive space, they do not physically disorient viewers so much as they temporally and perceptually displace them. Looking at a work like *Birches* (2002), viewers are coaxed out of the moment of initial apprehension and folded into the painting's envelope of time on the basis of the myopic details presented to them. This does not approximate what a viewer might see upon first encountering the scene in nature, but what one experiences after passing significant, rigorously observant time within it.

40.

A small exhibition at the American Academy in Rome has attempted to examine the two artists in tandem. While this exhibition was short on critical comment, letting the works speak for themselves, it was significant for broaching the comparison. It is noteworthy that the show was mounted overseas. See Linda Blumberg and Constance Lewallen, *Alex Katz, Edward Ruscha: American Academy in Rome*, exh. cat. (Rome, 2001).

41.

Ed Ruscha quoted in Hal Foster et al., *Art since 1900: Modernism, Antimodernism, Postmodernism* (London, 2004), 447.

42.

As Ruscha has noted: "I think [my paintings] become more powerful without extraneous elements like people, cars, or anything beyond the story.... I was able to subtract a romantic story from the scene—I wanted something that had some industrial strength to it. People would muddle it. There was a coldness I liked when I painted those pictures" ("Ed Ruscha/Thomas Beller," *Splash*, February 1989, n.p.). Ruscha's experimentation with cognitive constants is perhaps best exemplified by his oil on canvas *Actual Size* (1962), in which a can of Spam is painted true to its actual dimensions.

43.

Katz quoted in Cummings, Archives of American Art.

44.

Katz quoted in *Invented Symbols*, ed. Vincent Katz (Ostfildern-Ruit, Germany, 1997), 58.

45.

Rudolf Arnheim, *Art and Visual Perception: A Psychology of the Creative Eye* (1954; repr. Berkeley, 2004), 185.

BY KEVIN HATCH

ROY LICHTENSTEIN: WIT, INVENTION, AND THE AFTERLIFE OF POP

Again and again, scholars of Roy Lichtenstein have directed their readers to take note of the artist's sense of humor. Robert Rosenblum, writing in 1963, was among the first, identifying Lichtenstein's adaptation of his comic strip sources as "at once funny and disturbing" and his appropriation of Picasso as "comical" in its "ugliness."[1] Writing some years later on the occasion of a significant mural commission for the Equitable Assurance Company in New York, Calvin Tomkins pointed out that Lichtenstein's mural "makes us laugh in a salutary way," and that the artist "makes his point with a wit and a lighthearted intelligence that is thoroughly convincing."[2] Jack Cowart, a tireless proponent of Lichtenstein's later work, has singled out the artist's sculpture from the 1970s as representative of "his humor and wit, modesty, and modernism."[3] Even Lichtenstein himself once claimed, "Everything I do is a comment on something. It's ironic or humorous."[4] While the words "comic" and "wry," "droll" and "ironic," crop up repeatedly in the writing on Lichtenstein's work, little consideration has been made for the mechanics involved—that is, *why* and *how* it is funny. These questions are worth asking because the answers can help make sense of the artist's remarkably long and prolific career, as well as provide insight into the Pop moment of the 1960s and its afterlife—or at least, one of its afterlives.

When Lichtenstein first caught the attention of the New York art world in the early 1960s, his paintings were viewed by many, quite literally, as jokes—and bad ones at that. In spite of a professional artistic career stretching back to the late 1940s, Lichtenstein's entry into the rarified New York scene occurred in February 1962, with a commercially successful exhibition of paintings at the Leo Castelli Gallery. By the time of the landmark *New Realists* exhibition at the esteemed Sidney Janis Gallery at the end of that year, Pop art had arrived in force, with Lichtenstein one of its leading stars—eventually becoming a formidable enough presence to prompt *Life* magazine to run a feature provocatively asking, "Is He the Worst Artist in the U.S.?"[5] On offer at both the Castelli and Janis exhibitions were paintings in two chief modes: vignettes apparently taken wholesale from the panels of romance and war comics (*Masterpiece*, 1962; fig. 1), and images of consumer goods, such as hot dogs and home appliances, centered and isolated on otherwise empty canvases (as in *Roto-Broil*, 1961; fig. 2). The paintings made a splash, sold well, and immediately polarized the critics.

Much of the critical discussion centered on the degree to which Lichtenstein did or did not "transform" his source material. The artist and art historian Erle Loran, whose diagrams of Cézanne's paintings Lichtenstein had audaciously appropriated for his own paintings, disparaged the artist's work as mere "copies and enlargements of 'funny pitchers'."[6] In Loran's view, Lichtenstein's works defaulted on the noble tradition of "transformation" that had governed all serious modern painting from Cézanne through Abstract Expressionism.

Detail of **Still Life with Lobster**, 1974
Lithograph and screenprint on Rives BFK paper;
81.9 x 78.8 cm. image, 98.5 x 95.2 cm. sheet
Princeton University Art Museum, promised gift

Peter Selz, then curator at the Museum of Modern Art, also cited Lichtenstein's and other Pop artists' lack of "transformation," suggesting it was Pop's passivity that made it unworthy of serious contemplation (and even morally suspect, for what Selz saw as a celebration of consumer culture).[7] Other critics, even if unfavorably disposed, were willing to give Lichtenstein a little more credit. Harold Rosenberg, a chief proponent of Abstract Expressionism in the 1940s, saw Lichtenstein's work as uneven and even dull at times; nevertheless, he begrudgingly granted that it had its charms, among them a "gentle, professorial humor and a sincere liking for corny themes, colors, and postures."[8] Indeed, Lichtenstein's paintings were funny in part *because* they were corny. Lichtenstein's sources for his comic strip paintings came not from the (relatively) illustrious pages of superhero comic books, but rather from the trite, shopworn dramas of *Secret Hearts, Girls' Romances*, and *All-American Men of War*.[9] Although contemporary, these images had the look, even in 1962, of something slightly out of date, threatened as they already were by the media explosion that would soon render them

obsolete. The recognition was enough to prompt a nostalgic smile or a quiet chuckle.

But for many of Lichtenstein's most hostile critics, the joke was cheap and one-note. For them, Lichtenstein was a "charmer," giving a gullible public the "hard sell."[10] These critics saw a painting such as *Masterpiece* as a cynical betrayal of the hard-won tenets of advanced modern painting, from its vacuous dramatic situation and in-joke about artistic fame to its garish colors and aping of the mechanically reproduced Benday dots of commercial illustration. Any humor was viewed as infantile at best, the snickering of a child thumbing his nose at the authorities.[11]

Critics more positively disposed saw the joke to be not on the public, but on the institutions with which both artist and public had to contend, and indeed revolt against, in postwar America. This (smaller) group of critics proffered an ironic Lichtenstein, one who was critical of modern consumer culture and exposed its clichés as base and illusory. Rosenblum went so far as

Figure 1. Roy Lichtenstein, American, 1923–1997
Masterpiece, 1962
Oil on canvas; 137.2 x 137.2 cm.
Private collection

Figure 2. **Roto-Broil**, 1961
Oil on canvas; 174.0 x 174.0 cm.
Museum of Contemporary Art, Teheran

to identify the artist as the modern inheritor of the legacy of Courbet, positing Lichtenstein as an unyielding realist who embraced "not only the content, but also the style, of popular imagery in mid-twentieth-century America as a means of invigorating the moribund mannerisms of abstract painting."[12] "Moribund mannerisms," for Rosenblum and others, was code for the inglorious denouement of Abstract Expressionism, which for many by the early 1960s had begun to seem trite and tired, an institution as dull and stagnant as any other. If Rosenblum perceived an implicit critique of late gestural abstract painting in Lichtensten's comic strip paintings, the critique appeared to become explicit in a notable series of paintings on the theme of the brushstroke that the artist exhibited at Castelli in 1965.

When Lichtenstein took up the brushstroke motif in 1965, the gesture was immediately received as a satirical send-up of Abstract Expressionism.[13] The artist himself helped pave the way for this reception. Speaking in a 1964 interview, before he had taken up the theme, he said:

> I'm thinking now of doing something on Abstract Expressionism.... The problem there will be to paint a brush stroke, a picture of a brush stroke.... Purposely dripped paint and things, you know, where the drips are actually drawn as drips that look like drops of water drawn by a commercial artist.[14]

The solution Lichtenstein settled upon was inspired by an image found in a comic book, but he developed his own visual system to overcome the challenge of representing fluid brushstrokes in his trademark flat, graphic style.[15] For the first painting in the series, Lichtenstein set three overlapping strokes of bright red paint against an allover pattern of Benday-like dots (fig. 3). A hand holding a brush is partially visible in

the lower left corner of this first painting, although such anecdotal details would not appear in any of the other paintings in the series. Numerous other Brushstrokes followed, each adhering to the formula of one or more broad strokes sweeping over a regularized ground of Benday dots (fig. 4).

How such paintings could be construed as a satire of Abstract Expressionism is readily apparent. Each Lichtenstein Brushstroke painting presents a premeditated, carefully designed simulation of what, for the gestural painter, was supposed to be a spontaneous and somatic manifestation of ineffable feeling. Further, the relentless focus on the isolated brushstroke in the series brought attention to the way a central motif of "action painting" had devolved, in the work of many artists, into a kind of autographical tic emptied of meaning. Even the fact that the Brushstroke series could apparently continue ad infinitum seemed to strike at the core crisis within Abstract Expressionism between the commitment to innovation and the development of a mature, individual style.

Figure 3. **Brushstrokes**, 1965
Oil and magna on canvas; 121.9 x 121.9 cm.
Private collection

Figure 4. **Yellow and Green Brushstrokes**, 1966
Oil and magna on canvas; 213.4 x 457.2 cm.
Museum für Moderne Kunst, Frankfurt

Figure 5. **Mural with Blue Brushstroke**, 1984–86
Oil on canvas; 207.0 x 98.0 cm.
AXA Center, New York

Figure 6. **Brushstroke V**, 1986
Painted cherry wood; 148.3 x 78.4 x 34.3 cm.
Princeton University Art Museum, promised gift

Yet Lichtenstein's engagement with Abstract Expressionism was complex, and his invocation of its signature motif was no straightforward satirical jab. To begin with, Lichtenstein himself had worked in an Abstract Expressionist mode for some years before his decisive turn toward Pop in 1961, and his shift away from abstraction appears in hindsight as a logical development rather than a violent disavowal.[16] Moreover, in interviews he consistently expressed esteem for abstract painting and its major figures. But there is no need to rely upon his words, given the evidence found in the paintings in question. Every Brushstroke painting is a successful formal abstraction in its own right—at once balanced and forceful, with effects ranging from placid (fig. 3) to sweeping and soaring (fig. 4).

Perhaps it is better, then, to see the Brushstrokes as participating in a dialogue with the legacy of Abstract Expressionism, rather than aiming to tear it down or replace it.[17] Such a view would help account for an otherwise curious aspect of the Brushstroke motif— namely, that once he found it, Lichtenstein never let it go. The theme occupied him, in a variety of capacities, for some thirty-two years, from the first Brushstroke paintings in 1965 to his very last works in the late 1990s. The brushstrokes appear, again and again, in painting after painting, in various guises. Sometimes they intervene in an otherwise traditionally composed still life or landscape, like a rip or tear in the image; sometimes they structurally anchor a whole complex composition, as in the monumental mural commission for the AXA Center, completed in 1986 (fig. 5).[18]

In the early 1980s, the brushstroke even wandered off the canvas and into three dimensions, both in monumental outdoor works and in a series of intimately scaled sculptural editions in polychrome bronze and painted wood.[19] The wall relief *Brushstroke V* of 1986 (fig. 6), the fifth in a series of six related wall-mounted pieces, is a representative example of the latter. Here a

number of interlocking brushstroke-shaped pieces of wood painted in black, white, red, yellow, and two shades of blue radiate from a central point. The work gains dynamic tension from its lack of a visual center; in fact, nothing seems to be keeping it from fracturing into its constituent parts. In this, it calls to mind Lichtenstein's "wall explosion" sculptures of the mid-1960s, in which the cartoon equivalent of an explosion— the jagged starburst signifying a punch, crash, or explosive burst in the comics—was given solid form in enameled steel (fig. 7). In *Brushstroke V*, the radiating brushstroke elements are, as in the "explosions," representations of something amorphous that have been given concrete form. This gives *Brushstroke V*— like the earlier sculpture—the feeling of being strangely stilled, in spite of the dynamism of its composition. The stillness is intensified by the work's high degree of finish, for all signs of the process of production have been effaced beneath smooth, velvety layers of paint (an effect akin to the early Brushstroke paintings).[20]

Figure 7. **Wall Explosion I**, 1965
Enamel on steel; 203.0 x 213.0 cm.
Private collection

The sculpture's effect is therefore contradictory: cool and impersonal, it nonetheless anxiously threatens to break apart.

The Brushstroke sculpture series of the 1980s was not Lichtenstein's first foray into sculpture. In addition to the "explosions" already mentioned, and a number of polychromed trompe l'oeil ceramic pieces done in comic-book style in the early 1960s, there were two extended sculptural forays before 1980: a 1967 series of Modern Sculptures that played with the vocabulary of Art Deco and, in the late 1970s, a series of freestanding, poly-chrome, nearly planar treatments of everyday objects (fishbowls, pitchers, lamps, and so on) cast in bronze. The Brushstroke theme, however, became Lichtenstein's most elaborate and sustained meditation on a sculptural form, one that continually built on its own precedents while never losing touch with its originating moment in the initial Brushtroke paintings.

Thus, by 1996, a painted bronze like *Brushstroke* (1996; fig. 8), in which a lone white stroke cascades across a scant base, manages to be both a radical distillation of the possibilities for the Brushstroke motif in small-scale sculpture, and an allusion to Lichtenstein's earliest work—not just in its image of a single petrified brush-stroke (several of the 1965–66 Brushstroke paintings similarly isolate a solitary stroke), but also in its gestalt-like unity, which calls to mind the artist's early Pop "common image" paintings of consumer goods (fig. 2).[21] Yet while Pop works like *Roto-Broil* shocked viewers with their confrontational banality, *Brushstroke* is amiable, oddly animate, and genially self-contained.

The curious way in which Lichtenstein's Brushstrokes (and, in fact, all his later work) maintain dual loyalty to past and present has a great deal to do with their materialization in a variety of media. The intimate scale and what might be termed the "touchability" of both *Brushstroke V* and *Brushstroke* differ fundamentally from the overpowering experience of the large, slick Brushstroke canvases of the mid-1960s, many of which measured several meters in length and height. Lichtenstein was an artist deeply interested in medium, and he worked extensively in drawing, printmaking, and sculpture, in addition to his better-known paintings. Often he would explore a theme across several media, with subtle changes made to a similar image producing radically different effects. The conditions of possibility inherent in each medium allowed for an interrogation of a given theme from all sides, as it were, affording the artist an opportunity to return continually to what would otherwise have remained a deadened cliché.

By now, at least, it should be clear that Lichtenstein's engagement with the Abstract Expressionist brushstroke cannot be equated with satire; its meaning is too slippery to be pinned down so definitively. Such representational ambiguity in Lichtenstein's art—the sense that the signs it puts into play have no given meanings, but rather gain or lose meaning depending on context—has led a number of commentators to take a semiotic approach in their interpretations. For example, Lichtenstein was pivotal for one of Pop art's earliest proponents, Lawrence Alloway, in his argument against a "narrow" definition of Pop as an art utilizing mass-produced products as subject matter, and for a broader definition of Pop as "an art which assumes a spectrum of preexisting artifacts and *signs* as subject, including but not restricted to consumer goods."[22] For Alloway, Lichtenstein's trafficking in the "discredited values" of reproductions, whether consumer goods or photographs of modernist paintings in magazines, was evidence of the artist's acute understanding that *all* signs were arbitrary and devoid of secure meaning, from comic strips to Picasso. According to Alloway, "Lichtenstein's subject is the artificiality of communication, the discrepancy between signifier and referent."[23] Michael Lobel has also addressed the way Lichtenstein's painting operates semiotically, in particular how it concerned itself with the problems of finding the most economical means of communicating in graphic form. Unlike Alloway,

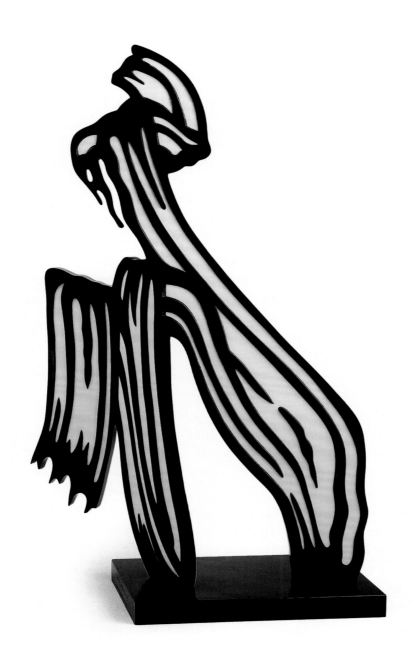

however, Lobel has presented this concern as fundamentally conflicted, given Lichtenstein's anxieties about artistic originality and mastery.[24] Most recently, Hal Foster has discussed the semiotics of the bronze polychrome sculpture of the 1970s, noting how, in their play with the conventionality of signs, these works recall and expand upon the experiments with signification found in the Cubist collages of Picasso and Braque—filtered, however, through the conventions of postwar mass media.[25]

Yet perhaps there might be another way to look at Lichtenstein's "play" with signs—a way to take the ludic dimension seriously, so to speak, and attempt to find some pattern of intention among the jokes and feints. In examining the broad sweep of Lichtenstein's very long career, it is startling how crowded the works are with visual conceits, from simple sight gags (the dimples of a golf ball as an early Mondrian, the marbling of a composition notebook cover as a Pollock) to complex allegories about the history of modern art (as in *Still Life with Lobster* [1974; fig. 9], in which the whole of the Dutch still-life tradition lurks behind a jumble of nautical kitsch). Paying careful attention to the array of witty devices at play in these works can add substantively to our understanding of Pop art and Lichtenstein's relation to it.

In the case of the Brushstroke motif, what begins as a caricature of a cliché is itself forcefully made over *into* a cliché by the artist—that is, it becomes a kind of trademark, which can subsequently be multiplied, stretched, and inverted. Hence the uncanny inner life of the late Brushstrokes—the unstable composition of *Brushstroke V* and the animistic energy of *Brushstroke*. Here the conceit is at the artist's own expense, and the joke grants the depleted sign new life.[26] What is of

Figure 8. **Brushstroke**, 1996
Oil on patinated bronze; 83.2 x 47.6 cm.
Princeton University Art Museum, promised gift

paramount importance, however, is the relationship to the past that such gaming implies—a relationship with the history of modern art that is not adversarial but also not acquiescent.

In a notable roundtable discussion about Pop art broadcast on a New York radio station in 1964 and published soon after, moderator Bruce Glaser asked the participants—Lichtenstein, Claes Oldenburg, and Andy Warhol—whether the subject matter of Pop art was, in fact, satirical. Oldenburg was the first to reply:

> If it was just a satirical thing there wouldn't be any problem. Then we would know why we were doing these things. But making a parody is not the same thing as a satire. Parody in the classical sense is simply a kind of imitation, something like a paraphrase. It is not necessarily making fun of anything, rather it puts the imitated work in a new context.

Lichtenstein had this to add:

> In the parody there is the implication of the perverse and I feel this in my own work even though I don't mean it to be that, because I don't dislike the work that I am parodying. The things that I have apparently parodied I actually admire and I really don't know what the implication of that is.[27]

Lichtenstein seems to express resistance to the consequences of his own practice. How could he avoid perverting his admired sources? The answer perhaps lay in embracing parody in the "classical sense" cited by Oldenburg. Rather than trafficking in debased and depleted signs, such a move would entail recognizing a historical continuum of signs into which the artist could inventively intervene. If this differed radically from the high-modernist model of agonistic creation against the void, of making-it-new at all costs, it differed as well from

Figure 9. **Still Life with Lobster**, 1974
Color lithograph and screenprint on Rives BFK paper;
81.9 x 78.8 cm. image, 98.5 x 95.2 cm. sheet
Princeton University Art Museum, promised gift

that cynical brand of post-modernism in which the world of signification is a fun house of floating signs, to be ransacked at random. In fact, the path Lichtenstein ultimately followed resembles, in retrospect, nothing so much as a *pre*modern model of artistic practice, one in which the relationship to the past, to history writ small or large, participates in a lively give-and-take with the present.

Seen from this perspective, Lichtenstein's works are indeed parodies, in the sense that they place an imitated source—a work of art, an artist, a movement, a genre—in a new context. More is at stake, however, than just displacement. Rather, Lichtenstein engages in a certain kind of competition with the original, and this competition has a long history in art. Its precedent lies in the Baroque—in the art of Orazio and Artemisia Gentileschi, of Velázquez and Rubens. With "ingenious" inventions, these Baroque artists prompted from their audience first recognition of the original, then admiration of the imaginative trumping of the prototype. A similar dynamic is at work in Lichtenstein's art.

For Lichtenstein to return again to a motif such as the brushstroke was thus not so much an attempt to draw attention to the arbitrary character of the sign as it was an assertion of a claim on a certain lineage, within which invention could take place. Such invention could be thought of as a kind of "transformation," but in a different register from that intended by Erle Loran and the other modernist critics hostile to Lichtenstein. Those critics demanded of an artist a new language through which to transform his sources. Lichtenstein recognized there was nothing new under the sun—but he also recognized that did not stop one from inventing.

After his initial Pop endeavors, Lichtenstein's career unfolded gracefully, with a series of related paintings or sculptures arriving nearly every exhibition season,

each elaborating a new visual or thematic problem while cycling back to precedents of motif, form, and technique in his own work. Beginning in the mid-1960s, these series were often inspired by a canonical artist, style, or movement from the history of modern art, as in the group, completed in 1969, of paintings after Monet's Haystacks and Cathedrals. Lichtenstein took up the theme after visiting the exhibition *Serial Imagery*, which had been organized by John Coplans at the Pasadena Art Museum the previous year. Albers, Duchamp, and Mondrian were among those included in the show, along with some of Lichtenstein's contemporaries working in a serial vein, including Kenneth Noland, Frank Stella, and Andy Warhol. The exhibition also included *Two Haystacks* and *Rouen Cathedral* by Monet, although the catalogue reproduced many more paintings by the artist.[28] Lichtenstein's paintings after Monet led to his first extended print series, produced at the master print workshop Gemini G.E.L. in Los Angeles. The Haystacks, along with the Cathedral series that soon followed, were widely admired for their accomplished lithographic technique (a product of intensive collaborative effort between artist and shop technicians).[29]

Dutifully producing multiple prints in a workshop based on a modernist master who prided himself on his work *en plein air* was a good joke, but Lichtenstein went further, setting himself the task of besting the modernist master at his own game. In each of the prints in the series, screens of Benday dots coalesce into a compelling evocation of diverse atmospheric effects—slightly hazy in *Haystack #4*, bright and crisp in *Haystack #5* (see Checklist). In the lithographs, the Impressionist brush-stroke is replaced by overlapping dots, but it is no worse for the substitution—when viewed from a distance, the flat image resolves into three dimensions as well as any Monet Haystack (and perhaps better).

None of this addresses the most fundamental difference of all: that the Lichtenstein prints are mechanically

reproduced multiples. Their production is mechanized— but only to a point, for the printmaking process, as practiced by Lichtenstein at Gemini, was a labor-intensive and highly handcrafted affair. Paradoxically, however, it would seem that Lichtenstein viewed printmaking as a *better* means of capturing the kind of transient effects Monet pursued so doggedly in oil on canvas. Lichtenstein himself suggested as much, in a discussion of the difference between his Haystack paintings and his prints of the same:

> The prints are a little smaller, but that's not significant. The paintings are all different images. In terms of exactness of placement and register, the prints are better, because they can be controlled in this medium. Working on canvas isn't controllable in the same way. The paintings bear the tracks of corrections of various things. The prints are all worked out beforehand and appear purer.[30]

The same lithographic matrices could be used repeat-edly, exchanging only colors to re-create, at least in theory, an infinite range of "impressions" of sunlight and weather conditions. Lichtenstein here uses the medium of printmaking to make a witty "improvement" on Monet's modernist project.

Lichtenstein's dialogue with the history of modern art was not limited to individual artists, but extended to whole movements and even genres. The still life, for example, was a long-standing interest. The modern still life, understood as a self-contained array of objects arranged for painterly depiction, has its origins in the sixteenth century, and was codified in the eighteenth century as a genre akin (although considered inferior) to those of history painting, landscape, and portraiture. Yet, as Norman Bryson has pointed out, it is a difficult category to define, encompassing as it does a wide-ranging welter of images.[31] Lichtenstein's own ventures in still life have mimicked this difficulty of definition.

In addition to his early Pop "common image" paintings, which constitute a kind of still life, he repeatedly returned to the genre, highlights of which include the aforementioned polychrome bronze sculptures of the 1970s, in which oscillation between two and three dimensions enlivens quotidian objects; canvases from the 1970s and 1980s in which still lifes by Léger, Matisse, and others are "Lichtensteinized";[32] and a droll set of Office still lifes, in which standard office supplies stacked on desks and tables are painted in drab, institutional colors. It would appear that the range of still life was limitless for Lichtenstein, and that this range itself has something to say about modernism's desire for freedom from boundaries.

A complex relationship to history is present even in work that at first seems simple, such as the late, sparse *Still Life with Red Jar* (1994; fig. 10). The work presents a schematic table or ledge, upon which sit a bottle and two apples, one yellow and one red. The red apple is positioned in the center of the composition, bridging the surface upon which it rests and the blue region of wall or sky above. The apples stand in arch tension with the bottle to the right.

The picture demands the language of formalist criticism due to its unmistakable evocation of Cézanne's carefully wrought compositions involving geometrically distilled apples and bottles. Yet it does so at one remove, mediated by Lichtenstein's customary Benday dots. Like the late Brushstrokes, the dots here have become quotations from the artist's own earlier work—and as with that motif, they are put to wholly new purposes. Lichtenstein developed his Benday dots in his Pop paintings both to signify the origins of his imagery in print media and to give otherwise flat imagery depth and color modulation.[33] By the 1990s, however, the Benday dot had come to signify "Lichtenstein" more than anything else. Thus in *Still Life with Red Jar*, the dots can be used for strictly formal ends—to produce a vibrating sense of depth, by increasing their scale from right to left (for the blue

AP 7/50 rf Lichtenstein 94

Figure 10. **Still Life with Red Jar**, 1994
Color screenprint on Lanaquarelle watercolor paper; 54.3 x 48.9 cm.
Princeton University Art Museum, promised gift

dots) and from left to right (for the red ones)—while retaining an echo of their past life in the Pop paintings. In this simple image, a whole history of modernist still life, from Chardin to Cézanne to Picasso, is placed in proximity with a history internal to Lichtenstein's own oeuvre. The result is a melancholic image, quiet and unassuming in spite of its brash Pop elements.

In the last years of his career, Lichtenstein focused on another genre with a long and rich history. In a series of Interiors, he depicted living rooms, bedrooms, and dens brimming with the trappings of idealized American domestic life: sectionals, coffee tables, houseplants, and works of art. The Interiors are legible as caricatures of the spreads of wealthy living spaces published in the pages of magazines like *Architectural Digest*, and they also pay homage to the early Pop collages of Richard Hamilton, as Robert Fitzpatrick has noted.[34] The paintings tend to be large and elaborate. Most depict works recognizable from the history of modern art

hanging on walls, placed on coffee tables, or displayed on shelves. Often the quotation is multilayered, as in *Interior with African Mask* (1991; fig. 11) in which a sculpture tucked away on a bookshelf at once represents the Lichtenstein sculpture *Ritual Mask* (1992), the Synthetic Cubist period of Picasso and Braque, and the African masks that inspired the Cubists.[35] The mirror hanging on the dining-room wall is multivalent as well; it could be a mirror, or it could be one of Lichtenstein's Mirror series of paintings from the early 1970s. Warhol's Flowers series (redone as a flower arrangement), a Japanese screen, and an anonymous, vaguely futuristic abstract "sculpture" in the foreground round out the collection.[36] By placing these works together in a domestic setting, Lichtenstein bridges the temporal disjunctions among them, without relegating any of them to the past. Rather, they nestle together like virtual objects on the shelves of some late-twentieth-century *Kunstkammer*, inviting the virtual inhabitant to make hitherto unrecognized connections.

Figure 11. **Interior with African Mask**, 1991
Oil and magna on canvas; 289.6 x 370.8 cm.
The Eli and Edythe L. Broad Collection, Los Angeles

Figure 12. **Interior**, 1996
Patinated bronze; 68.6 x 49.5 x 17.8 cm.
Princeton University Art Museum, promised gift

In a notable offshoot of the Interiors series, a handful of late sculptures took their orthogonal lines and sense of space from the paintings but cast them into three dimensions. These included large outdoor works as well as small-scale sculptures like *Interior* of 1996 (fig. 12). In their expert exploitation of the effects of plunging perspective, these late sculptures continue to challenge the viewer's perception even after their lack of actual, physical depth is rationally understood. The conundrums of visual perception were an abiding interest for Lichtenstein. As he once remarked, "I show the traps you fall into when you believe the things that are painted are real."[37]

Convincing as its illusion is, *Interior* creates a very unreal space, a product of its fragmentary form and utterly generic, cartoonish mode of representation. Like the Interior paintings from which it seems to have dislodged, *Interior* reverses the traditional imperatives of the genre of the interior, from Vermeer through Degas and after, which tend toward the specific and identifiable. *Interior* encodes a great deal of meaning, yet it does so through an extraordinary economy of means. Coming as it does at the end of Lichtenstein's career, it serves as a kind of emblem and coda for the artist. The doorway it presents, full of promise, leads only to an identical but reversed version of the same—figuring, with austere simplicity, the central conceit of every work of art.

The games Lichtenstein played with the history of modern art were specific to his practice. He operated within a particular model of the studio, one that treated it as an intellectual environment—*studio* in its original sense, meaning the space of the scholar[38]—and an arena for testing and surpassing precedents. If, as has been persuasively argued, other artists of his generation transformed the studio from the solitary space of the Romantic modernist recluse into something more

like a factory or an executive office,[39] Lichtenstein's practice looked *back*, to the learning, experimentation, and dialogue that characterized the major studios of the seventeenth and eighteenth centuries. Small wonder, then, Lichtenstein's devotion to his studio—a loyalty that found him in his "playpen," as he called it, seven days a week, without fail, from morning to evening.[40] Why this odd turn to an anachronistic model of artistic practice? The answer lies in the anxieties Lichtenstein expressed in 1964, when he identified the potentially perverse character of Pop parody. In those few sentences, Lichtenstein intuited, if he did not fully grasp, the impossibility of riding indefinitely the razor's edge between pop and Pop, so to speak. The animating tension Roland Barthes identified as the two competing "voices" in Pop art, "as in a fugue—the one saying, 'This is not Art'; the other saying, at the same time, 'I am Art',"[41] could not be sustained. Pop could never be a movement, only a moment. By the time the ad men came back—to *re*-appropriate Lichtenstein's appropriated mass media images and use them again to sell dish soap and insurance, with the addition of a veneer of art-world chic[42]—Lichtenstein had moved on, or rather back, to wrestle with the ghosts of modernism's past. Characteristically, though, he did so on his own terms: keeping alive the questions of originality and artistic mastery that had fueled his Pop provocations, but addressing them in a different register. In the last analysis, Lichtenstein's trajectory looks less like a conservative retreat into the safety of his own success, and more like an embrace of an alternate afterlife for Pop, one that sidestepped the cynical nostalgic gambits of post-Pop postmodernism and instead found the means for renewal in a deeper engagement with art history.

Notes

1.

Robert Rosenblum, "Roy Lichtenstein and the Realist Revolt" (originally published 1963), in *Roy Lichtenstein*, ed. John Coplans (New York, 1972), 133.

2.

Calvin Tomkins, "Brushstrokes," in Bob Adelman and Calvin Tomkins, *The Art of Roy Lichtenstein: Mural with Blue Brushstroke* (New York, 1987), 29.

3.

Jack Cowart, "Lichtenstein Sculpture: Multiple Personalities—A Quick Survey of Five Decades," in *Lichtenstein: Sculpture & Drawings*, ed. Jack Cowart, exh. cat., Corcoran Gallery of Art (Washington, D.C., 1999), 14.

4.

Roy Lichtenstein quoted in Ruth E. Fine, "Dots, Stripes, Strokes, and Foils: Roy Lichtenstein's High-Tech Classicism," in *The Prints of Roy Lichtenstein: A Catalogue Raisonné, 1948–1997*, ed. Mary Lee Corlett, 2d rev. ed. (New York, 2002), 42.

5.

Dorothy Seiberling, "Is He the Worst Artist in the U.S.?" *Life*, January 31, 1964, 79–81, 83.

6.

Erle Loran, "Cézanne and Lichtenstein: Problems of 'Transformation'," *Artforum* 2, no. 3 (September 1963): 34.

7.

Peter Selz, "Pop Goes the Artist," *Partisan Review* 30, no. 3 (Summer 1963): 314.

8.

Harold Rosenberg, "The Art World: Marilyn Mondrian," *The New Yorker*, November 8, 1969, 167–76.

9.

Kirk Varnedoe and Adam Gopnik exhaustively discuss the generic appearance of Lichtenstein's adaptations from romance and war comics, noting, "Ironically, he had to aggressively alter and recompose them to bring them closer to a platonic ideal of simple comic-book style—he had to work hard to make them look more like comics." See *High and Low: Modern Art and Popular Culture*, exh. cat., Museum of Modern Art (New York, 1990), esp. 194–208.

10.

Max Kozloff, "'Pop' Culture, Metaphysical Disgust, and the New Vulgarians," *Art International* 6, no. 2 (March 1962): 34–36.

11.

See, for example, Sidney Tillim, "Further Observations on the Pop Phenomenon," *Artforum* 4, no. 5 (November 1965): 17–19.

12.

Rosenblum, "Roy Lichtenstein," 133.

13.

Diane Waldman, *Roy Lichtenstein*, exh. cat., Solomon R. Guggenheim Museum (New York, 1993), 151.

14.

Lichtenstein quoted in Michael Lobel, *Image Duplicator: Roy Lichtenstein and the Emergence of Pop Art* (New Haven, 2002), 162.

15.

Diane Waldman identifies the source as a panel from "The Painting" in *Strange Suspense Stories*, no. 72 (October 1964), published by Charlton Comics. See Waldman, *Roy Lichtenstein*, 151. Lobel has speculated on what this source would have meant for Lichtenstein; see *Image Duplicator*, 159–68.

16.

On Lichtenstein's pre-Pop career, see Ernst A. Busche, *Roy Lichtenstein: Das Frühwerk, 1942–1960* (Berlin, 1988).

17.

Dave Hickey suggests that Lichtenstein's Brushstroke paintings proposed "a critique of the immediate past, clearly intending to supersede it without destroying it"—a proposal predicated on the paintings themselves being "achieved and persuasive objects." For Hickey, the appearance of Lichtenstein's Brushstroke paintings in 1965 definitively rendered irrelevant— "in the friendliest manner imaginable"— the long-standing agonistic struggle embodied in postwar abstract painting. As will become clear, I would argue for a subtler give-and-take between parodist and parodied. See Hickey, *Roy Lichtenstein: Brushstrokes, Four Decades*, exh. cat., Mitchell Innes & Nash (New York, 2001).

18.

For a detailed account of this commission, see Tomkins, "Brushstrokes," 7–29.

19.

At times the relationship between iterations of a motif in different media could be quite direct. For example, the bronze sculpture *Brushstroke* (1996), a promised gift to the Princeton University Art Museum, first appeared in the woodcut *Apple with Gray Background* (1983).

20.

Jack Cowart has noted the consistency with which Lichtenstein would efface the process of making from his sculptures, and has argued that this reflects the artist's desire to drain the works of any sense of "Romantic" personalization. See "Lichtenstein Sculpture," 14.

21.

Many of Lichtenstein's commentators have discussed the life-long impact on the artist of Hoyt L. Sherman's unique art training program focusing on visual unity. Lichtenstein taught in Sherman's "flash lab" while a graduate student at Ohio State University between 1946 and 1949. In the lab, based on one Sherman had seen at Princeton University, an image was projected to a group of art students for a fraction of a second in an otherwise darkened room. The students then drew in the dark what had registered on their retinas, in an effort to create a perfect relay between eye and hand. On the relationship between Sherman's teaching and Lichtenstein's work, see in particular David Deitcher, "Unsentimental Education: The Professionalization of the American Artist," in *Hand-Painted Pop: American Art in Transition, 1955–1962*, ed. Russell Ferguson, exh. cat., Museum of Contemporary Art (Los Angeles, 1992); Lobel, *Image Duplicator*, esp. chapter 3; and Graham Paul Bader, "Roy Lichtenstein, Pop, and the Face of Painting in the 1960s" (Ph.D. diss., Harvard University, 2005), esp. chapter 1.

22.

Lawrence Alloway, *Roy Lichtenstein* (New York, 1983), 42, emphasis added.

23.

Alloway, *Roy Lichtenstein*, 34.

24.

Lobel, *Image Duplicator*, 105–24.

25.

Hal Foster, "Pop Pygmalion," in *Roy Lichtenstein: Sculpture*, exh. cat., Gagosian Gallery (New York, 2005), 8–19.

26.

As Foster notes, "If the gestural brushstroke is indeed reified, why not take advantage of this fact, stand it up and make a figure of it, and so reanimate it a little?" ("Pop Pygmalion," 17).

27.

Bruce Glaser, "Oldenburg, Lichtenstein, Warhol: A Discussion," *Artforum* 4, no. 6 (February 1966): 23.

28.

The catalogue included a historical essay on serial art, along with a theoretical discussion of its meanings: John Coplans, *Serial Imagery*, exh. cat., Pasadena Art Museum (Pasadena, 1968).

29.

On Lichtenstein's collaborations at Gemini G.E.L. and elsewhere, see Fine, "Dots, Stripes, Strokes, and Foils," 27–46.

30.

Roy Lichtenstein, in an interview in 1970 with John Coplans, quoted in Coplans, *Roy Lichtenstein*, 96.

31.

"The first difficulty facing any book on still life painting lies in its opening move, in the assumption that still life exists. Of course we all know what still life looks like; that is not the problem. But despite our familiarity with still life and our ease in recognizing it, there is still something unjustified about the term, in that it takes in so much: Pompeii, Cubism, Dutch still life, Spanish still life, trompe l'oeil, collage. Why should these entirely different kinds of image be considered as a single category? What is the relationship, if any, between these images that are historically, culturally, and technically so diverse?" (Norman Bryson, *Looking at the Overlooked: Four Essays on Still Life Painting* [Cambridge, Mass., 1990], 7).

32.

The term is Carter Ratcliff's; see "The Work of Roy Lichtenstein in the Age of Walter Benjamin's and Jean Baudrillard's Popularity," *Art in America* 77, no. 2 (February 1989): 111–22, 177.

33.

Early on, Lichtenstein noted that, due to his limited range of colors, "actual color adjustment is achieved through manipulation of size, shape, and juxtaposition," including density and placement of the Benday dots. Quoted in John Coplans, "Talking with Roy Lichtenstein," *Artforum* 5, no. 9 (May 1967): 34.

34.

Robert Fitzpatrick, "Perfect Pictures," in *Roy Lichtenstein: Interiors*, ed. Robert Fitzpatrick and Dorothy Lichtenstein (New York, 1999), 14.

35.

The depiction of *Ritual Mask* in fact predates its creation; it was cast the year after the painting was completed.

36.

The sources for the painting are identified and illustrated in Fitzpatrick, *Roy Lichtenstein: Interiors*, 72–77.

37.

Lichtenstein quoted in Bonnie Clearwater, *Roy Lichtenstein: Inside/ Outside*, exh. cat., Museum of Contemporary Art (North Miami, 2001), 39. Clearwater identifies Lichtenstein's interest in the psychology of perception as the red thread of his entire oeuvre.

38.

On the transition of the concept of the studio from scholar's retreat to artist's working space, see the essays in Michael Cole and Mary Pardo, eds., *Inventions of the Studio: Renaissance to Romanticism* (Chapel Hill, N.C, 2005).

39.

Caroline Jones, *Machine in the Studio: Constructing the Postwar American Artist* (Chicago, 1996).

40.

Dorothy Lichtenstein, "The Misanthrope Manqué: Through a Glass Lightly," in *Roy Lichtenstein: Interiors*, 20.

41.

Roland Barthes, "That Old Thing, Art..." in *The Responsibility of Forms*, trans. Richard Howard (New York, 1985).

42.

On the reappropriation of Lichtenstein's imagery by advertising agencies, see Cécile Whiting, "Lichtenstein's Borrowed Spots," in *A Taste for Pop: Pop Art, Gender, and Consumer Culture* (Cambridge, 1997), 100–145.

BY JULIA E. ROBINSON

CLAES OLDENBURG: MONUMENTAL CONTINGENCY

In 1963 Lawrence Alloway, the critic who first coined the term "Pop art," organized the exhibition *Six Painters and the Object*, at the Solomon R. Guggenheim Museum in New York. It was one of several such shows in this early moment that explored the new art dealing with popular culture.[1] In an insightful review of Alloway's exhibition, Barbara Rose distanced Jasper Johns and Robert Rauschenberg from their colleagues and protested against the simplifications that abounded in the grouping of disparate artists and projects under the rubric of "pop art."[2] For Rose, content was the *only* link between them.

Indeed, early interviews with the key figures of Pop art—those conducted by Gene Swenson, for example—suggest that the name and the obsession with content never sat well with the artists themselves.[3] They seemed merely to accept the name "Pop art" as providing an entrée into a wider discourse. The contested status of the term suggests several questions: What would it mean to complicate the field of Pop art? If content is not the issue, then what are the implications of reading the movement as a structural engagement with the vocabulary of commodity culture? What would Pop art look like in a larger context, one that could include past art, future conceptual frameworks, and even a wider present?

For a figure like Claes Oldenburg, who in the early 1960s was operating closer to Happenings and Fluxus activities than to his putative colleagues in Pop, such a

Detail of **Profiterole**, 1989
Cast aluminum with latex and brass;
14.5 x 16.5 x 16.5 cm.
Princeton University Art Museum, promised gift

refocusing of critical attention is essential.[4] But even within Pop art, the emphasis on content masks the structural means by which content was deployed and the more general retooling of subject-object relations. This moment was fueled by the radical redefinition of subjectivity in art. From its prewar emergence and foregrounding in the context of Surrealism and its transcendent projection in Abstract Expressionism came its insertion back into what Rosalind Krauss has called the "writing of the world" in the new context of 1960s consumer culture.[5]

Repeated reference in histories of modernism to the relationship between Abstract Expressionism and Surrealist automatism has made it almost unfashionable to discuss the art of the 1960s as anything but a decisive break with the immediate past and, even more so, with the historical avant-gardes. While it seems mandatory to recognize and define a distinctly post-Pollockian subjectivity informing the art of the 1960s, to sever all of Pop art's links to the lineage extending from Surrealism through Abstract Expressionism would seem counter-productive. This is particularly true when thinking about the art of Oldenburg. The great theater of subjectivity and the unconscious illuminated in Surrealism that so inspired Pollock—and that he and his peers used to change the course of American painting in the 1940s and 1950s—was also crucial for Oldenburg. The salient difference in the 1960s was that the backdrop, the context of the artistic gesture, was so markedly changed. Between the decade preceding Pollock's death in 1956 and the one immediately thereafter, when Oldenburg entered the art scene, the stakes of artistic practice would seem all but incomparable.

To reveal the kind of field, or context, that the art of the 1960s constructed around its objects, two crucial precursors must be considered. On the one hand, there is the ready-made, Marcel Duchamp's invention that placed everyday objects into the context of art, a model repeatedly cited as having "returned" in the 1960s, after an exile of almost half a century. On the other hand, there is the Surrealist mode of framing experience—the representation or projection of subjectivity into everyday space—and its trafficking in an always already "written" world. Both strategies crucially inform Oldenburg's practice and that of many of his peers.

While it is insufficient to focus the discussion of Pop on its content, it is just as unsatisfactory to concentrate on the return of the ready-made. This form flourishes in the Pop moment but is not quite Duchamp's ready-made. What the art of the 1960s repeatedly generated were permutations, critical extensions of the ready-made concept that were as dependent upon context as was Duchamp's first performative act. Unlike the first ready-made, produced in Paris in 1913, the industrially produced object in New York in the 1960s was neither on the rise nor beginning to take over: it was virtually ubiquitous. If the ready-made of 1913 functioned as a biting statement about the impact of mass production on art and subject-object relations at large, suggesting commodification as inevitable, this so-called given, ready-made, commodity object, as it was seized upon in Pop art, was the "writing of the world."

Surrealism was the first art movement to reorient the ready-made, redesignating it as the "found object." By retooling the ready-made, recasting it as the *objet trouvé*—a momentary resolution of subjective desire understood to be constituted in lack, the always missing—this miraculous status of "being found" romanticized Duchamp's model and, according to some, evacuated its critical agency. But with and through this move, Surrealism made its greatest contribution to the art of the twentieth century by representing a much larger field of subjective experience. Debates about the ready-made notwithstanding, the vast subjective field realized in Surrealism—via painting, collage, photography, and writing—which the found object anchored and illuminated, remains a powerful precedent for the projective field of the 1960s, of Happenings, Pop, and Fluxus. Such a space, a construct safe for subjectivity because it mapped it, would be essential to Oldenburg throughout his career. Here was the very materialization of a context as contingent, fragile, and dynamic as that of the ready-made. In the 1960s, the quality of being ready-made is extended to the field in which the object is set, a field that is revealed to be as much a given construct as the object itself.

If these two key historical precedents might productively be considered the background to the strategies of Pop art and contemporaneous activities, the foreground was painting—in particular, the tremendous impact of Jackson Pollock, which impressed Oldenburg's generation differently than it had influenced Johns and Rauschenberg. The latter painted their way through it, recoding all the way, but the emerging artists of the 1960s took a different tack. Slightly more distanced from Pollock and from painting itself, they chose a performance practice that took them beyond Pollock and beyond painting in any conventional (or modernist) sense.

This enactment of escape and transcendence, the effort to move beyond an extreme case of painting, took the form of what we might call textual "performativity" as well as actual performance.[6] Oldenburg and most of his peers started out by translating the terms of Pollock's art, from the materiality of his drips to the dynamics of his actions. Around 1958 Oldenburg met the artist Allan Kaprow.[7] At this time, Kaprow was giving talks on his new ideas about where art was going, describing the conversion of the space of painting into what he named an "environment," and creating the first Happenings.

Kaprow's landmark essay of this period, "The Legacy of Jackson Pollock," published in 1958, has been much discussed as a kind of manifesto for the next generation.[8]

While Pollock and his peers were understood to have engaged the projective field of Surrealist subjectivity, this very space was about to be updated, inverted, and externalized. In his essay, Kaprow took hold of this field—basing his argument on the claustrophobic intensity he perceived in a Pollock installation at the Betty Parsons Gallery, in which the "all-over" paintings listed toward the environmental—and, rhetorically, he transformed the space of Pollock's paintings into the space of the world. This world, subjectively and performatively apprehended, rising up to crowd out the hallowed space of high art, is the first suggestion of the field that would be established in Pop. In this context, it is noteworthy that there are as many references to Pop, or perhaps proto-Pop, in Kaprow's essay as there are foreshadowings of the means and materials of Happenings. For Kaprow, Pollock showed the way beyond the canvas; the new art would now draw from "electric and neon lights … movies … police files … a billboard selling Drano…. Young artists of today need no longer say, 'I am a painter'…. They are simply artists."[9]

As Oldenburg saw immediately, Kaprow presented a highly selective notion of the legacy of Jackson Pollock. Like others of this generation, Kaprow wanted a particular Pollock, one who could speak to new artistic ambitions. Kaprow argued for a purposive form of de-skilling that would convert the space of painting to the ready-made space of the world—the vastness of 42nd Street, in Kaprow's words—and begin to transmute the gesture of the artist into a distinctly literal realm. He continued this project through the 1960s, culminating in his book *Assemblage, Environments and Happenings* (begun ca. 1959–60 and published in 1966).[10] Here, many of the new art forms of the 1960s (like those mentioned in the book's title) were brought together in photographs, establishing a historical record for the new decade. Crucial to Kaprow's presentation was the insertion of earlier radical art and, notably, the juxtaposition of Hans Namuth's photographs of Pollock "in action" with photographs of the environments and happenings of the generation that followed.

In 1967 Oldenburg spoke of how Pollock functioned in his art, evoking the mythical character of the earlier artist with reference to Kaprow's book:

> Pollock acts in my work as a fiction. I objectify him: American Painter, Painter of Life, Painter of New York. I honor all the stereotypes about him. This extends to the edge of magic procedures of identification, with which the stereotype receiving machinery more or less co-operates (for example, pp. 110–111 in Kaprow's recent book on Happenings).[11]

What is particularly fascinating about Oldenburg's language and the operation Kaprow performs visually, in the layout of his book, is that most of Pollock's distinctive legacy as a painter is lost. In Oldenburg's words, as we read them or speak them, Pollock becomes a "stereotype" (a key term for Oldenburg and one that here, in effect, reshapes Kaprow's model into his own). Oldenburg's references to Kaprow's book are photographs (the numbers Oldenburg uses actually refer to numbered illustrations rather than pages): Kaprow's figure 110 shows Oldenburg himself in his environment *The Store* of 1961; figure 111 shows Pollock in a strikingly similar pose. In both cases, the image on the facing page—Kaprow's juxtaposition—is a view of Kaprow in the midst of his famous tire piece, *Yard* (1961). In figure 109 and figure 110, Kaprow is on the left, throwing tires, and Oldenburg is on the right, loading paint onto his sculptures with equal dynamism. Both artists are presented as somehow enacting Pollock. It is as if they must literally work their way through him in order to forge ahead. Kaprow and Oldenburg are pictured in the Pollockian stances memorialized by

Namuth, crouching and rotating, surrounded by the environments of their work, both mourning and literalizing the legacy or, as the text says, "Recalling the Act of Art."

The remainder of Oldenburg's notes on Pollock speaks precisely to this working through as a performative operation in which the artist converts the raw matter of Pollock into the rawer matter of his own art. His words also illuminate the larger context that Oldenburg saw necessitating such radical transformations in artistic practice. Published later, in *Art News* in 1967, Oldenburg's comments reflect upon Happenings as a (primal? juvenile?) performance, a kind of rebirth of art after Pollock. Importantly, both the subject and the subjectivity of the father are relinquished. What is sought is no longer the release and expression of an interiority but rather the collection of all that is exterior to the subject. Paint is not painted but smeared, acquiring substitutes, like water and vinyl, that suture it to the world, which is implicated rather than represented.

> Pollock's paint immediately suggested city subjects, the walls, the stores, the taxicabs. I don't know if he cared about that. In Happenings, which owe something to him, the world is smeared with paint or its substitutes. I used that kind of paint to entangle the objects in my surroundings. Later I used paint like material, like water, for dipping people in. The vinyl I now use is still paint, the objects dissolving now in paint. Pollock is a paint legend because, unlike Picasso, he turned the Sapolin [a commercial enamel-based paint] loose.

Oldenburg's text traces a shift from so-called truth and a kind of authenticity to the relinquishing of the artist's claim over the creative process, suggesting a seismic shift and even dissolution of the very ground of modernism. "[Pollock's] statement in *Possibilities* is the model of truth and unsentimentality," says Oldenburg, "exactly what an artist can say about what he is

doing. It seems strange to hear him speak of 'my painting', which suggests a small piece of property, or ground, which he is standing on. The canvas on which I now (a post-Pollock painter) am standing on not only stretches as far as I can see or hear, but has layers, roofs, floors, basements, etc." Of special importance, finally, is the way Oldenburg contrasts the "symbol energy" of Pollock to the new totalizing conditions of "symbol production," against which his own art will attempt to be the counterforce.

> The big symbol energy that vibrates in Pollock's light cords is painful now, but also unnecessary. Every single thing is so engaged in its own vast symbol production that it seems better to switch off. That was a time when no thing spoke for itself and the landscape was full of noisy monuments. But now everything speaks for itself.

In the space between Surrealism and Pop art, the Surrealists' "forest of symbols" had turned into a forest of simulacra. The process of reification felt through the century and massively accelerated by the burgeoning commodity culture of the 1960s seemed ineluctably complete, hardened into reality. This effect is registered in art, and we can track it materially in the changing ground from Surrealism to Pop. Surrealism had used the found object to illuminate subjectivity, but Oldenburg, and the best of his peers, used ciphers of subjectivity to illuminate objecthood.

Oldenburg's involvement with Happenings, beginning in 1960, is as important to an understanding of his work as is his status as a Pop artist. Prior to the emergence of Pop, Oldenburg was creating a kind of projective field, represented as sets and environments for his works. Two of the first major projects in Oldenburg's oeuvre, *The Street* (1960) and *The Store* (1961), placed subjects and objects in a given, three-dimensional space. At this time, the artist had become deeply involved in reading the work of Sigmund Freud and reconstructing the

"scenes" of his own childhood, going so far as to ask friends to perform various memory fragments in a kind of restaging-as-research.[12]

From this perspective, *The Street* (fig. 1) reads as a kind of theater for acclimating to the initial trauma of living in New York; but as always with Oldenburg, it is at once personal and universal. The work uses the external world to refer to the subjective and vice versa. *The Street* was initially constituted as an installation at the Judson Gallery, a makeshift space in a church on New York's Washington Square. Comprising a series of cartoonish cardboard figures—with caricatural names like Street Chick—it was assembled from the very trash of the street. All the elements were scaled in terms of experience, as if one were to encounter them while walking; objects presented as large signified those closest to the viewer, while things presented as small signaled those most distant. The dirty, scorched garbage materials, dredged from the streets to make the figures (people, cars, trucks, signs, and clothing),

document the objects' own past contexts via the impurity of their surfaces.

In 1960 the installation of *The Street* doubled as the set for performances like *Snapshots from the City*. Figuring life and its doppelgänger, death, the performers (Oldenburg and his wife Patty) were seen, as one critic put it, "charging about dying."[13] The larger field of representation becomes clear, as the dirty and bandaged characters, surrounded by detritus, seem to anthropomorphize the trash and register the damage caused to and by humanity through the performance of the damaged body destroying itself (fig. 2). The performance uncannily suggests the painful, excruciating death that is obsolescence.

In Oldenburg's *The Store* (fig. 3) of the following year, the focus was on objects, with one key protagonist: the artist in his studio, seen going about his work.[14] The set here was an actual storefront on East 2nd Street, but there were also "sub-sets." In addition to

Figure 1. Claes Oldenburg, American, born Stockholm, 1929
The Street, Judson Gallery, New York, 1960
Cardboard, casein, paper, wire, oil wash, rags, and other media
Museum Ludwig, Cologne

Figure 2. Oldenburg and Patty Muschinski
Performance of **Snapshots from the City**, Judson Gallery,
New York, February 29 and March 1–2, 1960

the conditions of display, established by the work's exposure through a shop window to the street, the objects, or subjects, were plucked from consumer culture. Clothing, food, and other products were rendered as sculpted reliefs. Oldenburg, however, had not employed the figure/ground relationship of conventional painting. The ground here was quite literal; it was that of the product's source, such as a newspaper ad, poster, or torn page of an illustrated magazine. The context in which the subject of Oldenburg's art was seen became an aspect of the ready-made, its logical extension, as integral as the subject, or product, itself.

Oldenburg has always insisted that *The Store* was art and not life. For him art was the means by which the

"stereotypes" of the object world could be returned to a condition of originality: *his* Pepsi sign is like no other (fig. 4). The sculptures made in *The Store* are the beginning of an object vocabulary that is repeated throughout Oldenburg's entire oeuvre, as everyday things are processed into art from a singular subjective stance, one that seeks a quality of the universal. With this effort, he attempts to counter the commodity's perfection, its contrived address to a collective lack, with the messy imperfection of ruptured, manhandled surfaces depicting those same subjects/objects as compromised by "the real."[15]

Throughout his career, Oldenburg has simultaneously alluded to the apotheosis of the product as simulacrum

Figure 4. **Pepsi-Cola Sign**, 1961
Muslin soaked in plaster over wire frame painted with enamel;
148.0 x 118.1 x 19.1 cm.
Museum of Contemporary Art, Los Angeles, Panza Collection

Figure 3. **The Store**, New York, 1961

and established his own parallel system of manipulations and substitutions. "My subjects are as apt to be depictions of the real thing as the real things (even real pie these days does not taste like pie)," he has argued.[16] As art, the objects can be converted from stereotypical sameness and perfection to a new differentiation. The brilliance of the operation is that in taking the *same* from the world and converting it into the *different*, rendered original by his hand, the artist illuminates the circular nature of the system. His intervention takes away the identity of the objects—as pie, hamburger, stockings, or profiterole (fig. 5)—and turns them into art, that is, into yet another commodity.

That all objects are part of a system of exchangeability is a phenomenon Oldenburg represents, literally, in his art. For him the object actually begins as a simulacrum. There is not and never was an original. The system that dedifferentiates the things of the world (the representations constructed in advertising, for example) can just as easily be countered by another system (that of artistic representation) in order to redifferentiate things. As Oldenburg has explained:

> There is first the ice cream cone as it is. *This would be one imitation.* Then begins a series of parallel representations, which are not the ice cream cone but nevertheless realistic or objective; for ex. the ice cream cone in a newspaper ad.... The ice cream cone altered in scale (giant). The ice cream cone as a symbol, etc.

As *The Store* demonstrates, the realization of objects and contexts that was developed in the early 1960s is not the same as the merging of art and life, which has been so much a part of the literature on Pop art. The actual operation in each case, as we see with Oldenburg, is more complicated than this. Its disenchantment involves an acknowledgment that certain conventional skills (like direct painterly representation or even abstract expression) are obsolete, that they no longer

can be *read* in the context of contemporary aesthetic experience. Oldenburg thus strives toward a recalibration of artistic representation in the face of the increasing stakes of all representation(s).

Oldenburg has said that one motivation for making the pieces in *The Store* was his desire to make "monuments to everyday things."[17] For Oldenburg, as for Warhol, such an apparently simple, seemingly acquiescent quip conveys a great deal. If we let this statement retain its surface banality, we lose its extraordinary pathos and polemic. So we must ask, what could it mean to attribute monumentality to everyday things? And in this moment, what power, currency, or agency does the idea of the monument still hold? Like the performance of obsolescence in *The Street*, this striving toward the commemoration of a particular kind of object experience suggests that such experience is lost, or in a permanent process of dying, and that everyday things can evoke this disposable quality. At the same time, Oldenburg's statement demotes the monument, giving that structure the lowly job of representing *things*—things that are being superseded—rather than people or events.

In the mid-1960s, Oldenburg worked to expand the field of reference for his "sculpture." During this period, he made a work that still seems exceptional in his oeuvre, the *Bedroom Ensemble* (1963; fig. 6). A "set" comprising distorted "furniture," its subject is the ground of subjectivity itself. It uses the intimacy of the private sphere in its most personal manifestation, not the larger realm of the home but the usually concealed space of the bedroom, and converts it into public space, a site of display.[18] The distortions are real excerpts from life, deployed to overwrite the old illusionist space of art with the literal perspective of advertising.

The *Bedroom Ensemble* thrives on its ambiguous layering of "sidedness." The original layer is the site of an advertisement from the *Los Angeles Times* for a suite of bedroom furniture; the strangely skewed perspective

began to work with banana shapes and imagined his experiments—like Rorschach tests mobilized against the instrumentalization of object relations—morphing into other splayed forms, like flowers and fans. Logically, at least to Oldenburg, such loose metaphoricity "made them look like sculptures or monuments."[19] From here came the idea for an actual monument: "Times Square seemed a perfect spot for the Banana Monument, because there the streets converge like parts of a banana skin."[20] However absurd the idea sounds, it represented Oldenburg's serious attempt to reclaim, apparently single-handedly, public space "overwritten" by all manner of representation(s) with forceful subjectivity and the inscription of non-instrumentalized desire.

of Oldenburg's installation is first present in the advertisement. Oldenburg projects this view onto real objects and places them in three-dimensional space. Building upon this initial ambiguity, in later showings of the *Bedroom*, the space was always the same and, necessarily, could never be the same. Oldenburg would emphasize this loss by adding the peculiarities of the site of its first showing at the Sidney Janis Gallery in New York—the architectural details of that space, such as the gallery's office door, window-mounted air conditioners, and so forth—to the reconstructions of the *Bedroom Ensemble* at other sites (London and Los Angeles). This odd accrual of marked perspectives and settings (making less and less sense) built up, physically, a model of the reification of spatial experience.

The slippage of meaning as objects metamorphose into simulacra in the course of being absorbed and projected by advertising was a process Oldenburg tried to keep up with and counter. He imagined continual formal and metaphorical substitutions animating his sculpture. He

The dramatic redefinition of the project of sculpture in the mid- to late 1960s, as it began to appropriate the features of the monument, was happening across an entire generation. As early as the 1950s, the ground was laid by numerous artists, from Barnett Newman to Allan Kaprow, signaling the crisis of the monument. With the redefinition of sculpture, the utter fragility and contingency of the monument was underscored. But to grasp the specific logic that generated Oldenburg's shift toward the monument requires an adroit reading of the persistent ambiguity of his work in all media. For example, one must consider issues of scale in the recurring items of his object vocabulary (from hats to blueberry pie), the anthropomorphizing of fragments from the world, and the objectification of subjecthood (such as in his mini-monument to Alfred Barr, *B Tree* [see Checklist], discussed below). Some specific examples of the strategies governing Oldenburg's early monument work stake out this emergent critical field.

Proposed Monument for the Intersection of Canal Street and Broadway, New York: Block of Concrete Inscribed with the Names of War Heroes (1965; fig. 7) was the first in a series of what Oldenburg called "obstacle monuments." With this work, it becomes clear that it is not only the dominance of the commodity (as object/fetish)

Figure 7. **Proposed Monument for the Intersection of
Canal Street and Broadway, New York: Block of Concrete
Inscribed with the Names of War Heroes**, 1965
Crayon and watercolor on paper; 40.6 x 30.5 cm.
Private collection

that is being presented and undermined, but also the monument form itself. The hypostasis of the commodity fetish (echoed by Oldenburg's interest in making monuments to everyday things, discussed above) and the utter evacuation of the social validity of the monument are brought into a directly proportional, if not causal, relationship in his sculpture-monuments. The slab of concrete Oldenburg envisaged being placed to block the key Manhattan arteries of Canal Street and Broadway was derived from a pat of butter at the center of a split potato. One imagines a huge billboard ad for a brand of butter featuring a twenty-foot potato, or another kind of largeness: the omnipresence of such commercials on television. Like Oldenburg's earlier giant soft sculptures—ice cream cones, cakes, and hamburgers—the scale is psychological, calibrated to the domination of subjective imagination by advertising.

Although the escalating Vietnam War was barely a glimmer in the eye of the mass population of the United States, its pathos is viciously reflected in the "butter-tomb" structure to be inscribed with the names of the dead.

An equally strong statement, Oldenburg's first realized monument proposal was created by opposite means: subtraction rather than addition. Encompassing elements of a performance, *Placid Civic Monument* (fig. 8) consisted of a six-foot-by-three-foot hole in the ground, presented for barely an hour on October 1, 1967. Dug by hired gravediggers, the monument existed only for the duration of the workers' lunch break; when they returned, the hole was filled in. In its radical inversion of the model of the conventional monument—from upward to downward thrust, and from the ideal of permanence to the commemoration that lasts only as long as the performance—and in the sheer modesty of the gesture, this is one of Oldenburg's most eloquent monument statements.

A different kind of reversal can be seen in another work, *Proposed Colossal Monument to Replace the Washington Obelisk, Washington, D.C. —Scissors in Motion* (1967; fig. 9). In 1963 Oldenburg had been in Washington for an exhibition and was struck by the large number of monuments in one place, which he characterized then as "sex and power in a Neoclassical setting."[21] Soon thereafter he made a small maquette of a soft obelisk in canvas hanging from wire (later placed in his *Mouse Museum* of 1965–77). But rather than softening the phallic power of the existing obelisk, as the small-scale piece does, the scissors proposal qualifies the finitude of the actual monument by constructing a doubling effect and replaces the obelisk/phallus, as whole, with the image and attendant threat of castration.

One of several monuments Oldenburg proposed for the city of London was his *Small Monument for a London Street: Fallen Hat (for Adlai Stevenson)* (1967; fig. 10). The subject is the former governor of Illinois, an intellectual who ran twice as the unsuccessful Democratic candidate for president (1952 and 1956), and served as the United States Ambassador to the United Nations under President Kennedy. In 1965 Stevenson died suddenly, collapsing on a London Street, with his hat rolling away. Two years later, Oldenburg imagined him as a figure who would be tripped over in history rather than studied carefully. Two hats suddenly become obstacles, positioned on the diagonal at either end of a rectangular base to be set into the sidewalk.[22] In this case, the distinguishing detail of the monument, the hat, retains its actual size but is also given a double.

Although Oldenburg would continue with hats—as prints and drawings (see Checklist) and as small and large-scale sculpture—the unrealized Stevenson monument is unique in the way it incorporates in one form numerous traits of the earlier ones. It employs a void, like the hole in the ground of *Placid Civic Monument*, representing its deceased subject through absence, with Stevenson present only through his hat; the work also privileges the horizontal over the convention of verticality. Furthermore, it signifies its meaning by functioning as an obstacle, an unavoidable element of street navigation, like the butter-tomb at Canal Street and Broadway. Finally, as was the case with the butter-tomb, it has a real human referent. Stevenson, however, was one person (as opposed to the collective referent of the war dead), and thus the hat monument relates

Figure 8. **Placid Civic Monument**, Central Park, New York, October 1, 1967. Work made for *Sculpture in Environment*, October 1–31, 1967, sponsored by the New York City Administration of Recreation and Cultural Affairs Showcase Festival

Figure 9. **Proposed Colossal Monument to Replace the Washington Obelisk, Washington, D.C.—Scissors in Motion**, 1967 Crayon and watercolor on paper; 76.2 x 48.9 cm. Private collection

to Oldenburg's similar treatment in a more personal objectification of a subject, *B Tree (for Alfred Barr)* (1969). In this work, the artist humorously pays tribute to the first director of the Museum of Modern Art by representing him as a tree but also perhaps an ice cream bar on a stick, composed of letters. That this objectifying operation relates to Oldenburg's monument strategies seems to be corroborated by the inclusion of the *B Tree* in his 1971 *Object into Monument* exhibition at the Pasadena Art Museum.

Almost all the monuments have a human referent, more or less specified, and most of them depend on the pathos of the interplay between humanity and object-hood. Two years after Oldenburg created the Adlai Stevenson proposal, and in the same year as he made the *B Tree*, his *Feasible Monument for a City Square: Hats Blowing in the Wind* (1969) further dramatized a pathetic game of David and Goliath, between subject and object, in the public sphere of representation. In the catalogue for Oldenburg's retrospective exhibition in 1995 at the Guggenheim Museum, Mark Rosenthal noted the marked shift represented by *Feasible Monument.* While the many hats (exceeding the simple doubling of the Stevenson piece) start to take on the role of protagonists in the civic space, the pieces more generally recalling Alberto Giacometti's *The City Square*, "they lack even the existential dignity of Giacometti's frail beings."[23] Furthermore, the objects (the hats) dominate Oldenburg's sculpture in a manner that becomes grotesquely comical, while the ostensible "subjects," little more than stick figures, seem present merely to indicate scale, as they would in an architectural model.

Figure 10. **Small Monument for a London Street: Fallen Hat (for Adlai Stevenson)**, 1967
Graphite, colored pencil, and watercolor on paper; 58.4 x 81.3 cm.
Private collection

Figure 11. Oldenburg and Coosje van Bruggen, Dutch, born 1942
Study for a Sculpture of 1992, Version Four, 1992
Cardboard, canvas, steel, epoxy, urethane, and latex with latex-painted aluminum base; 34.3 x 64.1 x 48.3 cm.
Princeton University Art Museum, promised gift

Figure 12. Oldenburg and van Bruggen
Dropped Bowl with Scattered Slices and Peels, 1990
Steel, reinforced concrete, and fiber-reinforced plastic with polyurethane enamel and stainless steel in seventeen parts in an area ca. 510.0 x 277.0 x 320.0 cm.
Metro Dade Open Space Park, Miami

Oldenburg's work with Coosje van Bruggen from the
mid-1970s onward systematically began to engage with
architecture, including collaborations with Frank Gehry—
like the sculptures designed for the Chiat/Day Building
and the Disney Concert Hall, both in Los Angeles—that
were initiated by van Bruggen. With this reorientation,
the drawing, the sculpture, and the monument projects
all willfully absorbed the challenges of architecture
and the shifting stakes between modernism and post-
modernism. In the process, the works responded, almost
viscerally (perhaps eviscerating ly), to the enforcement of
context and the threats that rose up, in quicker succession
than ever, to the gesture of the artist(s). In the later
sculpture, which mostly consists of models for Large-
Scale Projects (as van Bruggen dubbed them), the form

Figure 13. Oldenburg and van Bruggen
Valentine Perfume 2/2, 1999
Cast aluminum with polyurethane enamel and latex;
118.1 x 63.5 x 50.8 cm.
Princeton University Art Museum, promised gift

Figure 14. **Pie à la Mode**, 1962
Muslin soaked in plaster over wire frame with enamel;
55.9 x 47.0 x 29.9 cm.
Museum of Contemporary Art, Los Angeles, Panza Collection

reflects the challenges and the relative depth of what
each piece wants to say, and can say, about its site.[24]

Study for a Sculpture of 1992, Version Four (fig. 11) is a
model after the large-scale sculpture of this subject
realized in Miami in 1990, *Dropped Bowl with Scattered
Slices and Peels* (fig. 12). The small sculpture, with its
seemingly indexically rumpled and peel-like surfaces,
retains something of the surfaces of Oldenburg's
early work, while also striking the viewer as a kind of
hybrid between the food in *The Store* and the much-
altered meaning system of the Large-Scale Projects. The
work in Miami includes five giant, hard-edged orange
segments that, with the shift in scale and media, shed
much of the surface differentiation present in the smaller
work. Most of the large-scale sculpture generate
contrasts with their smaller models, like *Valentine
Perfume 2/2* (1999; fig. 13), in this way.

Considering the context of the city of Miami within
the landscape of contemporary America and the role of
the "Florida orange" as hybrid symbol-logo, the means
of signification available to the large-scale sculpture
become significantly circumscribed. As a kind of symbol,
the orange at once homogenizes the representation

Figure 15. Oldenburg and van Bruggen
Blueberry Pie, Flying, Scale B 2/3, 1998
Cast aluminum and steel with latex, 83.8 x 64.8 x 45.7 cm.
Princeton University Art Museum, promised gift

Figure 16. Oldenburg and van Bruggen
Blueberry Pie, Flying, Scale C I–VI 2/3, 1998
Six pieces. Cast aluminum with acrylic urethane;
h. 38.1 cm. max., base 1.3 x 10.2 x 10.2 cm.
Princeton University Art Museum, promised gift

of a diverse polity and substitutes a monolithic product for the representation of the labor that generates it. In the differences between the sculpture-study and the morphology of the "dropped" fruit, the contrast between soft and hard, small and giant, also changes the "symbol energy" of the piece, making the larger, harder one seem less dropped than shattered. In terms of monumental scale, then, the issue of why the orange is shattered becomes poignantly present.[25] Indeed, the insistent morphological concerns of Oldenburg's earlier sculptures and the polemics of his first monument proposals seem all but barred from the field of contemporary public statement by a kind of unspoken censorship: the enforced obsolescence of the critical voice, possibly reflecting the fate of all newly constructed monuments.

Oldenburg and van Bruggen's recent sculpture raises many of these kinds of issues. The revivals of *Blueberry Pie* in 1998 display marked differences from their precursor, the *Pie à la Mode* (1962; fig. 14), which Oldenburg had characterized as just one imitation in a series—the first, in his terms, being the real pie. At the turn of the twenty-first century, the pie emerges again to diagnose ever-shifting conditions surrounding notions of monumentality (fig. 15) and seriality (fig. 16). It is a context very different from that of Pop, when these models of artistic production first instantiated their particular relationship to production mechanisms of the commodity world.

Today—when sculpture, monument, commemoration, and the cooption of art toward symbolic ends are being wholly redefined—an object-monument (or "sketch for a large-scale sculpture," in Oldenburg/van Bruggen terminology) in the charged domain of downtown Manhattan is especially poignant. In their *Proposal for a Colossal Monument in Downtown New York City: Sharpened Pencil Stub with Broken-off Tip of the Woolworth Building* (1993; fig. 17), the demise of drawing (that is, the hand of the artist) is evoked by a broken pencil, as it takes on the conditions of architecture,

albeit neither vertical nor horizontal but rendered on the diagonal. Meanwhile, in the background, the green of the copper top of the Woolworth Building seems at first to resemble an eraser, as function itself is scrambled so that architecture and drawing appropriate each other's identity. With typical Oldenburgian duplicity, the building's top is part eraser, part hat, reprising the hats, the props, even the performance, of the earlier work. The message of this piece, finally, is unclear. Perhaps this proposal is a prediction: Does it represent the future of drawing, architecture, and the radical gestures of art, from Duchamp to Pop?

Such incoherence and uncertainty is underscored by the other status famously attributed to the Woolworth Building, which Duchamp had designated as his last ready-made. Oldenburg and van Bruggen probably knew this alter ego of the building, in which case their artistic statement seems to finalize the one Duchamp made eighty years earlier. If the first ready-made established the means by which a work of art registered the conditions of the world around it, particularly those of commercial production that paralleled and even threatened its own practice, by the end of the century, the implications of this phenomenon were much expanded. What the performances of *Sharpened Pencil Stub* demonstrate is that the threat to art is no longer concerned only with the object—whether sculpture or monument—but now implicates a much broader field, one that includes drawing as well as architecture. As the "symbol energy" of this appropriated monument is redirected and radically diffused, the work itself seems to reveal that the scope for the artistic gesture now, more than ever, is one of monumental contingency.

Figure 17. Oldenburg and van Bruggen
Proposal for a Colossal Monument in Downtown New York City: Sharpened Pencil Stub with Broken-off Tip of the Woolworth Building, 1993
Color etching with aquatint on Hannemuhle paper; 60.3 x 40.6 cm. image, 83.2 x 55.9 cm. sheet
Princeton University Art Museum, promised gift

P.P. 3/8

Notes

I sincerely thank Professors Foster and Wilmerding for including me in this project. I have appreciated Professor Wilmerding's generosity in allowing access to the works in his collection and for the wonderful discussions about them that ensued. I would also like to thank Jill Guthrie and Mary Cason for their extraordinary commitment and professionalism throughout the project. Finally, I am most grateful to Christian Xatrec for his careful reading of my text and his sensitive and constructive comments.

1.
Other exhibitions included *1961* (Dallas Museum for Contemporary Arts, 1962); *Art 1963: A New Vocabulary* (Arts Council of the YM/YWHA, Philadelphia, 1962); *The New Realists* (Sidney Janis Gallery, New York, 1962); *My Country 'Tis of Thee* (Dwan Gallery, Los Angeles, 1962); *The Popular Image* (Washington Gallery of Modern Art, Washington, D.C., 1963); *Pop Art USA* (Oakland Art Museum, California, 1963); and *Mixed Media and Pop Art* (Albright-Knox Art Gallery, Buffalo, N.Y., 1963).

2.
Barbara Rose, "Pop Art at the Guggenheim," *Art International* 7, no. 5 (May 1963): 20–22. In addition to Johns and Rauschenberg, the exhibition included Jim Dine, Roy Lichtenstein, James Rosenquist, and Andy Warhol.

3.
See Gene Swenson, "What Is Pop Art: Part I" and "What Is Pop Art: Part II" (originally published 1963, 1964), in Steven Henry Madoff, *Pop Art: A Critical History* (Berkeley, 1997), 103–17.

4.
Oldenburg performed his own Happenings, first at the Judson Gallery and then at the Reuben Gallery, with Happenings and Fluxus artists. He even presented one Happening (*Stars*) at the time of *The Popular Image* exhibition (see n. 1) in Washington, D.C. In 1964 he worked with George Maciunas, founder of Fluxus, to produce a Fluxus multiple, his soft food in a box.

5.
The notion of the "writing of the world" comes from Rosalind Krauss's account of Surrealist photography, in particular, its mode of exposing the world as always already constructed. See "Photography in the Service of Surrealism," in Krauss et al., *L'Amour Fou: Photography & Surrealism*, exh. cat., Corcoran Gallery of Art (Washington, D.C., 1985).

6.
Here I invoke the model of "performative" use of language, in this case visual language as well as verbal text, to critique convention through mimicking and altering the system it instantiates. For a fuller exemplification of this concept, see Judith Butler, *Gender Trouble: Feminism and the Subversion of Identity* (New York, 1999).

7.
Allan Kaprow is the artist credited with founding Happenings and coining the actual term for this approach to performance and art, which emerged in the late 1950s through the early 1960s. Although there was much experimentation with the model from 1957 onward, the first formal public presentation of the Happening idea (and the first use of the term) was Kaprow's *18 Happenings in 6 Parts*, staged at the Reuben Gallery in New York in October 1959.

8.
Allan Kaprow, "The Legacy of Jackson Pollock" (originally published 1958), in *Essays on the Blurring of Art and Life: Allan Kaprow*, ed. Jeff Kelley (Berkeley, 1993), 1–9.

9.
Kaprow, "The Legacy of Jackson Pollock," 9.

10.
Allan Kaprow, *Assemblage, Environments and Happenings* (New York, 1966).

11.
This and the following excerpts from Oldenburg's comments are in "Claes Oldenburg: Ego-messages about Pollock," in "Jackson Pollock: An Artist's Symposium, Part II," *Art News* 66, no. 3 (May 1967): 27, 66–67.

12.
Oldenburg spent the summer of 1960 reading Freud in Provincetown; see Barbara Rose, *Claes Oldenburg*, exh. cat., Museum of Modern Art (New York, 1970), 51. Rose comments that Oldenburg imagined "curing civilization of its discontents by forcing a curious acknowledgment of repressed instincts" and describes his desire to restate "the erotic and instinctual" through art.

13.
This description is Al Hansen's, from his book *A Primer of Happenings & Time/Space Art* (New York, 1965), 64. It is perhaps noteworthy that this early book, a wide-ranging account of the initial years of these activities, carries the following dedication: "to Claes Oldenburg, a giant in an art world full of midgets."

14.
I have elaborated upon this strategy elsewhere as the literal enactment (or re-enactment) of the creative process — or "performing making." See my *Fetish or Foil: The Caprices of Claes Oldenburg*, exh. cat., Zwirner & Wirth (New York, 2005).

15.
Here I am invoking the Lacanian "real" in the sense of that which has not yet been turned into a symbolic system or is somehow inassimilable because the subject cannot instantly attribute a meaning to the object. Oldenburg's

work on objects strives to make them unrecognizable in precisely this sense.

16.

This and the following quotation from Oldenburg are in Coosje van Bruggen, *Claes Oldenburg: The Mouse Museum/ Ray Gun Wing*, exh. cat., Museum Ludwig (Cologne, 1979), 22, emphasis added.

17.

Rose, *Claes Oldenburg*, 51.

18.

From Freud onward, of course, the bedroom has been the founding site of subjective formation, the location of the primal scene of childhood experience. In this context, Max Ernst's *The Master's Bedroom* (1920) comes to mind as the founding image/precursor of the psychoanalytically charged bedroom in the context of art. With its overpainting of the existing com- position (the *Lehrmittel*), it stands as an artistic landmark of the hardening of psychic space into a "given," pre- ordained, and ineluctable structure, one that circumscribes all subjective experience. On this point, see Hal Foster's discussion of this work by Ernst in *Compulsive Beauty* (Cambridge, Mass., 1993), 81–83.

19.

Oldenburg quoted in Barbara Haskell, *Object into Monument*, exh. cat., Pasadena Art Museum (Pasadena, Calif., 1971), 17.

20.

Ibid.

21.

Oldenburg quoted in Mark Rosenthal, "Unbridled Monuments; or How Claes Oldenburg Set Out to Change the World", in Germano Celant et al., *Claes Oldenburg: An Anthology*, exh. cat., Solomon R. Guggenheim Museum (New York, 1995), 254–55.

22.

A distant precursor to this idea of an "obstacle monument" would seem to be Duchamp's "obstacle ready-made"— a coat rack nailed to the floor and entitled *Trebuchet* [*Trap*] (1917).

23.

Rosenthal, "Unbridled Monuments," 258–59.

24.

That Oldenburg has preferred to call this work "sculpture" rather than "monuments" may attest to the scope he perceives for its representative capacities.

25.

One is moved to ask a question with regard to the sited, large-scale sculpture: Might the shattering represent the dreams of Cuban immigrants in the reality of America? It might, but it probably would not have been accepted for realization if it evoked such a message.

ANDY WARHOL: SURFACE TENSION

Andy Warhol's art trades relentlessly in surfaces. His technique of silkscreening places special emphasis on them, and his standard imagery of commercial packaging and saleable celebrities appears to maintain a superficial stance. The concern with surfaces was common to much postwar artistic practice. The work of Jasper Johns, in particular, displays a notable awareness, if not anxiety, over surface matters and is thus a logical place to begin the task of charting a genealogy of surfaces.

In 1960 Johns made his *Painted Bronze (Ale Cans)* (fig. 1) in response to Willem de Kooning's snide remark that Leo Castelli, Johns's dealer, could sell two cans of beer as art. Fitting comfortably into an inventory of everyday items like *Flashlight I* (1958) and *Coathanger* (1958), Johns's new sculpture took as its starting point the presumptions and prejudices of the preceding generation; more than just a clever reply to his predecessor, it meant to signify a break. De Kooning's work—known for a "grand" and "heroic style" of tough brushstrokes—struck its claim on the belief that the work of art was necessarily the result of a drawn-out and often tortured inner experience, requiring solitude and distance from worldly concerns.[1] Abstract Expressionist work was inspired by "eternal" themes—like Woman, the Cosmos, or the Unconscious—and the ways artists struggled with them as individuals.[2] For de Kooning, therefore, as for most other Abstract Expressionists, the pedestrian and mundane were necessarily undesirable qualities, far removed from the realm of art. With *Ale Cans*, Johns

flagrantly parted company from this school of thought. Rather than take his own subjectivity as a starting point, he began with what was in front of him. From there, he worked the objects of daily life into the space of art.

Despite the public nature of his subject matter—a rebuke to de Kooning's autobiographic gestures—Johns did not imagine his ale cans as disconnected from his person; in turning to the banal, in other words, he did not intend to leave the artist behind. Patchy with uneven paint and marked with a thumbprint, *Ale Cans* is clearly handmade. The artist's traces appear all over its surface, as if he were attempting to remake the world in correspondence with his touch. Importantly, Johns's hand comes into contact with something, or the idea of something (the ale can), already extant, which is to say that he can remake a given form but cannot generate one from scratch. Although the process of making personalizes the object somewhat, it is not intended as a way of divulging the artist's self, which Johns saw as Abstract Expressionism's persistent wish; the ale cans are harnessed not as vehicles of self-expression but rather as mediums of privacy. The handmade touches indicate only presence; they evidence an outer material body without indexing an inner emotional core.

In a 1973 interview, Johns described his practice in similar terms, as a way of making his feelings opaque, a strategy that he figured as a direct rebuff to the high dramatics of Abstract Expressionism. "I have attempted to develop my thinking," he said, "in such a way that the work I've done is not me—not to confuse my feelings with what I produced. I didn't want my work to be an exposure of my feelings. Abstract-Expressionism

was so lively—personal identity and painting were more or less the same, and I tried to operate the same way. But I found I couldn't do anything that would be identical with my feelings. So I worked in such a way that I could say that it's not me. That accounts for the separation."[3]

In its insistence on the division between the subjectivity of the artist and his work, *Ale Cans* makes a similar claim. It is important to note that Johns's art is the result of frustrated efforts: although he tried to envision his work in Abstract Expressionist terms—as a manifestation of his identity—he ultimately found this way of working to be an impossibility; it led only to a dead end. The subject of the ale cans makes the point emphatic: they are not him. Read in this light, Johns's sculpture displays the end of a certain form of self-expression: the private, interior self can no longer be exteriorized. Significantly, however, it is maintained.

Just as Johns reverses de Kooning's valuation of surface and self, moving from a position of confident

equivalence to one of reclusive discrepancy, it is Warhol who reconfigures Johns's legacy, meshing surface and self together once again—albeit in a fashion highly distinct from the Abstract Expressionist model. Despite its departure from the logic of its antecedent's work, therefore, Warhol's *Brillo Box* (1964; fig. 2), with its courting of the everyday, must be read as a self-conscious attempt at working in a Johnsian tradition. Although only a few aisles over from *Ale Cans*, *Brillo Box* evacuated the central message of Johns's work, making it a strange homage. First exhibited with a series of duplicates at New York's Stable Gallery in long rows echoing a supermarket's endless aisles, the Brillo Boxes assumed an air of frank commercialism contrary to the intimacy of Johns's couple. Placing the boxes directly on the floor (and thus into the physical space of the viewer), Warhol eliminated the artistic conventions that Johns maintained with his object/pedestal composition. Even more drastic than these changed strategies of display, however, is the way in which Warhol's work departed from Johns's conception of objecthood.

In Johns's work, there is a sincere concern for the object. The ale cans, rendered in precious bronze, appear to have been made over time and with care. Confirmation of this approach is found in a 1965 interview in which the artist confided, "I think the object itself is perhaps in greater doubt than the illusion of the object."[4] Read in light of this comment, Johns's practice of remaking must be seen as an attempt to salvage materiality, to make the world palpable in the face of an increasing dematerialization. As part of this effort, Johns focuses not just on surface but on the object's physical properties as well. It is significant that the ale cans are not attached

Figure 1. Jasper Johns, American, born 1930
Painted Bronze (Ale Cans), 1960
14.0 x 20.3 x 12.1 cm. overall
Museum Ludwig, Cologne (ML 1439)

Figure 2. Andy Warhol, American, 1928–1987
Brillo Box, 1964.
Synthetic polymer and screenprint on wood;
43.4 x 43.6 x 35.8 cm.
Princeton University Art Museum, museum purchase, the Jean and Leonard Brown Memorial Fund, and partial gift of the Andy Warhol Foundation for the Visual Arts (y1993-132)

at the base, that they are meant to be held, that the opened can is lighter than its sealed partner. In short, it is significant that they are tangible, worldly things.

This attentiveness to the object in its entirety is over-turned in Warhol's oeuvre, confirming Johns's suspicion concerning the ascendance of illusion. Composed of a basic wooden cube, the commercial insignia of *Brillo Box* has been hastily painted with the aid of stencils. It lacks the mottled care of Johns's work, not to mention its heft and physicality. As a result, our focus falls entirely on the image, which jumps out at us larger than life.

This shift from the tactile to the optical entails a shift in tone as well. Whereas the viewer senses a certain seriousness from Johns's cans, Warhol's box has comic timing. The humor of the work is that Warhol has bothered to make an object at all—just as it may be humorous to think that we are buying things rather than reified images when we purchase commodities. As Jean Baudrillard has pointed out, in Warhol's work "there is no longer any privileging of the object over the image in essence and signification." Objects, in other words, do not possess any qualitative value that images lack; both inhabit "the very same logical space, where they equally act as signs."[5] *Brillo Box* is the perfect case in point. Despite being a three-dimensional object, it functions as nothing more than a label. It is not a container of something else—there is no Brillo pad inside it—but a sign complete in itself.

Importantly, *Brillo Box* is not an isolated incident; labels are a recurring theme in Warhol's oeuvre. Throughout his career, the artist would return again and again to various signs and labels, reproducing everything from his endless Campbell's Soup Cans (fig. 3) to the German package of a "Fips" Mouse game (1983; fig. 4), until one almost forgets that the ubiquitous can holds any nourishment or that the toy box contains the promise of play. The reward is in the packaging, on the surface. Labels have become ends in themselves.

This disembodiment of the sign from its object-referent endows the sign with a new self-sufficiency, initiating a changed valuation of surface as well. Surface becomes the autonomous territory of the image rather than the site of physical contact, as it was in Johns's work. As such, the relationship between the artist and his work is reoriented, the two becoming increasingly estranged from one another. Through his display of bodilyness, Johns imagined the artist as possessing a unique and internal self, whereas Warhol, in taking a physical leave of absence from the work's making, conceives of a maker both generic and public. When Warhol does this—deleting the body from the making of *Brillo Box*—he does not hide his interiority as Johns did, but rather negates its very existence. Not only is the subject matter public here, but the means of production are as well. As Rosalind Krauss has observed in another context: "By automating the production of art, the [artist] arrive[s] at a result in which the structure of the image is absolutely disconnected from the psychological and emotional structure of the person who initiates the art, who sets the machine in motion."[6] A public subject matter can also forge this disconnection, as in the work of Johns, but Warhol combines both strategies to new effect: the coupling of the ready-made subject with a removal of the body creates a work of art that effectively rejects not only any connection between the artist and his work but any sense that the artist possesses psychological space at all. With his endless stencils and silkscreens mimicking mechanical production, Warhol does just this, distancing himself from his work, denying, in his public persona and artistic practice alike, any vestiges of a psychological or emotional make-up. Not only does he use machines, he claims that he would like to be one as well.

Figure 3. **Pepper Pot**. From the portfolio of 10 screenprints *Campbell's Soup I*, 1968
Color screenprint on smooth white wove paper; 89.1 x 58.6 cm. Princeton University Art Museum, gift of Ileana and Michael Sonnabend (x1986-209)

Figure 4. **"Fips" Mouse**, 1983
Synthetic polymer and silkscreen ink on canvas; 20.3 x 25.4 cm.
Princeton University Art Museum, promised gift

Despite this negation of Warhol's psychological structure, a strange thing happens in the work's reception: Warhol's output comes to be ever more closely associated with Warhol himself. It emerges as a stand-in, another version of the artist. Things were not always this way, however. In an early commentary on the work, Larry Bell wrote that Warhol's paintings "have very little to do with Andy Warhol, maybe nothing, because it is dubious whether he had anything to do with the act of painting them."[7] In this statement, Bell imagines Warhol (and artists more generally) as a psychological entity. Furthermore, he imagines painting in primarily Abstract Expressionist terms, as a physical act divulging the self. With Warhol, however, the viewer experiences a shift in what it means to be an artist and a person; the idea of a self-contained psychological entity falls away, to be replaced by a public image. The artist assumes a more promotional role in relation to his work; he is transformed from Genius into Personality. As a result, the work of art is seen less as a unique object made by a particular person and more as an object that someone stamps or signs off on. The artist becomes a kind of brand name, labeling his product. This shift in the function of the artist, which we might think of as the remaking of corporeality into corporate entity, is perhaps Warhol's greatest inversion of Johns's practice. Rather than provide a limit behind which one can take refuge, surface emerges in Warhol as a public space; the possibility of privacy, or of an inside to keep private, is expunged. In accordance with this shift, the work of art is no longer viewed as a screen to an inside, as it was seen in Johns, or an exposure of it, as it was imagined in Abstract Expressionist thought, but rather as an avatar, emblem, or logo. When Warhol proclaims, "If you want to know all about Andy Warhol, just look at the surface of my paintings and films and me, and there I am. There's nothing behind it"[8]—we must take him seriously.

To think of Warhol and his work as similar, however, is not merely to say that Warhol is one-dimensional and superficial, which we have heard many times before. The point is more significant: what Warhol's work insists upon most of all is the likeness between his painting and his person, and their mutual vulnerability; his ego is like his blank canvas, imprinted and stamped upon by an outside world. Interestingly, this idea closely parallels a formulation put forth by the Hungarian psychoanalyst Sándor Ferenczi (1873–1933): "The ego," he wrote, is "molded photochemically—is in fact always molded—by external stimuli. Instead of asserting myself, the external world (an alien will) asserts itself at my expense; it forces itself upon me and represses the ego."[9] Importantly for Ferenczi, the ego assumed this function out of "fear," which might be to say that it assumes this passive position as a result of trauma.[10] Similarly, Warhol's radical passivity often appears as the result of a failed attempt at maintaining a self-fashioned or self-contained subjectivity. The stamping of Warhol's work with photographic techniques and imagery rhymes nicely with Ferenczi's definition, allowing the former to function as a kind of allegory of ego-formation. The ego, a blank but chemically sensitive surface, receives outside forces, which stamp, shape, limit, and repress it all at once. Like Warhol's paintings, the ego is a surface, the site of reception of an external world.

In Warhol's hands, Ferenczi's theory turns into a kind of Pop philosophy. "Pop comes from the outside," Warhol wrote in his memoir *POPism*; Pop is formed through contact with a world of media, product, and capital. We would be misled, however, to hear only Pop art in this declaration. For "Pop," we must understand Pop people as well; as we have just seen, it is not only art that is reformulated through external contact. As Warhol said elsewhere, "A Pop person is like a vacuum that eats up everything, he's made up from what he's seen."[11] If people are vacuums, made up from what they see, so is Warhol's art. And if people and art are formed by an outside world of image-streams, both are public as well. Hence, the two are roughly equal; if you want to know all about Andy Warhol, just look at his work.

Although it hardly needs saying, Warhol's equation of art and the self is a complete inversion of the formulation that Johns put forward, which not only maintained surface and self as radically discontinuous realities but preserved the latter sealed in a private space. While he doubted his own ability to represent it, Johns nevertheless believed in the idea of an interior and private self. The thumbprint signing his work emphasizes not only his particularity; it pressures the division between inner and outer states as well, without negating the existence of either. Bodilyness is what the artist offers in lieu of an interiority he cannot divulge. Warhol, by contrast, offers his self in its entirety, a self, importantly, that he imagines to be not only wholly public and constructed at the level of surface, but free of a body as well. If surface in Johns signifies the base materiality of the body and the utter inexpressibility of identity, in Warhol surface becomes self, which is another way of saying that the self has become radically transparent and vulnerable to an outside. In this reversal, Warhol returns (parodically although perhaps also tragically) to the position put forth by the Abstract Expressionists. In both situations, the artwork is held up as a kind of "self-evidence." In Warhol's version, however, the artist no longer paints out of an interior space but is impressed upon by an outside world, one full of consumer goods and media images, both alluring and repulsive alike.

Surface, then, is Warhol's domain. This is why he made so many paintings, prints, and films. Aside from the Brillo Boxes and a sundry assortment of other packages, he did not flirt with sculptural forms like many other artists of his generation. The viscous materiality of Oldenburg's commodities and the clever play between surface and depth characteristic of Lichtenstein's sculptures are equally far away.[12] Negating physical space in favor of an image world, Warhol's work is emphatically, unflinchingly flat: films, television, newspapers, magazines, brand-name labels, and photographs—preferably of wanted men and movie stars but also of car crashes and race riots—are the provenance of his own films, paintings, and prints.

It would be misleading, however, to suggest that Warhol's flatness and emphasis on surface stem from a media world of images alone, for his work also can be understood as a response to modernist tradition. If modernist painting, as sketched by Clement Greenberg in his eponymous essay of 1960, was characterized by a quest for flatness—the undeniable fact of the medium— Warhol's work fulfilled its wish while simultaneously doubling as its nightmare.[13] Whereas modernist painting sought to expunge any traces of an outer figurative world in order to entrench itself more firmly in its own conventions and retreat from culture-at-large, Warhol let a world of commodities and images flood into his picture plane, showing that the figurative can be flat too. As Warhol's work leveled a tradition of figuration, it also combined the ostensibly opposing paradigms of avant-garde and kitsch, to borrow another Greenbergian phrase. Both studied and immediate, Warhol's work contains both the "processes of art" and its "effects," seemingly courting the "masters" and the "masses" at once.[14] Flaunting these mixed identifications, Warhol painted a wide cast of characters from both sides of culture—Robert Rauschenberg *and* Mickey Mouse— effectively collapsing Greenberg's terms. Warhol's courting of modernism, then, functioned as a dismissal of it. Not out of contempt, but perhaps cynically to infer the fate of all art, Warhol often tacked a monochrome canvas to the side of his paintings in order to increase their value, thus transforming a hallmark of modernist practice into simply more merchandise.[15]

If Warhol played modernist endgames, he ultimately did so to dismiss them; in the end, the flatness of his work—its emphasis on surface—depended more heavily on a mimetic relation to image production and how it constructs our lives, how people and events are mediated, and how, in turn, these mediations return

to do their work on us as well. For Warhol, this mediation was tightly bound up with the explosion of image-capture technologies, such as film, television, and photography. Given this pedigree, it is fitting that he dedicated a significant amount of work to the figures of John F. Kennedy, the "Television President," and Jackie Kennedy, his ubiquitous wife. By looking at some of Warhol's many works revolving around the Kennedy assassination in particular, we can begin to see how the artist imagined the connections between art, life, and the media and how Warhol positioned himself in relation to the influence of all three.

In *POPism*, Warhol describes his reaction to John F. Kennedy's assassination in a characteristically unaffected manner:

> When President Kennedy was shot that fall, I heard the news over the radio while I was alone painting in my studio. I don't think I missed a stroke. I wanted to know what was going on out there, but that was the extent of my reaction....
>
> I'd been thrilled having Kennedy as president; he was handsome, young, smart—but it didn't bother me that much that he was dead. What bothered me was the way the television and radio were programming everyone to feel sad. It seemed like no matter how hard you tried, you couldn't get away from the thing.[16]

In this passage we find a position on the formative influence of the media that runs consistently throughout Warhol's thought. As noted earlier, Warhol proclaimed that "a Pop person" is composed of "what he's seen." Significantly, Warhol specifies television as a particularly influential visual source. "Television has done it and that's why people are really becoming plastic, they are just fed things and are formed and the people who can give [the same] things back are considered very talented."[17] This statement on television's reach, power,

and transformative potential, coupled with Warhol's recollection of the Kennedy assassination, forms one of the most direct positions ever taken by the artist: it is not reality that affects or upsets people, he asserts, but a fabrication delivered by television, which is where most people get their external contact. In this regard, Branden Joseph has pointed out, "Aside from those in Dallas on that fateful day, the vast majority of the public sat before their television sets, anxiously awaiting the news."[18] Fittingly, Warhol's work on the assassination engages less with the event itself and more with its representation by various media; his intent, therefore, is not to recover the assassination as an original event but to flirt with its representations, to play across its surface.

In his 1966 film *Since*, a group of superstars lounges around Warhol's studio, a crumbly looking loft patched with silver paper, acting out scenes vaguely related to the assassination of John F. Kennedy. As the film begins—there is no title sequence, no credits—we hear a voice-over (it is Warhol): "First it happened," the voice says, "then it was played back in tape and then it was played back in slow motion. So, yeah, it will happen again and it will happen again right now."

What is striking in this monologue is the lack of differentiation between the actual assassination ("first it happened"), its capture by media ("then it was played back in tape"), and its imminent reenactment ("it will happen again right now"). Rather than positing the event as a static unit undisturbed by its travels through time, the assassination is understood as volatile and mutating. The importance of the original moment—the assassination itself—is downplayed and called into question as each instance of it is given equal footing. Claiming that the assassination will happen again three years after the fact, in a loft in New York, is tantamount to saying that the assassination was not a unique event in the first place but merely an initial rehearsal of a script that can be reenacted wherever, whenever.

Not surprisingly, *Since* strikes the viewer as something of a cruel and camp travesty; at the same time, however, the film has seemingly little to do with the Kennedy assassination itself.[19] It is more of an excuse or a pretext for making a movie and hanging around. Given the absence of a script, the narrative has unraveled. In its place, the themes and postures of the assassination take center stage, providing the actors with a template of how to act. Subject matter related to Kennedy weaves in and out in no coherent order. More than anything, the actors seem under the influence of Kennedy (as well as other things). Ironically trying to capture the aura of Camelot, they come off as estranged and detached.

The film includes a bizarre sequence of events: People point bananas at one another and say "Bang! Bang!" and then eat the bananas. People bop each other on the head with large inflatable Baby Ruth bars. Someone says, "This is a sad time for all people. For me, this is a deep personal tragedy." Everybody laughs. Someone lies down on a large crinkled piece of red construction

paper, playing dead. A calendar card reading "Friday 22 November"—the date on which Kennedy was shot—is placed on his chest. This person is not the person who had been playing Kennedy earlier. A woman playing Jackie, who later assumes the role of Lady Bird Johnson, whines, "They killed my President." People practice waving. The camera moves around lazily, zooming in and out, cutting in close on various faces that mug for the camera. There is no narrative thread, no sense of causation. The primary Kennedy character ironically announces: "I have to talk louder of course because my thoughts should be heard." This is a joke.

As the above description attests, the characters are not compelled by any inner thoughts or convictions. Their actions and utterances are prefabricated. What dictates their movement is anything vaguely associated with the Kennedy assassination and the affectations that surround it, which they take on and off like pieces of clothing. What they have gleaned from the event is not Jackie's angst, for example, but her famous Jackie-isms— her surface qualities. Indeed, Warhol saw Jackie as more of an actress, a compilation of effects, than anything else. To him, her "performance" during the Four Dark Days was "the best thing she's ever done!"[20] Following suit, Warhol's superstars perform in a fashion that

Figure 5. **Orange Car Crash Fourteen Times**, 1963
Synthetic polymer paint and silkscreen on canvas on two panels;
268.9 x 416.9 cm. overall
Museum of Modern Art, New York, gift of Philip Johnson

Figure 6. **Flash—November 22, 1963**, 1968
From the portfolio of 11 screenprints
Flash—November 22, 1963, 1968
Color screenprint on smooth white wove paper; 53.3 x 53.3 cm.
Princeton University Art Museum, promised gift

Figure 7. **Blue Marilyn**, 1962
Acrylic and screenprint ink on canvas; 50.5 x 40.3 cm.
Princeton University Art Museum, gift of Alfred H. Barr Jr.,
Class of 1922, and Mrs. Barr (y1978-46)

suggests there is no offstage. To them, everything is an act. The idea that someone might have something meaningful to say, or something to be upset about, is preposterous. Only superficial gestures are significant— for example, the way people wave. In any case, the film never really ends. It just drifts off. To be continued.

And continued it is. In 1968 Warhol returned to the theme of the Kennedy assassination with a portfolio of ten prints, *Flash—November 22, 1963*. The event still loomed large in the artist's mind—or at the very least, its significance had not been buried and settled. (Oddly,

Warhol's revisiting of the subject preceded by mere months his own near fatal shooting and the killing of Robert Kennedy.[21]) Like *Since*, *Flash* has a confused and scattered quality. If the performances in the earlier film incorporated the assassination's mediated gestures and personae, *Flash* borrows its found images to find its form. The prints contain a miscellany of signs relating to the assassination—an advertisement for a rifle, the presidential seal, a photograph of the infamous Book Depository, and numerous instances of faces, including those of Kennedy, Jackie, and Lee Harvey Oswald. Although we know the thread that runs through these images (we are able to make a story from the discrete parts, in other words), it is never made explicit. The prints that comprise the edition both resist and coalesce into narrative at once.

The composition of *Flash* is more cacophonous than most of Warhol's other prints and paintings, which often compulsively repeat or centralize their object. Resisting the uncanny repetition characteristic of much of the artist's other mature work, the haphazard layout of these prints suggests a sense of off-kilter fragmentation. There are odd angles, overlapping images, and disjunctive colors, which produce a kind of tension verging on confusion. Unlike Warhol's Death and Disaster paintings of the early sixties, however, there is no sense of horror here. Whereas we wince at the sight of a race riot or a car crash (fig. 5), or at the crude way in which these scenes are treated, a mere depiction of a rifle elicits none of the same affect. Here, Kennedy is never shot; his head never falls back; Jackie never recoils in horror. Connections are suggested, and we flesh them out with our own knowledge, but nothing is ever spelled out. We are left with a collection of clues that refuse to tell a story. The overall impression of the ten prints is of a sordid, if not particularly moving, collection of signs.

Figure 8. **Round Jackie**, 1964
Spray paint and silkscreen on linen; diam. 44.9 cm. each
Princeton University Art Museum, lent by the Schorr Family
Collection

Significantly, the characters' faces that make up *Flash* are drawn from various media sources — never from life: one comes from a television screen, another from a campaign poster, another ostensibly from film. Rendered in lurid reds, pinks, and greens, the characters are depicted as almost inhuman. In one print (fig. 6), a clapperboard closes over Kennedy's face as if to mark the end of a scene, making any media inferences explicit. (Cut! we almost hear someone say.) This does more than metaphorically suggest Kennedy's death, however; it functions as a sign of his capture by the media.

Kennedy's "death by media," however, does not signal his demise. Death does not signal an end in this world; to the contrary, it emphasizes the freedom of the image. It frees the sign from the actual life of the object-referent. (Note that Marilyn Monroe is transformed into *Blue Marilyn* [1962; fig. 7] only after she dies.) The making of an image, of course, does not require actual death. Photography itself suffices, as Roland Barthes has argued, excising images from a bodily world and entering them into surface circulation, where they assume a life of their own.[22] This point is reiterated in *Round Jackie* (1964; fig. 8), Warhol's coin-shaped and penny-colored canvases of 1964, which feature a photo-based

silkscreen of the by-then ex-First Lady. Through the grafting of her image onto the painting surface, she becomes a kind of currency. Even more so than the old profiles of Washington and Lincoln, it is now the visages of Jackie and Marilyn (and Elvis Presley and Troy Donahue) that we emulate and follow. Their surfaces are what we trade in.

One final surface, a sleeve, a protective case, a surface cover—a surface, therefore, par excellence—should be considered. The *Flash* prints originally came in a slip-cover fashioned from the front page of a newspaper announcing Kennedy's death—the November 23, 1963, edition of the *New York World Telegram* (1968; fig. 9). In it, Warhol has covered the front-page news with dense rows of his signature flowers, making the message all but illegible, intervening on the level of surface. He attempts to paper over paper media, to fashion a cover-up—to make a band-aid, a block, a screen. He tries to heal by inundating the surface with flower power. Flowers make things better, cheer up bad news. Although they are banal and garish, it would be wrong to read them as simply more evidence of Warhol's superficiality. To the contrary, they are an affective mark. Like a reformatted wreath, the flowers function as a kind of Pop memorial, a tribute to a new way of being.

Figure 9. Cover of **Flash—November 22, 1963**, 1968
Screenprint on felt mounted on cardboard; 113.7 x 54.6 cm.
Andy Warhol Foundation, Inc.

Notes

1.

I borrow these descriptions of de Kooning's painting from Clement Greenberg, "American-Type Painting," in *Art and Culture* (Boston, 1961), 213.

2.

For a complete discussion of Abstract Expressionism's "subject matter," see Michael Leja, *Reframing Abstract Expressionism* (New Haven, 1993).

3.

Johns, cited in Vivien Raynor, "Jasper Johns: 'I have attempted to develop my thinking in such a way that the work I've done is not me'," *Art News* (March 1973): 22. It is important to note that Johns responds here not only to Abstract Expressionist work but also to its reception. His remarks are a direct inversion of the writings of Harold Rosenberg: "A painting that is an act is inseparable from the biography of the artist.... The act-painting is of the same metaphysical substance as the artist's existence" ("The American Action Painters," in *The Tradition of the New* [1959; New York, 1965], 27–28).

4.

Jasper Johns, interview (1965) in David Sylvester, *Jasper Johns: Drawings* (London, 1974), 16.

5.

Jean Baudrillard, "Pop — An Art of Consumption?" in *Post-Pop Art* (Cambridge, Mass., 1989), 34.

6.

Rosalind Krauss, "Forms of Readymade: Duchamp and Brancusi," in *Passages in Modern Sculpture* (Cambridge, Mass., 1981), 70.

7.

Larry Bell, "Andy Warhol," in *Pop Art Redefined* (New York, 1969), 116.

8.

Gretchen Berg, "Andy: My True Story" (originally published in *East Village Other*), *Los Angeles Free Press*, March 17, 1967, n.p.

9.

Sándor Ferenczi, *The Clinical Diary of Sándor Ferenczi*, ed. Judith Dupont and trans. Michael Balint and Nicola Zarday Jackson (Cambridge, Mass., 1988), 111.

10.

See Hal Foster, "Death in America," in *Andy Warhol*, ed. Annette Michelson (Cambridge, Mass, 2001), 75.

11.

Warhol quoted in Branden W. Joseph, "Nothing Special: Andy Warhol and the Rise of Surveillance," in *CTRL Space: Rhetorics of Surveillance from Bentham to Big Brother*, ed. Thomas Y. Levin et al. (Karlsruhe, 2002), 246.

12.

For more on these aspects of Pop sculpture, see Julia E. Robinson, "Claes Oldenburg: Monumental Contingency," and Kevin Hatch, "Roy Lichtenstein: Wit, Invention, and the Afterlife of Pop," both in this volume.

13.

See Clement Greenberg, "Modernist Painting," in *Art in Theory: 1900–2000*, ed. Charles Harrison and Paul Wood (Oxford, 2003).

14.

Clement Greenberg, "Avant-Garde and Kitsch," in *Art and Culture: Critical Essays* (Boston, 1961), 15, 21.

15.

For a full discussion of Warhol's relationship to the monochrome, see Benjamin H. D. Buchloh, "Andy Warhol's One-Dimensional Art," in *Andy Warhol*, ed. Michelson, 15–19.

16.

Andy Warhol and Pat Hackett, *POPism: The Warhol '60s* (New York, 1980), 116.

17.

Warhol quoted in Joseph, "Nothing Special," 246.

18.

Branden W. Joseph, "You Are There," in *Dear Print Fan: A Festschrift for Marjorie B. Cohn*, ed. Craig Bowen et al. (Cambridge, Mass., 2001), 179.

19.

A camp reenactment of the Kennedy assassination is not particular to *Since*. See also John Waters, *Eat Your Make-Up* (1968), and Ant Farm, *The Eternal Frame* (1975).

20.

Warhol quoted in John Alan Farmer, "Pop People," in *The New Frontier: Art and Television, 1960–65* (Austin, 2000), 60–61.

21.

The media would somewhat cruelly make a connection between these two figures as well. "It almost seemed as if the shooting on Monday of Andy Warhol, the foremost creator of pop images, was a mad rehearsal, stage-managed by some diabolical cosmic impresario, for the shooting less than 48 hours later of Robert Kennedy, the most brilliant and mercurial political image of these days" (*Newsweek*, June 17, 1968, 86).

22.

Roland Barthes, *Camera Lucida*, trans. Richard Howard (New York, 1981).

BY JOHANNA BURTON

"LIKE A ROUSSEAU AMONG THE CUBISTS": TOM WESSELMANN'S UN-POP PROCEDURES

I've always felt that, first of all, subject matter got in the way. And subject matter for me was always an excuse to make a painting anyway. That's why I think still lifes are just as exciting as the nude because it's just an excuse to make a terrific painting.[1]

—Tom Wesselmann

If ever there were a figure to illustrate the dictum "I would never join a club that would want me as a member," it is the artist Tom Wesselmann. From the moment Pop was nominated as a way of grouping a handful of artists taking up "popular" subjects and utilizing commercial techniques, Wesselmann—along with Jim Dine, Robert Indiana, Roy Lichtenstein, Claes Oldenburg, James Rosenquist, and Andy Warhol—was almost ubiquitously understood as being central to its narrative.[2] Yet, as certain as everyone else seemed to be about Wesselmann's Pop status, the artist himself pleaded just the opposite, as he would continue to do throughout his forty-five-year career. The problem with Pop art, as Wesselmann saw it, was the undo interest afforded to its subject matter, while formal issues were underplayed or reduced in status. "Some of the worst things I've read about Pop Art have come from its admirers," Wesselmann complained. "They begin to sound like some nostalgia cult—they really worship Marilyn Monroe or Coca-Cola. The importance people attach to things the artist uses is irrelevant."[3]

It was not that Wesselmann lacked admiration for Dine, Rosenquist, or Warhol: he found all these artists of interest, although he tended to focus, as might be expected, on the formal rather than the iconographic aspects of their work.[4] He never saw his own practice as particularly rooted in the *now* (and, thus, as responding to the ever-escalating spectacle and consumption of post-World War II America) but more in terms of a kind of updated retrospect (working through, that is, old—traditional, in fact—artistic problems by way of new means).[5] To this end, when discussing his aesthetic concerns, Wesselmann identified less with his peers than with a troupe of hand-picked forebears (Mondrian and Matisse, for example, are cast time and again by Wesselmann as beloved ancestors, while de Kooning never ceases to play the looming father figure, simultaneously adored and battled).

One could argue that Wesselmann's stated anti-Pop attitude is hardly convincing or even consequential in the face of his flatly iconic painting and utilization of commodity items, which not only turn up in his work as images but often make appearances as three-dimensional plastic one-offs and sometimes even as real objects. Indeed, reading the artist's work as anything but Pop is a difficult exercise, particularly since so many of his works—the Smokers series, for instance (figs. 1, 2)—have come in many ways to stand as identical with the term. Yet, there is a case to be made for taking the artist at his word—provisionally—in order to explore just what Wesselmann's strident and unwavering disavowal might reveal about his mode of production. It is also important to note that the blatant incongruity between what he said and what he did has been

Detail of **Still Life #54**, 1965
Grip-Flex on Uvex plastic; 116.8 x 147.3 x 12.7 cm.
Princeton University Art Museum, promised gift

Figure 1. Tom Wesselmann, American, 1931–2004
Smoker Study Sculpture, 1981
Alkyd on steel; 27.9 x 81.3 x 33.0 cm.
Princeton University Art Museum, promised gift

Figure 2. **Fingertips with Cigarette**, 1978
Watercolor and charcoal on J. Barcham Green heavyweight
mold-made watercolor paper; 55.9 x 76.2 cm.
Princeton University Art Museum, promised gift

previously recognized. In a *New York Times* review written in 1968, Brian O'Doherty devoted most of his word count to a consideration of what would happen if we followed Wesselmann's directive to subtract Pop from his equation. "Mr. Wesselmann," wrote O'Doherty, "seems to be asking the critic to perform a highly interesting trick—to consider the forms of transposed banality, but not their content; to concentrate on a soup can in a new esthetic environment, but not to read the label."[6]

Two years earlier, in 1966, J. A. Abramson had similarly taken up the challenge of Wesselmann's request for exemption from Pop status. Yet, unlike O'Doherty, Abramson empathized with Wesselmann's rejection of subject matter, insisting that if the artist was, indeed, to be read as Pop, it was because he shared an "attitude" that could be seen as binding together a group of otherwise disparate artists. Pop, Abramson explained, "would seem, contrary to Dada, to be a uniquely and purposefully passive kind of art, not in its choice or handling of subject matter, but rather in its attitude toward subject matter and, by extension, toward art itself."[7] Such passivity, as Abramson had it, manifests as *leveling*—a sort of equal opportunity, apathetic approach. Everything is potential grist for the artistic mill, so long as it is understood as equal to everything else (for example, Mondrian on a par with Marlboros) and so long as it can be transformed from particular to emblematic (so that woman becomes Woman).[8]

For both O'Doherty and Abramson, Wesselmann's attempt to opt out of Pop was compelling but easily enough disproven. The artist's arguably deadpan use of girls and cars, Sterling salt and *Four Roses* whisky (1962; fig. 3)—to say nothing of his near-total removal of the trace of the hand—appeared to clear up any confusion as to his affiliation. Yet, for all the back-and-forth about what made Pop Pop (a conversation that extended far beyond the parameters of the artist under discussion),[9] there is one significant aspect of

Wesselmann's practice that was—and continues to be—largely ignored. While it was obvious enough that he was interested in bringing together art historical references and components of popular culture, Wesselmann tended to do so by way of a very particular set of conventions: tropes of classical genre painting. More apparent today, since we can look at the span of the artist's career, Wesselmann was from the beginning creating works that could be defined as—and indeed were often entitled—still lifes, landscapes, interiors, and nudes.[10] One might argue that the "un-Popness" of Wesselmann's work—if it is to be taken seriously—resides in his emphatic return to these categories. Although he clearly engaged the vernacular of the "new," Wesselmann was also speaking, as it were, out of both sides of his mouth, invoking tradition even as

Figure 3. **Still Life #15**, 1962
Collage, oil, printed papers, photograph, and fabric on canvas; 214.6 x 183.6 cm.
Sheldon Memorial Art Gallery and Sculpture Garden, University of Nebraska–Lincoln, gift of Mrs. Olga N. Sheldon (1975.U-3282)

could almost get upside down, or not be there, or come back again, she could be any size. Because this content could take care of almost anything that could happen.[13]

—Willem de Kooning

The most thorough interpretative text written on the artist Tom Wesselmann is also uncannily personal. Written in 1980—and thus nearly smack in the middle of the artist's career—a long monographic essay by one Slim Stealingworth reflects not only on the formative experiences of Wesselmann's life but seems able to sense his private thoughts as well.

As a student, Wesselmann was primarily drawn to de Kooning's women and Merritt Parkway paintings [fig. 4]. In fact, one of the few decent paintings he remembers doing as a student, *Big Nude*, was a quite literal conversion of a Merritt Parkway composition into a nude figure. De Kooning's work seemed to him *the* example of the most full-blown use of all the exciting ideas of the time; his work seemed to get the most form excitement out of the most use of all the elements of painting—line, color, mass, etc.[14]

he infused it with the patina of pornography and the culture industry.[11] Considering Wesselmann as a genre painter suggests important connections between the early, better-known works by the artist and his late work, which is very often given short shrift in narratives of his career.[12]

Discussing a difficult patch in the artist's life, Stealingworth notes that Wesselmann "finally threw out his belief in a supreme being and fell into an increasing, although still loose, identification with the ideas and emotions of atheistic existentialism. The existentialist concept of being lost but in a state of home-seeking fit him perfectly at this time."[15] The reader may wonder just how close a biographer must get to his subject to wrest this kind of information from him.

Content is a glimpse of something, an encounter like a flash. It's very tiny—very tiny, content. When I was painting those figures, I was thinking about Gertrude Stein, as if they were ladies of Gertrude Stein—as if one of them would say, "How do you like me?" Then I could sustain this thing all the time because it could change all the time; she

Reading the eighty pages of illustrated text (followed by a hearty sampling of color plates, studies and drawings, and prints and editions), one is constantly aware of the

Figure 4. Willem de Kooning, American, born Netherlands, 1907–1997
Merritt Parkway, 1959
Oil on canvas; 203.2 x 179.0 cm.
Detroit Institute of Arts, bequest of W. Hawkins Ferry (1988.177)

play between straight biography, art criticism, and a kind of inner reflection more typical of a memoir. All three categories stand as correct in the case of Slim Stealingworth's close consideration of Wesselmann, since the former was the nom de plume of the latter. Choosing to take critical matters into his own hands, Wesselmann—as Stealingworth—aims to set his oeuvre apart from Pop and to insist on what he sees as its proper place in art history. Yet, equally important, it seems, is the narration of so many primal scenes of paintings, places, and people. An artist's practice, Wesselmann implies, extends far beyond the canvas and is necessarily imbued with its own self-fashioned myths. To that end, Stealingworth (a character whose name, Wesselmann claims, is borrowed from a Bowery bum and whose career is none other than country western singer) starts his tale at the very beginning, detailing the most blank-slate artistic origin imaginable:

> Tom Wesselmann, growing up in the suburbs of Cincinnati, knew nothing of art or artists. He had a persistent creative impulse but it had no direction, and nothing in his immediate experience could give it artistic form. Its strongest expression had been his adolescent ambition to own a sporting goods store and thus extend his interest in sports and fishing. He planned a store featuring a large waterfall pouring into a trout stream which would meander the length of the store. His only art education before the age of twenty-four was one class a week in the eighth or ninth grade, an experience of which he has no memory except a feeling of discomfort.[16]

Wesselmann hailed from Ohio (as did Jim Dine and Roy Lichtenstein, although the three were not acquainted until their New York years), and until he arrived in New York, he'd had little contact with art or, for that matter, the literature and philosophy he would soon read voraciously. Indeed, Wesselmann claimed that the only artist he had ever heard of prior to setting his

soles upon east-coast soil was Norman Rockwell.[17] Enrolled first at Hiram College in Ohio and soon after at the University of Cincinnati, Wesselmann began studying psychology. He was drafted, in 1952, into the U.S. Army and stationed in Fort Riley, Kansas. During his two years of military service, Wesselmann decided to teach himself how to cartoon—well enough, he hoped, to sell his drawings to magazines like *1000 Jokes, True*, and *The New Yorker*. Returning to Cincinnati after his discharge from the military, he set about finishing his psychology degree, although he also enrolled in the Art Academy of Cincinnati in order to improve his cartooning skills. While there, an instructor suggested he apply to the Cooper Union, in New York. Surprisingly, given the nature of his work, Wesselmann was accepted, and he and his then-wife, Dot Irisis, moved to Brooklyn.

According to his "biography," Wesselmann was completely out of his element, and he quickly began educating himself by walking the city streets (his foraging there provided him with many of the materials he would use in his early collages) and going to art museums and galleries. He arrived in New York in 1956, just as the Tenth Street Touch was coming under critical scrutiny. "The abstract expressionist battle was just

Figure 5. Robert Motherwell, American, 1915–1991
Elegy to the Spanish Republic, 108, 1965–67
Oil on canvas; 208.3 x 351.2 cm.
Museum of Modern Art, New York, Charles Mergentime Fund

beginning," Stealingworth narrates, although he describes Wesselmann's "first esthetic experience of his life" as an encounter with Motherwell's *Elegy to the Spanish Republic* (1965–67; fig. 5) at the Museum of Modern Art: "He felt a sensation of high visceral excitement in his stomach, and it seemed as though his eyes and stomach were directly connected. Throughout the early half of the sixties he used this same feeling to determine the completion of his own paintings."[18] Yet, as much as Wesselmann felt himself completely overwhelmed and inspired by his gut-wrenching response to work by New York School painting, he also felt this was not his road to take. Abstraction promised the kind of transcendental encounter many described as experiencing in front of a Rothko, for example, but Wesselmann felt his calling was to work in the very form that, in the late 1950s in the United States, was the least appreciated; for him, this meant a return to the figurative and the accoutrements of the everyday — quite literally, a grounding in the *things* that Abstract Expressionism would seem to leave behind.[19]

It is telling that Wesselmann cited de Kooning as both his inspiration and the figure against whom he bucked most aggressively. De Kooning was the one Abstract Expressionist to offer up a substantial mix of figuration and abstraction, so it was possible for Wesselmann to assume one aspect of de Kooning while ostensibly leaving the other behind (unless, that is, one considers genre itself a kind of abstraction). Wesselmann offered the following coming-of-age story, detailing a yet-to-be-fully formed artist who was still a year or so away from pro-ducing what he would consider his first admissible work of art: "Wesselmann often went to the Metropolitan Museum and would sit in front of de Kooning's *Easter Monday* [1955–56; fig. 6], and would become quite depressed because the kind of painting he loved was already being done, and done far better, he felt, than he could ever do it."[20] Such depression in the face of what he saw as already perfectly executed abstraction sent Wesselmann running toward representational

painting, but it is interesting that, in Stealingworth's account, there is no admission of the fact that this artistic choice was not a total departure from de Kooning but, instead, a way of meeting up with him under different circumstances.

Still, there was little obvious indication, in 1959, that Wesselmann's work was in open dialogue with the likes of Franz Kline and Barnett Newman, to say nothing of de Kooning. Having moved away from cartooning for good, Wesselmann began making collages — tiny works, often less than a foot in either length or width. By using materials found on the streets or in bodegas, every move Wesselmann made was positioned against what he saw as the major tenets of Abstract Expressionism. He chose minuscule, inconsequential materials and boring everyday subjects; for him there would be no

Figure 6. De Kooning
Easter Monday, 1955–56
Oil and newspaper transfer on canvas; 243.8 x 188.0 cm.
Metropolitan Museum of Art, Rogers Fund (56.205.2)

Figure 7. **Still Life**, 1988
Porcelain; 47.6 x 50.8 cm.
Princeton University Art Museum, promised gift

lyrical line or transformative color but rather shapes and hues left as they were found. Instead of producing works that evoked movement, he hoped to produce objects of intensity whose compactness would heighten their static nature, a practice that he followed from his earliest collages through to his much later works in metal and even porcelain, such as his *Still Life* of 1988 (fig. 7). Spending, as he did, a good deal of time at the Metropolitan Museum of Art, he took a most unlikely model for these early works: Hans Memling's diminutive *Portrait of a Young Man* (fig. 8). Seated, hands folded, in a schematic interior, the fifteenth-century figure turns his back on a sprawling manicured landscape, which we view only partially due to massive pillars demarcating— and also confusing—the passage from inside to out- side. Certainly not the first art historical reference that might come to mind when we think of Wesselmann, this work by Memling continued to exert its influence spatially and conceptually on the un-Pop artist for the long span of his career.

Wesselmann's fascination with collage grew, and he experimented with different combinations of found objects and paint, producing a number of Portrait Collages (fig. 9) and small interiors with figures. He turned, almost immediately, to the female nude as a subject and to the domestic interior as its site. Showing a number of these small works in a group show at the Judson Gallery (of which Wesselmann was a founding member—along with Jim Dine, Marc Ratliff, and Bud Scott)—he received the first published response to his work, in which he was named the artist who made "weird collages of women" by one well-known reviewer, who liked the eccentricity of what he saw.[21] The comment pleased Wesselmann, who, while continuing to focus on nudes, had in the meantime decided to increase the scale of his works. Whereas it had initially seemed important to keep a small scale that would encourage a visual intimacy, suddenly he felt inclined to go big—very big. Swapping his tiny studio for a larger one and rethinking the operations of representation, Wesselmann began to produce what is generally con-

Figure 8. Hans Memling, Netherlandish, ca. 1430/40–1494
Portrait of a Young Man
Oil on oak panel; 38.3 x 27.3 cm.
Metropolitan Museum of Art,
Robert Lehman Collection (1975.1.112)

Figure 9. **Portrait Collage #1**, 1959
Pencil, pastel, collage, and staples on board; 24.1 x 28.0 cm.
Private collection

Figure 10. **Beach at Easthampton**, 1989–91
Alkyd on steel; 78.7 x 246.4 cm.
Princeton University Art Museum, promised gift

sidered his most canonical body of work: the Great American Nudes, a series that began in 1961 with *Great American Nude #1* and culminated in 1973 with *Great American Nude #100.*[22]

The Great American Nudes typically began as loose, fast drawings done from living models—or, to be more exact, a small handful of women friends up for the task, one of whom was a fellow artist named Claire Selley (she would become Claire Wesselmann after marrying Tom in 1963). The small drawings were gridded and enlarged, then placed alongside other collaged and painted elements. The speed of execution and Wesselmann's interest in a general—rather than specific—sense of the body resulted in "women" that were at once explicit yet pared down in content. (The artist's desire to capture the intuitive and chance-driven nature of drawing would eventually lead him to experiment in the 1980s with laser-cut steel and aluminum, where lyrical gesture would be rendered sculpturally; fig. 10.) To varying degrees in the Great American Nudes, Wesselmann experimented with the nebulous terrain between abstraction and figuration, seeking the moment where an organic form took on the contours of the body, or where identifiable form slipped into intangible shape. Sometimes the models were recognizable—Claire, for example—but at other times they exhibited just the bare minimum of sexualized coding: if the head was not cut out of the frame, it was adorned with suggestive lips but no other features. Any attention to detail was condensed in the breasts and pubic area, the latter often painted as shaved bare, a gesture that in mid-sixties America was understood by many of his viewers as approximating "girly magazine" material because of its seeming explicitness, even though one could hardly argue that these works were realistic representations of nudity.

Still, the paring down of details failed to tame those that remained. The "erotic simplification,"[23] as the artist phrased it, only heightened the already overdetermined interest in (and formal interchangeability between) nipples, lips, and vulva in the otherwise smooth plane of the simplified body. Yet, while Wesselmann never disavowed his personal investment in such imagery (he found his rendition of the nude at once adequately "aggressive" *and* "an expression of his joy at rediscovering sex, following the breakup of his first marriage"[24]), he chose the nude as subject in part as a way *not* to think about content. The nude was, as far as he was concerned, a priori when it came to art history, so why not take it as a given in order to see what could happen when subject matter was so front-and-center that it could serve as simply a means to an end? Wesselmann found irrelevant, and even irritating, critical references to newly mainstream pornography in relation to his work. His images of women, he hoped, took their cues less from pin-ups and *Playboy* than from art history and, most importantly (and unexpectedly) from Abstract Expressionism, which he considered visually forceful in its address and which he characterized as "keeping the sense of the picture plane in front of the real picture plane, so that the image seemed right in front of [the viewer's] face, and forward of the canvas."[25]

But it was precisely the aggressivity and frontality of Wesselmann's nudes that kept them from being safely read as the kinds of "nudes" that would be understood as simply *nude* (i.e., art historical) rather than *naked* (i.e., pornographic). In this regard, it is important to consider Wesselmann's continued preoccupation with de Kooning. The obvious similarity between the two artists is that both represented women in their work. But perhaps more interesting is the different way each moved into the purely formal by means of the figurative, and the way that their ostensibly shared subject matter came to simultaneously mark entry- and sticking-point for viewers, refusing to function as secure representational mooring.[26] It is worth revisiting a succinct review by Leo Steinberg of de Kooning's 1955 show at the Martha Jackson Gallery. "In the spring of 1953 Willem de Kooning shocked the New York art

also concerns the way we reconcile de Kooning's move from figuration into abstraction and back again. "Two years ago it seemed to some that his 'return' to the figure marked a retreat from more advanced positions, or a change of heart."[29] But, in Steinberg's view, de Kooning's figure, which in the early 1940s had still operated traditionally, was only visually—never ideologically—abandoned in the purely abstract works that followed. "Her solid contours had…to be dismembered, blasted, and atomized; and the upshot was to be a violent discharge of subhuman, even suborganic, energies."[30] Indeed, in giving himself over totally to speed, movement, and chance, "a grammar of forms where all nouns were held in abeyance," de Kooning's abstract works were less pictures than "events," and the return of the recognizable figure was hardly a reversal of these terms but—rather—an unexpected way to extend them.[31]

world with six enormous paintings 'on the theme of Woman'," Steinberg wrote (fig. 11). "The present works at Martha Jackson's, most of them done last year, are still devoted to that theme. How do they look now that we've caught our breath?"[27]

How they look, the critic answers, depends largely on the viewer, as we take stock of past representational tropes without adhering to past standards for judging them. "Like the Venuses of Willendorf and Mentone she is all vulgar warmth and amplitude; like them she stands huge, stupid, and receptive, without arms or feet, innocent of that acquired grace which is bred into the girls we think we know," he writes, after pithily describing de Kooning's *Woman* (the singular standing for the plural) as "disastrously erotic in some remote Paleolithic way."[28] But how they look, Steinberg argues,

On the face of things, it would seem that Wesselmann's refusal of de Kooning is straightforward enough, with the younger artist embracing the representational to an almost perverse degree and doing away with the implication of gesture and movement in favor of grounded, immobile intensities. Yet, Wesselmann, too, performs upon his own figures a kind of dismembering, blasting, and atomizing, through a kind of smoothing, abstracting, and eventual absenting of the body that can be seen taken to its extreme in, for example, his *Study for Nude Edge with Seascape* (1984; fig. 12) or even more radically in his steel, laser-cut portraits of his model, Monica, in which she is barely there, reduced completely to line (figs. 13, 14). In 1964 he described his own work in a way similar to the terms in which Steinberg had cast de Kooning's "events": Wesselmann claimed to create "situation[s] resembling painting, rather than painting,"[32] a comment that would allude to a practice prone to oscillating between form and content. Indeed, his compulsion had always been to create not harmony but "competition" in his compositions, as he put it, "to generate excitement and demand attention,"

Figure 14. **Monica Reclining in Chinese Robe**, 1985–99
Alkyd on steel; 12.1 x 43.2 cm.
Princeton University Art Museum, promised gift

primarily through color and the play of positive and negative space.[33] Looking at a very early collage work, such as *Little Bathtub Collage #1* (1960; fig. 15), alongside a much later one, like his silkscreen *Still Life with Blonde* (1999; fig. 16), one surmises how fundamental these concerns were, even as they were manifested very differently over the artist's long career. And while Wesselmann made a point of never "transcending" representational imagery, as had been the way of the generation of nonobjective painters that preceded him, the competition he staged between formal elements was meant to neutralize (although not tame) that content's cultural specificity (and thus its Pop patina). Counterintuitively, it was genre—that traditional marker of distinctions in type—that allowed him to both invoke and defer content, to render the pair form/content a productive, if not absolute, antinomy.

Figure 15. **Little Bathtub Collage #1**, 1960
Mixed media and collage on board; 24.1 x 19.1 cm.
Private collection

not see his own as related to either of their practices.[36] By 1962 he was, nonetheless, officially grouped with Lichtenstein and Rosenquist, as well as Dine, Indiana, Oldenberg, and Warhol, among others, in the seminal *New Realists* exhibition at the Sidney Janis Gallery.

By choosing representational painting, I chose the history of art: I would paint nudes, landscapes, still lifes.... [34]

—Tom Wesselmann

If in 1961 Wesselmann felt "like a Rousseau among the Cubists," it was because, as he put it, he "deliberately worked against the influence of the painters he envied,"[35] who were almost entirely from previous generations. After he became acquainted with some of his peers whose practices would come to be associated with his own, this feeling of not quite fitting in would only heighten. Following his first one-man show at Tanager Gallery, at the invitation of Alex Katz, Wesselmann started hearing about a number of other young artists. Ivan Karp (the director of Leo Castelli's gallery) told him about two, Roy Lichtenstein and James Rosenquist, with whom he felt Wesselmann might have some affinities; curious, Wesselmann saw shows by both men and, while interested in their work, did

Yet while his work was being read increasingly as Pop, Wesselmann could be seen as investing even more interest in genre. His collages (which he continued to refer to most usually as paintings) had been changing. While playing with masses of color (found objects alongside painted areas) and creating new modes of organizing positive and negative space, Wesselmann was, for a time, increasingly interested in bringing in outside elements. After enlarging his scale, he had started using images from posters; he would often scrape advertisements from the interiors of subway cars or from bus stops until he increased his scale even more, getting the idea of writing to billboard companies directly, asking them to send their enormous photographic images, which, surprisingly enough, many did. Wesselmann became a collector of such images, and soon had a studio full of grinning girls, oversize

Figure 16. **Still Life with Blonde**, 1999
Color screenprint on white wove paper; 76.2 x 94.0 cm.
Princeton University Art Museum, promised gift

boxes of Lipton tea, and enormous glasses of snow-white milk (fig. 17). While he initially resisted an urge to incorporate actual objects into his work, by 1964 he began using real windows and furniture as well as household fixtures, three-dimensional signs, and even carpets upon which he found viewers tempted to walk and chairs in which some tried to sit. But these were not environmental works, at least according to the artist. "I work in a painting concept—a two dimensional image. The third dimension exists only to intensify the two dimensional image."[37] One can even think of his later, undeniably sculptural works in this way, such as his *Dropped Bra (Big Maquette)* (1978–80; fig. 18).

His Great American Nudes began to occupy increasingly complex pictorial space, and he began to work simultaneously on series he called Interiors, Still Lifes, Landscapes, and Seascapes, all during the mid-1960s. While the realistic nature of some of these works was obviously heightened (as the tableaux began to include operating televisions, radios, and clocks),[38] Wesselmann's work was also becoming increasingly

general—the artist was calling less upon individual things, real or not, than on their power to signify more generally.[39]

To this end, Wesselmann's Still Life works offer a particular twist on the meaning of *nature morte*. In *Still Life #20* (1962; fig. 19), for instance, a real (stocked) kitchen cabinet is hung over a real sink alongside a pair of two-dimensional images: the first a conglomeration of foodstuffs, including Coca-Cola, a loaf of bread, a bunch of bananas, two bottles of Ballantine ale, and a number of apples;[40] the second a reproduction of a red, yellow, and blue composition by Mondrian. *Still Life #54* (1965; fig. 20), in contrast, was inspired by an illuminated vacuum-formed gas station sign, which Wesselmann had rendered in a radically simplified version: a single sheet of plastic with painted contours represents one wall of a tiled kitchen, with its single shelf holding two objects, an apple and a radio. The work, a seemingly schematic realistic composition, borrows its color and composition (as does *Still Life #20*) from Mondrian. Hardly straight portrayals of the

Figure 17. **Still Life #36**, 1964
Oil and collage on canvas; 304.8 x 488.3 cm. overall
Whitney Museum of American Art, New York,
gift of the artist (69.151)

Figure 18. **Dropped Bra (Big Maquette)**, 1978–80
Alkyd on aluminum; 71.1 x 147.3 x 55.9 cm.
Princeton University Art Museum, promised gift

contemporary world and its branded commodities, Wesselmann's Still Life works utilize the genre as a means by which to explore the compelling forms of everyday aesthetic items through a strange coupling of, for example, Cézanne and Mondrian.

Indeed, if the young Wesselmann found he could convert de Kooning's Merritt Parkway into a nude, he also found he could just as easily render landscapes through isolating and magnifying bodies—both human and machine.[41] His large, standing cutouts, which he called Landscapes, showed off the contours and horizon line of nearly life-size Volkswagen beetles, while his Seascapes were graphic painted renditions of women's feet reclining Odalisque-like in or rising totemically from the sand, totally disconnected from the rest of the body. His isolation of parts of the body continued as he zoomed in on nipples and mouths, those elements that he had from the beginning highlighted for the effect of "erotic simplification"and that he now felt could stand alone (or nearly alone, since they began to operate similarly to the way apples would in still life, as forms in a schematic context).

Wesselmann's last series is entitled the Sunset Nudes. In these works, large bright compositions that circle back to the Great American Nudes while taking into account all that happened in between, Wesselmann seems to acknowledge all his reasons for staying with genre for nearly half a century. Here, the morphological equation of oranges and breasts bluntly exhibits how such objects are simultaneously readable in at least three ways: first, as luscious, abstracted, metonymic forms that are promiscuously interchangeable; second, as ostensibly "straight" representations of things in the world; and third, as overdetermined art historical references. In *Sunset Nude with Matisse Odalisque* (2003), such terms become even clearer. Matisse's brunette figure is transported onto Wesselmann's canvas to sit alongside a second figure, undeniably "Wesselmannesque"—her blonde tresses framing a

featureless (except for a gash of red lips) face, her nipples and pubic hair adorning an otherwise absented (if heavily outlined) body. The figures recline amidst a plethora of flattened spatial elements—decorative fabrics and wall coverings, a landscape glimpsed through a window, enormous fruit, some yellow tulips. Like Memling's *Portrait of a Young Man*, these spatial cues create and eliminate space, just as Wesselmann's two women serve to affirm and negate art history. To read Wesselmann as a genre painter is not to read him out of his own time, but instead to insist on ways his work made connections and competitions between new and old modes of representation. As Slim Stealingworth once put it of Wesselmann, "He is part of the broad and diverse world of figurative painters, in his version dealing less with the real world than with a theoretically real world."[42]

Figure 19. **Still Life #20**, 1962
Mixed media; 104.14 x 121.92 x 13.97 cm.
Albright-Knox Art Gallery, Buffalo, gift of Seymour H. Knox Jr.
(K62:16)

Figure 20. **Still Life #54**, 1965
Grip-Flex on Uvex plastic; 116.8 x 147.3 x 12.7 cm.
Princeton University Art Museum, promised gift

Notes

1.
Tom Wesselmann, interview by Irving Sandler, January 3–8, 1984, Smithsonian Archives of American Art, Collection of Oral Histories Transcripts, 57.

2.
The Pop contingent named here necessarily leaves out important factions: specifically, the Independent Group in London, made up of artists, architects, and critics (Lawrence Alloway, Richard Hamilton, and Eduardo Paolozzi among them) who took up both the iconography and the name Pop earlier than the American artists; West Coast artists, such as Edward Ruscha, who are omitted from this narrative; and figures working in Europe, especially Germany (such as Gerhard Richter).

3.
3. Tom Wesselmann quoted in Gene Swenson, "What Is Pop Art: Part II" (originally published 1964), in Steven Henry Madoff, *Pop Art: A Critical History* (Berkeley, 1997), 103–17.

4.
It is not coincidental that all three of these artists were interested in the interstitial terrain shared between representation and abstraction, as Wesselmann would come to be in a less obvious way.

5.
Having been asked the question, "Is Pop easy art?" Robert Indiana answered, "Yes, as opposed to one eminent critic's dictum that great art must necessarily be difficult art. Pop is Instant Art...." He also described Pop as "walk[ing] young

for the moment without the weight of four thousand years of art history on its shoulders" (ibid.). Quite differently, Wesselmann's Pop willingly and visually bears this art historical weight. While some of his works may appear to buck art history in favor of visual culture, I will argue that his oeuvre operates strictly by the books (art history books, that is).

6.
Brian O'Doherty, "Art: 'Pop' Show by Tom Wesselmann Is Revisited" (originally published 1968), in Madoff, *Pop Art*, 347–48.

7.
J. A. Abramson, "Tom Wesselmann and the Gates of Horn" (originally published 1966), in Madoff, *Pop Art*, 349–53.

8.
The "attitude" described by Abramson might be thought of today as a form of pluralism. This is precisely opposed to what I argue for Wesselmann's work; while he took objects primarily for their formal value (placing content secondary), he did so in order to activate, rather than negate, the differences and ambivalences created in relation to other objects.

9.
Debates about Pop—its nomenclature and manifestations—were many. While content was Pop for some, handling was Pop for others. And while Pop was largely discussed as a break with artistic traditions from the past, some found this an outrageous proposition. See, for example, Robert Rosenblum, "Pop Art and Non-Pop Art" (originally published 1965), in Madoff, *Pop Art*, 131–35.

10.
Abramson has noted Wesselmann's decision to utilize classical categories of painting. For Abramson, however, the artist's turn to genre seems to have less to do with a productive tension between the very new and the very old and more to do with what the author has called a "conscious eclecticism." See his "Tom Wesselmann and the Gates of Horn," 351.

11.
It bears mention that many Pop artists might be seen as similarly taking up the task of blurring high and low, art and culture. It is Wesselmann's accomplishment of this feat through the unlikely path of genre that is of interest here.

12.
Much has been made of Wesselmann's decision to push the boundaries of painting, from the very beginning with his collages, but even more so as he moved toward experimentation in all manner of materials, including found objects and, later, plastics and metals. In fact, it is tempting to argue that Wesselmann was never a painter at all, but rather emphatically blurred medium-specificity, flirting with "environmental collage" (as Brian O'Doherty would name installation-type works by Oldenberg and others in his 1976 essay "The Eye and the Spectator," in *Inside the White Cube: The Ideology of the Gallery Space* [Berkeley, 1986]), and even more specifically by confusing the boundaries between painting and sculpture. While I would hardly disagree that Wesselmann's works can be defined as medium-hybrids,

it seems that the more the artist experimented materially, the more he utilized tropes of genre painting.

13.

Willem de Kooning quoted by David Sylvester, "Content Is a Glimpse…" (originally published 1963), in *Theories and Documents of Contemporary Art: A Sourcebook of Artists' Writings*, ed. Kristine Stiles and Peter Selz (Berkeley, 1996), 197–99.

14.

Slim Stealingworth, *Tom Wesselmann* (New York, 1980), 13.

15.

Ibid.

16.

Ibid., 11.

17.

Marco Livingstone, "Obituary: Tom Wesselmann," *The Independent* (London), December 22, 2004. Such a comment, while ironic, does point to an interesting tension within Wesselmann's oeuvre, if one considers his project as in part dedicated to representing contemporary Americana.

18.

Stealingworth, *Tom Wesselmann*, 12.

19.

In his 1964 interview with Swenson, Wesselmann slyly updated Rauschenberg's famous 1959 statement: "Painting relates to both art and life. Neither can be made. (I try to act in that gap between the two.)" Wesselmann's version was: "Painting relates to both beauty and ugliness. Neither can be made. (I try to work in the gap between the two.)" The play on Rauschenberg here is telling, for it implies that Wesselmann was not interested in distinctions between high and low or composed and spontaneous (perhaps he believed such polarities were no longer applicable). Rather, the slippery slope of aesthetics became the focus, and Wesselmann worked (rather than acted) with the inherent ambivalence of qualitative, taste-driven hierarchies.

20.

Stealingworth, *Tom Wesselmann*, 13.

21.

Irving Sandler, "In the Art Galleries," *New York Post*, December 2, 1962, quoted in Constance Glenn, *Tom Wesselmann: The Early Years. Collages, 1959–62*, exh. cat., The Art Galleries, California State University, Long Beach (Long Beach, 1974), n.p.

22.

The Great American Nudes were named by Wesselmann, who, thinking back to his cartooning days, liked the word play on the "Great American Dream" and the "Great American Novel." The color scheme for the Nudes, at least at first, was restricted—mainly to red, white, and blue (American, of course, but also reflecting Mondrian). According to Wesselmann, the idea for using red, white, and blue came to him in a dream, a story that uncannily resembles one told by Jasper Johns, in which his dream of a flag prompted him to paint the 1954 work with that name and content. As for the numbering of the Great American Nudes, Wesselmann hardly gave up the nude once he reached number 100; after the centenary work was produced, his nudes took on titles, rather than numbers, usually reflecting the name of the model. The look of the later nudes changed, too, as Wesselmann became more and more invested in closely cropped compositions, cutouts, and odd angles; this shift in his practice is discussed below.

23.

Stealingworth, *Tom Wesselmann*, 24.

24.

Ibid., 23.

25.

Ibid., 18. For an interesting interpretation of the Great American Nudes as tied to an American context of rising commodity culture, loosening obscenity laws, and the legalization of oral contraception, among other issues, see David McCarthy, "Tom Wesselmann and the Americanization of the Nude, 1961–1963," *Smithsonian Studies in American Art* 4, no. 3/4 (Summer/Autumn, 1990), 102–27. For an important consideration of Pop's relationship to class and gender, see Cécile Whiting, *A Taste for Pop: Pop Art, Gender, and Consumer Culture* (Cambridge, 1997). Whiting argues that, while the nudes Wesselmann produced were clearly made for male viewers, the domestic scenes they inhabit appeal to female viewers.

26.

It is also interesting to note the role of collage in both practices. De Kooning was famous for cutting women's mouths from cigarette ads (these rounded, inhaling-exhaling mouths appearing to be engaged in a much more suggestive act than smoking, an effect that Wesselmann clearly recognized, then utilized in his own Smokers).

27.

Leo Steinberg, "De Kooning's Woman" (originally published 1955), in *Other Criteria: Confrontations with Twentieth-Century Art* (New York, 1972), 259.

28.

Ibid., 259–60.

29.

Ibid., 260.

30.

Ibid., 261.

31.

Ibid., 262.

32.

Wesselmann quoted in Swenson, "What Is Pop Art? Part II," 112.

33.

Stealingworth, *Tom Wesselmann*, 18–19.

34.

Wesselmann quoted in *Tom Wesselmann*, ed. Danilo Eccher, exh. cat., Museo d'Arte Contemporanea (Rome, 2005), 296.

35.

Stealingworth, *Tom Wesselmann*, 25. Matisse, however, is the figure that most often comes to mind when looking at many of Wesselmann's works, particularly the nudes and cutouts. His impact on Wessselmann cannot be underestimated. Wesselmann's problem with Matisse, as he put it, however, was that Matisse's use of line exaggerated the figure, while Wesselmann aimed to place the figure as just one element among many, first "neutralizing," then "supercharging" it. See Slim Stealingworth, "Notes on Tom Wesselmann," in Danilo Eccher and Slim Stealingworth, *Tom Wesselmann*, exh. cat., Flora Bigai Arte Moderna e Contemporanea, Venice, and Pietrasanta, Lucca (Milan,

2003), 15. This article, penned by the artist's alter ego, appeared nearly twenty-five years after the first publication by Stealingworth.

36.

Stealingworth, *Tom Wesselmann*, 25.

37.

Ibid., 17.

38.

Wesselmann described his use of real objects as totally different from the use of real-world things by Rauschenberg or Johns, who placed them in "abstract environments." In contrast, Wesselmann "put things together in such a way that they were not transformed but were simply heightened" (Stealingworth, *Tom Wesselmann,* 31). The description would seem to imply that Rauschenberg and Johns used real things as abstract forms while Wesselmann insisted on their particularity. I would suggest, however, that his comment in fact implies the opposite, and that he is proposing we need not ask objects to transcend their function before we can approach them aesthetically.

39.

For a time, Pop artists were dubbed "commonists" because of their use of ostensibly "low" subject matter. As a genre painter, Wesselmann's enterprise must be seen differently— Budweisers and Pall Malls were, of course, the stuff of everyday life, but so were oysters for Dutch Masters in the seventeenth century. In this sense, Wesselmann's utilization of the things around him must be seen as part of a tradition (that of still life, the nude, and so forth) rather than a break from or banalization of it.

40.

Ballantine, in bottles or not, is obviously a reference to Johns, and what still life doesn't include apples?

41.

There is, however, no confusion or mingling of these kinds of bodies. Whereas members of the Independent Group, such as Richard Hamilton, had explored the intersection of woman and car—and the sexualized advertisements of both— Wesselmann's images did not chart this terrain. His cars are surprisingly deadpan.

42.

Stealingworth, *Tom Wesselmann*, 80.

CHECKLIST OF THE COLLECTION

Works with an asterisk are reproduced in the essay section of the book. Parenthetical notations preceding the credit lines indicate catalogue raisonné references, which are listed in full in the selected bibliography following the checklist.

ALLAN D'ARCANGELO
Buffalo, New York 1930–Kenoza Lake, New York 1998

Side View Mirror, 1970
Mixed media
55.9 x 58.4 x 50.8 cm. (22 x 23 x 20 in.)
Promised gift

JIM DINE
Cincinnati, Ohio 1935

A Tool Box, 1966
Portfolio of ten prints with cover sheet
Screenprint and collage on various

papers, acetates, and other materials in red Plexiglas box
60.4 x 47.6 cm. (23³⁄₄ x 18³⁄₄ in.) each sheet; box: 64.3 x 52.0 x 3.4 cm.
(25³⁄₈ x 20¹⁄₂ x 1³⁄₈ in.)
Edition of 150 and 30 sets of artist's proofs
Printed by Christopher Prater and assembled at Kelpra Studios, Ltd., London; published by Editions Alecto, London
Each print signed in graphite: *Dine*; numbered on verso in graphite, bottom right: *34/150*, stamped in black ink, bottom right: *ED 334*
Gift of Ileana and Michael Sonnabend
x1986-204 a-k

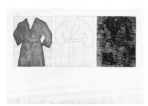

Etching, Self-Portrait (primary colors), 1969–72
Etching from 3 plates printed separately in yellow, red, and blue ink on a single sheet of Hodgkinson handmade paper, watermarked with the artist's signature and Petersburg Press monogram
29.8 x 22.3 cm. (11³⁄₄ x 8³⁄₄ in.) each image; 56.5 x 78.5 cm. (22¹⁄₄ x 31 in.) each sheet
Edition of 75 and 15 artist's proofs
Printed by Maurice Payne at Petersburg Press, London; published by Petersburg Press
Numbered, signed, and dated in graphite, bottom left: *61/75 Jim Dine 1969–72*

(Krens and Castleman 57)
Museum purchase, Laura P. Hall Memorial Fund
x1977-116

The Art of Painting No. 2, 1973
Enamel and acrylic on canvas with objects attached
122.5 x 91.5 cm. (48¹⁄₄ x 36 in.) each of five panels
Signed and dated in crayon (?), first panel (proper left), left: *Spring/Sprayed/ with/the help/of some/nitrogen*, right: *left/to rite/#A/Jim Dine/1973/PUTNEY*; second panel, center: *#B/Jim Dine 1973/"Spring Spraying Nitrogen"*; third panel, center: *C/"Spring Spraying/ Nitrogen"/Jim Dine 1973*; fourth panel, center: *"The Art of Painting/#2/ Second/Series"/#D/Jim Dine 1973*; fifth panel, center: *"The Art of PAINTING"/ (second series)/#E/Jim Dine 1973*
Gift of Stanley J. Seeger Jr., Class of 1952, in memory of his mother, Helen B. Seeger, on the date of her birthday, through the Helen B. Seeger Fund
y1974-1

Five Paintbrushes (second state), 1973
Etching on Copperplate DeLuxe paper
Second of six states
59.6 x 81.2 cm. (23½ x 32 in.) image;
75.2 x 94.5 cm. (29⅝ x 37¼ in.) sheet
Edition of 20 and 5 artist's proofs
Printed by Alan Uglo and Winston
Roeth at Petersburg Press, New York;
published by Petersburg Press
Signed, numbered, and dated in graphite,
bottom left: *Jim Dine 3/20 1973*
(Krens and Castleman 136)
Museum purchase, Laura P. Hall
Memorial Fund
x1974-19

The Venice Night, 1986–87
Oil on canvas with tree branches
155.5 x 425.3 cm. (61¼ x 167⅜ in.)
overall
Titled, signed, and dated on verso in
black crayon, top center: *THE/VENICE ni*
[crossed out] *NIGHT/panel 4/Jim Dine/
1986/Venice*, inscribed in black paint,
center: *NE*
Gift of Doris and Donald G. Fisher
y1992-27

JIM DINE
and **RON PADGETT**
Tulsa, Oklahoma, 1942

Oo La La, 1970
Portfolio of 15 color lithographs by both
artists, offset from zinc plates on
Hodgkinson handmade paper with printed
silk-bound case, title page, and
credit page
44.5 x 69.5 cm. (17½ x 27⅜ in.) each
sheet
Each sheet signed in graphite by both
artists, lower edge; numbered in graphite,
lower right: *23/75*; watermarked with

both artists' signatures and Petersburg
Press initials
Edition of 75 and 15 artist's proofs
Published by Petersburg Press, London,
1972
(Krens and Castleman 16–30)
Gift of Jim Dine
2006-43.1-15

ROBERT INDIANA
New Castle, Indiana 1928

Eternal Hexagon, 1964
Color screenprint on off-white Mohawk
paper
From the portfolio *Ten Works by
Ten Painters*, 1964
44.5 x 40.7 cm. (17½ x 16 in.) image;
61.0 x 50.8 cm. (24 x 20 in.) sheet
Edition of 500, with no proofs
Published by the Wadsworth Atheneum,
Hartford, Connecticut; printed by
Sirocco Screenprinters, New Haven,
Connecticut, under the supervision
of Ives-Stillman, New Haven
Printer's blindstamp, lower right;
portfolio numbered on colophon in
blue ink: *314*
(Sheehan 33)
Gift of Ileana and Michael Sonnabend
x1986-210.9

American Art since 1960, 1970
Color screenprint on white wove paper
89.0 x 63.5 cm. (35 x 25 in.)
Edition of 2,000
Printed by American Poster Company,
New York City; published by the
Princeton University Art Museum for
the exhibition *American Art since 1960*,
May 5–27, 1970

Signed and dated in graphite, bottom
right: *R. Indiana '70*
(Sheehan 60)
Gift of the Department of Art and
Archaeology, Princeton University
x1970-140

***Colby Art Tondo**, 1973
Color screenprint on white wove paper
Diam. 70.5 cm. (27¾ in.) image;
88.9 x 88.9 cm. (35 x 35 in.) sheet
Edition of 50, 3 artist's proofs, 5 hors
commerce proofs, and 6 printer's proofs
Printed by Seri-arts, New York City;
published by the artist
Signed in graphite, bottom right:
R Indiana; numbered in graphite,
bottom left: *4/50*; stamped, bottom
left: © *Robert Indiana 1973*
(Sheehan 81)
Promised gift

Liberty '76, 1974–75
From the *Kent Bicentennial Portfolio:
Spirit of Independence*, 1975
Color screenprint on Lenox 100%
rag paper
101.5 x 91.7 cm. (40 x 36 in.)
Edition of 125 and 10 artist's proofs
Printed by Styria Studio, Inc., New York
City; published by Lorillard, a division
of Loews Theaters, Inc., New York City
Signed in graphite, bottom right:
R. Indiana; numbered in graphite,
bottom left: *13/125*; Styria Studio
blindstamp, bottom center; printed,
bottom left: © *Lorillard 1975*
(Sheehan 84)
Gift of Lorillard, a division of Loews
Theaters, Inc.
x1976-284

Philadelphia LOVE, 1975
Color offset lithograph
19.0 x 19.0 cm. (7½ x 7½ in.) image;
38.0 x 24.0 cm. (15 x 9½ in.) sheet
Edition of 500
Printed by Thorner-Sidney Press, Buffalo,
New York; published by the Friends of
the Philadelphia Museum of Art
(Sheehan 83)

Gift of Carl Otto von Kienbusch, Class
of 1906, for the Carl Otto von
Kienbusch Jr. Memorial Collection
x1975-128

***Six**, 1980–96
Polychrome aluminum on steel base
44.5 x 45.7 x 25.4 cm. (17½ x 18 x 10 in.)
Edition of 8
Stamped on verso of base: © *1980-1997
R INDIANA 8/8*
Promised gift

***Two**, 1980–2001
Polychrome aluminum on steel base
44.5 x 45.7 x 25.4 cm. (17½ x 18 x 10 in.)
Edition of 8
Stamped on verso of base: © *1980-1997
R INDIANA 8/8*
Promised gift

***The Bridge**, 1983
From the portfolio *New York, New York*,
1983
Color screenprint on white BFK Rives
paper
89.9 x 62.9 cm. (35⅜ x 24¾ in.) sheet
Edition of 250 and 25 artist's proofs,
35 proofs numbered with Roman
numerals, and 10 printer's proofs
Printed by Alexander Heinrici, New York
City; published by the New York Graphic
Society, Greenwich, Connecticut
Signed and dated, bottom right:
RM Indiana '83; numbered in graphite,
bottom left: *AP VI/X*
(Sheehan 132)
Promised gift

***Art**, 1992
Color etching and aquatint on white
wove paper
40.6 x 38.1 cm. (16 x 15 in.)
Edition of 100, with an unknown
number of proofs
Printed and published by Vinalhaven
Press, Maine
Signed and dated in graphite, bottom
right: *R Indiana '92*; titled and numbered
in graphite, bottom left: *ART 23/100*
Promised gift

***Art**, 2000
Polychrome aluminum
45.7 x 45.7 x 25.4 cm. (18 x 18 x 10 in.)
Edition of 8
Cast by Milgo Brooklyn, New York
Stamped, inside left: © *2000 R Indiana
4/8*; Milgo Brooklyn stamp, bottom left
Promised gift

***Peace Escapes Once Again**, 2003
Oil on canvas
128.3 x 128.3 cm. (50½ x 50½ in.)
Stenciled within circle on verso, bottom
center: [five-pointed star]; dated, left of
star: *03*; encircling star: *INDIANA
VINALHAVEN*; inscribed on verso in
graphite, right, within circle: *8*
Promised gift

JASPER JOHNS
Augusta, Georgia 1930

Pinion, 1963–66
Color lithograph on Italia handmade paper
120.0 x 71.0 cm. (47¼ x 28 in.)
Edition of 36, 6 artist's proofs, and
1 printer's proof
Printed by Zigmunds Priede at
Universal Limited Art Editions, West
Islip, New York; published by Universal
Limited Art Editions
Signed and dated in red pencil, top
right: *J. Johns/'63-'66*; numbered in
graphite, bottom left: *3/36*; ULAE
blindstamp, bottom left
(Field 49)
Gift of Herbert C. Schorr, Graduate
School Class of 1963, and Mrs. Schorr
x1979-99

Targets, 1967–68
Color lithograph with rubber stamp on
East India handmade paper
86.3 x 64.1 cm. (34 x 25¼ in.)
Edition of 42, 5 artist's proofs, and 2
printer's proofs
Printed by Zigmunds Priede and Fred
Genis at Universal Limited Art Editions,
West Islip, New York; published by
Universal Limited Art Editions
Signed and dated in graphite, bottom
right: *J. Johns '67-'68*; numbered in
graphite, bottom left: *34/42*; ULAE
blindstamp, bottom left
(Field 69)
Museum purchase, Laura P. Hall
Memorial Fund
x1977-3

No, 1969
Lithograph with embossed string and
lead object on Arjomari paper
117.1 x 70.6 cm. (46⅛ x 27¾ in.) image;
142.3 x 88.9 cm. (56 x 35 in.) sheet
Edition of 81 (signed as an edition of 80),
10 artist's proofs, and 1 printer's proof
Printed by Kenneth Tyler and Charles
Ritt at Gemini G.E.L., Los Angeles;
published by Gemini G.E.L.
Signed and dated in graphite, bottom
right: *J. Johns '69*; numbered in
graphite, bottom left: *22/80*; Gemini
and copyright blindstamps, bottom left
(Field 117)
Gift of Herbert C. Schorr, Graduate
School Class of 1963, and Mrs. Schorr
x1978-93

Light Bulb, 1970
Lithograph with rubber stamp on Fred
Siegenthaler paper, watermarked with
the artist's signature
27.0 x 26.5 cm. (10⅝ x 10⅜ in.) image;
48.5 x 30.5 cm. (19 x 12 in.) sheet
Edition of 40 and 6 artist's proofs
Printed by Fred Akers at Universal
Limited Art Editions, West Islip,
New York; published by Universal
Limited Art Editions
Signed and dated in graphite, bottom
right: *J. Johns '70*; ULAE blindstamp, and

numbered in graphite, bottom left: *10/40*
(Field 128)
Museum purchase, Laura P. Hall
Memorial Fund
x1975-39

Decoy II, 1971–73
Color lithograph on Rives BFK paper
105.5 x 75.0 cm. (41¹/₂ x 29¹/₂ in.)
Edition of 31, 5 artist's proofs, and
2 printer's proofs
Printed by Bill Goldston and James V.
Smith at Universal Limited Art Editions,
West Islip, New York; published by
Universal Limited Art Editions
Signed and dated in graphite, bottom
right: *J. Johns 71-73*; numbered
in graphite, bottom left: *7/31*; ULAE
blindstamp, bottom left
(Field 169)
Gift of the artist in memory of William
C. Seitz, Graduate School Class of 1955
x1976-313

Good Time Charley, 1972
Color lithograph with rubber stamp on
Angoumois paper
96.8 x 63.1 cm. (38¹/₈ x 24⁷/₈ in.) image;
110.8 x 73.6 cm. (43⁵/₈ x 29 in.) sheet
Edition of 69, 9 artist's proofs, and
1 printer's proof
Printed by Kenneth Tyler and James
Web at Gemini G.E.L., Los Angeles;
published by Gemini G.E.L.
Signed and dated in graphite, bottom
right: *J. Johns '72*; numbered in
graphite, bottom left: *21/69*; copyright
and Gemini blindstamps, bottom left
(Field 148)
Museum purchase, Laura P. Hall
Memorial Fund
x1973-2

Painting with a Ball, 1972–73
Lithograph on J. Whatman paper,
watermarked J. Whatman 1962
55.0 x 46.5 cm. (21⁵/₈ x 18³/₈ in.) image;
79.0 x 58.0 cm. (31¹/₈ x 22⁷/₈ in.) sheet
Edition of 42, 5 artist's proofs, and
2 printer's proofs
Printed by Bill Goldston and James V.
Smith at Universal Limited Art Editions,
West Islip, New York; published by
Universal Limited Art Editions
Numbered, signed, and dated in graphite,
bottom right: *12/42, J. Johns, 72-73*;
ULAE blindstamp, lower left
(Field 170)
Museum purchase, Laura P. Hall
Memorial Fund
x1976-7

Target, 1973
From the portfolio *For Meyer Schapiro*,
1974
Color screenprint on Ohiro Mimitsuki
paper
30.5 x 30.6 cm. (12 x 12¹/₈ in.) image,
61.0 x 41.7 cm. (24 x 16³/₈ in.) sheet
Edition of 100 and 13 artist's proofs
Printed by Kenjiro Nonaka and Hiroshi
Kawanishi; published by the artist and
Simca Print Artists, Inc., Tokyo
Signed and dated in graphite, bottom
right: *J. Johns '73*; numbered in
graphite, bottom left: *47/100*; Simca
Print Artists blindstamp, bottom right
(Field 171)
Gift of the Albert List Family Collection
x1977-134

ALEX KATZ
Brooklyn, New York 1927

Vincent, 1972
Two-color lithograph on buff Arches paper
37.9 x 53.1 cm. (14⁷/₈ x 20⁷/₈ in.)
Edition of 120, with an unknown number
of proofs
Printed by Paul Narkiewicz, New York
City; published by and for the benefit
of Phoenix House Foundation
Signed and numbered in graphite,
bottom left: *Alex Katz/31/120*
(Maravell 63)
Gift of James Kraft, Class of 1957
x1993-238

Vincent with Open Mouth, 1974
Aquatint and drypoint on German
etching paper
37.5 x 56.5 cm. (14³/₄ x 22¹/₄ in.)
Edition of 58, 8 artist's proofs, and
2 printer's proofs
Printed by Jennifer Melby, New York City;
copublished by Brooke Alexander, Inc., and
Marlborough Graphics, New York City
Signed and numbered in graphite, bottom
left: *Alex Katz 9/58*
(Maravell 76)
Gift of James Kraft, Class of 1957
x1993-239

Boy with Branch I, 1975
Seven-color aquatint on white Arches
Cover paper
61.0 x 102.0 cm. (24 x 40¹/₈ in.)
Edition of 90, 9 artist's proofs, and
1 printer's proof
Printed by Prawat Laucheron, New York
City; copublished by Bo Alveryd,
Kavlinge, Sweden, and Marlborough
Graphics, New York City
Signed and numbered in graphite,
bottom left: *Alex Katz 30/90*

(Maravell 77)
Gift of Herbert C. Schorr, Graduate
School Class of 1963, and Mrs. Schorr
x1981-108

Washington, 1975
From the *Kent Bicentennial Portfolio:
Spirit of Independence*, 1975
Color lithograph on white Arches
Cover paper
50.8 x 101.6 cm. (20 x 40 in.)
Edition of 125, 25 artist's proofs, and
5 printer's proofs
Printed by Styria Studio, Inc., New York
City; published by Lorillard, a division of
Loews Theaters, Inc., New York
Signed and numbered in graphite,
bottom left: *Alex Katz 11/125*
(Maravell 85)
Gift of Lorillard, a division of Loews
Theaters, Inc.
x1976-285

Henry Geldzahler, 1976
Graphite on white wove paper
37.8 x 55.5 cm. (14⁷⁄₈ x 21⁷⁄₈ in.)
Signed and dated in graphite, bottom
right: *For Cris—Alex Katz '76*
Gift of Christopher Scott
x1986-27

Dana, 1978
Graphite on white wove paper
38.5 x 55.0 cm. (15¹⁄₈ x 21⁵⁄₈ in.)
Signed in graphite, bottom left: *Alex Katz*
Gift of Stephanie H. Bernheim
2005-122

***The Wedding Dress**, 1993
Etching with aquatint on paper
132.0 x 55.9 cm. (52 x 22 in.)
Signed and numbered, lower left:
Alex Katz 17/75
Edition of 75
Promised gift

***Anne**, 1996
Oil on aluminum cutout
106.7 x 55.9 cm. (42 x 22 in.)
Signed and dated on verso in black ink:
Alex Katz 96
Promised gift

***Jessica**, 2002
Four-color, two-sided screenprint on
aluminum cutouts
Head 43.2 x 33.0 cm. (17 x 13 in.);
stand h. 132.1 cm. (52 in.);
base diam. 25.4 cm. (10 in.)
Edition of 35
Signed and numbered on verso in black
ink, bottom left: *Alex Katz 28/35*
Promised gift

ROY LICHTENSTEIN
New York City 1923–1997 New York City

Sandwich and Soda, 1964
Two-color screenprint on clear plastic
sheet
48.3 x 58.4 cm. (19 x 23 in.) image;
50.8 x 61.0 cm. (20 x 24 in.) sheet
Edition of 500, with no proofs
From the portfolio *Ten Works by
Ten Painters*, 1964
Published by the Wadsworth Atheneum,
Hartford, Connecticut; printed by
Sirocco Screenprinters, New Haven,
Connecticut, under the supervision
of Ives-Stillman, New Haven
Signed in pen and black ink, lower right:
[. . .] *Lichtenstein*; portfolio numbered
on colophon in blue ink: *314*
(Corlett 35)
Gift of Ileana and Michael Sonnabend
x1986-210.7

Fish and Sky, 1967
From the portfolio *Ten from Castelli*, 1967
Screenprint on silver gelatin photographic
print mounted on three-dimensional
lenticular offset lithograph on white
composition board with window mount
28.0 x 35.5 cm. (11 x 14 in.) image;
58.3 x 53.7 cm. (23 x 21¹⁄₈ in.) mount
Edition of 200, 25 artist's proofs

lettered A–Y, and 15 additional proofs
Printed by Maurel Studios, New York
City, in collaboration with Sheila Marbain
(collage and screenprinting); published
by Tanglewood Press, Inc., New York City
Signed on window mount in graphite,
bottom right: *roy Lichtenstein*; numbered
in graphite, bottom left: *113/200*;
signed on verso in graphite, top left:
roy lichtenstein, numbered, top right:
113/200, stamped in black ink, bottom
center: *G-11*
(Corlett 50)
Gift of Paul F. Walter
x1975-389

Haystack #4, 1969
Color lithograph and screenprint margins
on Rives BFK paper
34.1 x 59.7 cm. (13¹⁄₂ x 23¹⁄₂ in.) image;
52.4 x 78.0 cm. (20⁵⁄₈ x 30⁵⁄₈ in.) sheet
Edition of 100, 10 artist's proofs,
1 printer's proof, 3 publisher's archive
proofs, and 1 right-to-print proof
Printed by Kenneth Tyler, Stuart
Henderson, and Jeff Wasserman at
Gemini G.E.L., Los Angeles; published
by Gemini G.E.L.
Signed and dated in graphite, bottom
right: *Roy Lichtenstein '69*; numbered in
graphite, bottom left: *60/100*; copyright
and Gemini blindstamps, bottom right;
workshop number inscribed on verso in
graphite, bottom left: *RL69-234*
(Corlett 68)
Museum purchase, Laura P. Hall
Memorial Fund
x1974-2

Haystack #5, 1969
Color lithograph and screenprint margins
on Rives BFK paper
34.1 x 59.7 cm. (13½ x 23½ in.) image;
52.6 x 78.1 cm. (20⅝ x 30¾ in.) sheet
Edition of 100, 10 artist's proofs,
1 printer's proof, 3 publisher's archive
proofs, and 1 right-to-print proof
Printed by Kenneth Tyler, Richard Wilke,
and Jeff Wasserman at Gemini G.E.L.,
Los Angeles; published by Gemini G.E.L.
Signed and dated in graphite, bottom
right: *Roy Lichtenstein '69*; numbered in
graphite, bottom left: *60/100*; copyright
and Gemini blindstamps, bottom right;
workshop number inscribed on verso in
graphite, bottom left: *RL69-235*, stamped
in blue ink, bottom left: *GEMINI G.E.L./
LOS ANGELES, CALIF.*
(Corlett 69)
Museum purchase, Laura P. Hall
Memorial Fund
x1974-3

Finger Pointing, 1973
From the portfolio *The New York
Collection for Stockholm*, 1973
Color screenprint on smooth white
wove paper
30.4 x 22.8 cm. (12 x 9 in.)
Edition of 300, with an unknown
number of proofs
Printed by Styria Studio, Inc., New York
City; published by Experiments in Art
and Technology, Inc., New York City
Numbered on verso in graphite, bottom
right: *252/300*; stamped in black ink,
bottom left: *COPYRIGHT 1973
BY ROY LICHTENSTEIN/PRINTED
AT STYRIA STUDIO*
Gift of Mr. and Mrs. James Regan
x1974-35 o

***Still Life with Lobster**, 1974
From the series *Six Still Lifes*, 1974
Color lithograph and screenprint on
Rives BFK paper
81.9 x 78.8 cm. (32¼ x 31 in.) image;
98.5 x 95.2 cm. (38¾ x 37½ in.) sheet
Edition of 100 and 10 artist's proofs
Printed by Styria Studio, New York City;
published by Multiples, Inc., and Castelli
Graphics, New York City
Numbered, signed, and dated in graphite,
bottom right: *67/100 Roy Lichtenstein
'74*; Styria Studio blindstamp, bottom
right; stamped on verso, bottom left:
*Copyright 1974/By Roy Lichtenstein/
Multiples, Inc./& Castelli Graphics*
(Corlett 129)
Promised gift

**Untitled (Still Life with Lemon and
Glass), or Untitled 5**, 1974
From the portfolio *For Meyer Schapiro*,
1974
Color lithograph and screenprint with
debossing on smooth white wove paper
82.8 x 60.6 cm. (32½ x 23⅝ in.) image;
102.9 x 81.0 cm. (40½ x 31⅞ in.) sheet
Edition of 100, 10 artist's proofs
inscribed *AC*, and 13 additional artist's
proofs
Printed by Styria Studio, Inc., New York
City; published by the Committee to
Endow a Chair in Honor of Meyer
Schapiro at Columbia University,
New York City
Numbered, signed, and dated in graphite,
bottom right: *47/100 Roy Lichtenstein '74*;
Styria Studio blindstamp, bottom right
(Corlett 134)
Gift of the Albert List Family Collection
x1977-137

***Brushstroke V**, 1986
Painted cherry wood
148.3 x 78.4 x 34.3 cm.
(58⅜ x 30⅞ x 13½ in.)
Edition of 10
Signed on verso in black paint, center:
Roy Lichtenstein, inscribed in black ink,
below signature: *VE-12*
Promised gift

Nude, 1989
From the series *Brushstroke Figure*
Color lithograph, waxtype, woodcut, and
screenprint on cold-pressed Saunders
Waterford paper
135.9 x 77.0 cm. (53½ x 30⅜ in.) image;
142.9 x 82.6 cm. (56¼ x 32½ in.) sheet
Edition of 60 and 8 artist's proofs,
2 printer's proofs, 2 presentation proofs,
3 publisher's proofs, 2 special proofs,
and 1 right-to-print proof
Printed under the supervision of
Donald Saff by Patrick Foy, Alan Holoubek,
Richard Karnatz, and others at
Graphicstudio, University of South Florida,
Tampa; published by Waddington
Graphics, London, and Graphicstudio,
University of South Florida, Tampa
Numbered, signed, and dated in graphite,
lower right; Graphicstudio blindstamp,
lower right; stamped on verso, lower
left: *© 1989 Roy Lichtenstein/
Graphicstudio U.S.F.*; workshop number
on verso in graphite, lower left: *1071*
(Corlett 233)
Promised gift

***Still Life with Red Jar**, 1994
Color screenprint on Lanaquarelle
watercolor paper
54.3 x 48.9 cm. (21⅜ x 19¼ in.)
Edition of 250, 50 artist's proofs,
1 printer's proof, 3 publisher's archive
proofs, 30 special proofs, and 1 right-
to-print proof
Printed by James Reed at Gemini G.E.L.,
Los Angeles; published by Gemini G.E.L.
Numbered, signed, and dated in graphite,
bottom right: *AP 7/50 Roy Lichtenstein
'94*; Gemini G.E.L. blindstamp and
copyright, bottom right
(Corlett 291)
Promised gift

***Brushstroke**, 1996
Oil on patinated bronze
83.2 x 47.6 cm. (32¾ x 18¾ in.)
Edition of 3
Numbered, signed, and dated on base:
1/3 Roy Lichtenstein '96
Promised gift

***Interior**, 1996
Patinated bronze
68.6 x 49.5 x 17.8 cm. (27 x 19$\frac{1}{2}$ x 7 in.)
Edition of 6
Stamped on base, bottom right: *2/6
Roy Lichtenstein '96/ARGOS*
Promised gift

Still Life, 1997
From *The Geldzahler Portfolio*, 1998
Color screenprint on Somerset
3000-gram textured paper
44.4 x 48.0 cm. (17$\frac{1}{2}$ x 18$\frac{7}{8}$ in.) image;
75.7 x 55.8 cm. (29$\frac{7}{8}$ x 22 in.) sheet
Edition of 75, 15 artist's proofs,
8 printer's proofs, and 20 proofs
numbered in Roman numerals
Printed by Jean-Yves Noblet and Alene
Jackson at Noblet Serigraphie, Inc.,
New York City; published by the artist
and the Estate Project for Artists
with AIDS, West Hollywood, California
Numbered, signed, and dated in graphite,
bottom right: *35/75 Roy Lichtenstein '97*
(Corlett 310)
Museum purchase, Art and Apparatus
Fund
1998-284.7

CLAES OLDENBURG
American, born in Stockholm 1929

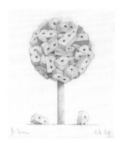

B Tree (For Alfred Barr), 1969
Graphite with blue pencil and white
gouache corrections on white wove paper
73.5 x 58.3 cm. (29 x 23 in.)
Titled in graphite, bottom left: *B—Tree*;
initialed and dated in graphite, bottom
right: *CO 69*
Bequest of Margaret Scolari Barr
x1988-142

Hats Vesuvius, 1973
Color lithograph on J. Barcham
Green paper
33.9 x 44.5 cm. (13$\frac{3}{8}$ x 17$\frac{1}{2}$ in.) image;
50.4 x 66.9 cm. (19$\frac{7}{8}$ x 26$\frac{3}{8}$ in.) sheet
Edition of 25, 10 artist's proofs,
2 printer's proofs, 4 publisher's proofs,
and 5 subscriber's proofs
Printed by Jack Lemon and Thomas
Minkler at Landfall Press, Inc., Chicago;
published by Landfall Press
Signed and dated in graphite, bottom
right: *Oldenburg 73*; numbered in
graphite, bottom left: *4/25*; Landfall
Press blindstamp, bottom left; copyright
blindstamp, bottom right; workshop num-
ber inscribed on verso in graphite, bottom
left: *CO72-332*, stamped on verso in gray
ink, bottom left: *Landfall Press Inc./63
West Ontario Street/Chicago, Illinois/
60610*; titled in plate: *hats Vesuvius*
(Axsom and Platzker 107)
Museum purchase, Laura P. Hall
Memorial Fund
x1974-4

**M. Mouse (with) 1 Ear (equals) Tea
Bag, Blackboard Version (1965)**, 1973
From the portfolio *The New York
Collection for Stockholm*, 1973
Screenprint and lithograph wiped with
talcum powder on Rives BFK paper
30.4 x 22.7 cm. (12 x 9 in.)
Edition of 300, 30 artist's cancellation
proofs, 25 artist's proofs, 9 printer's
proofs, 31 publisher's proofs, 4 trial
proofs, and 1 workshop proof
Printed by Adolf Rischner at Styria
Studio, Inc., New York City; published by
Experiments in Art and Technology, Inc.,
New York City
Numbered and initialed in white pencil,
bottom left: *252/300 CO.*; stamped on
verso in black ink, bottom left: *COPY-
RIGHT 1973 BY CLAES OLDENBURG/
PRINTED AT STYRIA STUDIO*; titled and
signed in plate, bottom: *M. Mouse—
1 ear — Oldenburg*
(Axsom and Platzker 109)
Gift of Mr. and Mrs. James Regan
x1974-35 s

Picasso Cufflink, 1974
From portfolio 6 of *America's Homage
à Picasso*, 1974
Color lithograph on Arches Cover
300-gram paper
74.0 x 60.5 cm. (29$\frac{1}{8}$ x 23$\frac{7}{8}$ in.) image;
91.6 x 68.2 cm. (36 x 26$\frac{7}{8}$ in.) sheet
Edition of 90, 15 artist's proofs,
2 cancellation proofs, 15 hors commerce,
2 printer's proofs, 15 professional proofs,
13 progressive proofs, 30 proofs num-
bered in Roman numerals, 4 publisher's
impressions, 15 publisher's proofs, and
1 right-to-print proof
Printed by Jack Lemon, David Keister,
and David Panosh at Landfall Press, Inc.,
Chicago; published by Propyläen Verlag,
Berlin
Signed and dated in graphite, bottom
right: *Oldenburg © 1974*; numbered in
graphite, bottom left: *3/90*; Landfall
Press blindstamp, bottom left; copyright
blindstamp, bottom right; stamped on
verso in gray ink, bottom left: *Copyright
1974/Landfall Press, Inc/63 W. Ontario
Street/Chicago, Ill. 60610*, workshop
number in graphite, bottom left:
CO73-423, titled in plate: *P. Cufflink*
(Axsom and Platzker 113)
Gift of Herbert C. Schorr, Graduate
School Class of 1963, and Mrs. Schorr
x1992-105

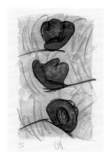

Three Hats, 1974
From the portfolio *For Meyer Schapiro*,
1974
Color lithograph on Twinrocker
handmade rag paper
89.6 x 58.7 cm. (35$\frac{1}{4}$ x 23$\frac{1}{8}$ in.)
Edition of 100, 13 artist's proofs, 3 hors
commerce proofs, and 16 trial proofs

Printed by Adolf Rischner at Styria Studio, Inc., New York City; published by the Committee to Endow a Chair in Honor of Meyer Schapiro at Columbia University, New York City
Initialed in graphite, bottom center: *CO.*; numbered in graphite, bottom left: *47/100*; dated in graphite, bottom right: © *1974*; Styria Studio blindstamp, bottom right; stamped on verso in black ink, bottom right: *COPYRIGHT 1974/BY CLAES OLDENBURG*
(Axsom and Platzker 115)
Gift of the Albert List Family Collection
x1977-140

***Profiterole**, 1989
Cast aluminum with latex and brass
14.5 x 16.5 x 16.5 cm.
(5³⁄₄ x 6¹⁄₂ x 6¹⁄₂ in.)
Edition of 75, 25 artist's proofs, and 7 special proofs
Published by Gemini G.E.L., Los Angeles, for the Hereditary Disease Foundation, Santa Monica, California
Stamped, bottom center: *S P 7*; engraved with Gemini G.E.L. monogram, bottom center; initialed and dated, bottom center, *CO. '89*; engraved, bottom of curved edge: *PROFITEROLE*
Promised gift

CLAES OLDENBURG and COOSJE VAN BRUGGEN
Dutch, Groningen, Netherlands, 1942

***Study for a Sculpture of 1992, Version Four**, 1992
Cardboard, canvas, steel, epoxy, urethane, and latex with latex-painted aluminum base
34.3 x 64.1 x 48.3 cm.
(13¹⁄₂ x 25¹⁄₄ x 19 in.)
Stamped on base, left: *STUDY FOR A SCULPTURE . . . 1992*; stamped on base, right: *CO. © Claes Oldenburg/ VERSION FOUR*
Promised gift

***Proposal for a Colossal Monument in Downtown New York City: Sharpened Pencil Stub with Broken-off Tip of the Woolworth Building**, 1993
Color etching with aquatint on Hannemuhle paper
60.3 x 40.6 cm. (23³⁄₄ x 16 in.) image; 83.2 x 55.9 cm. (32³⁄₄ x 22 in.) sheet
Edition of 60, 8 artist's proofs, 8 printer's proofs, and 1 right-to-print proof
Printed by Aldo Crommelynck at the Spring Street Workshop, New York City; published by Aldo Crommelynck; distributed by Pace Prints, New York City
Numbered in graphite, lower left: *3/60*; signed in graphite, lower right: *C/Oldenburg*
(Axsom and Platzker 248)
Promised gift

Blueberry Pie à la Mode, Tipped Up, and Spilling, 1996
Crayon and watercolor on white wove paper
41.0 x 26.8 cm. (16¹⁄₈ x 10¹⁄₂ in.)
Initialed and dated in graphite, bottom right: *CO Cos/'96*
Museum purchase, Kathleen Compton Sherrerd Fund for Acquisitions in American Art
2004-264

***Blueberry Pie, Flying, Scale B 2/3**, 1998
Cast aluminum and steel with latex
83.8 x 64.8 x 45.7 cm.
(33 x 25¹⁄₂ x 18 in.)
Edition of 3
Stamped on base, left: *BB PIE A LA MODE—FLYING SCALE B 2/3*; stamped on base, right: *CO/COS 1998*
Promised gift

***Blueberry Pie, Flying, Scale C I-VI 2/3**, 1998
Cast aluminum with acrylic urethane
Six pieces; h. 38.1 cm. (15 in.) max.; base 1.3 x 10.2 x 10.2 cm. (¹⁄₂ x 4 x 4 in.)
Edition of 3
Stamped on each base: *BLUEBERRY PIE—FLYING SCALE C*; each numbered, initialed, and numbered *I-VI* in black marker on bottom of base: *2/3/CO. COS*
Promised gift

***Valentine Perfume 2/2**, 1999
Cast aluminum with polyurethane enamel and latex
118.1 x 63.5 x 50.8 cm.
(46¹⁄₂ x 25 x 20 in.)
Edition of 2
Stamped on base, left: *VALENTINE PERFUME 2/2*; stamped on base, right: *CO/COS 1999*; stamped on verso of base, right: *TALLIX*
Promised gift

ROBERT RAUSCHENBERG
Port Arthur, Texas 1925

Shadow Play, 1967
Color photo-screenprint on white wove paper
87.0 x 73.0 cm. (34¹⁄₄ x 28³⁄₄ in.)
Edition of 100 and 25 artist's proofs
Published by Maurel Studios, New York City, for the Judson Memorial Church
Titled, signed, numbered, and dated in graphite, bottom right: *SHADOW PLAY RAUSCHENBERG 33/100 '67*
Gift of Dr. and Mrs. Albert L. Rosenthal
x1971-538

Sack, 1969
Number 67 from the *Stoned Moon Series*, 1969
Color lithograph on Arjomari paper
100.9 x 71.0 cm. (39¾ x 28 in.)
Edition of 60, 10 artist's proofs,
1 printer's proof, 3 publisher's archive proofs, and 1 right-to-print proof
Printed by Daniel Freeman at Gemini G.E.L., Los Angeles; published by Gemini G.E.L.
Signed, numbered, and dated in graphite, top center: *RAUSCHENBERG 52/60 69*; copyright and Gemini blindstamps, bottom right; inscribed on verso in graphite, top right: *5508*, workshop number in graphite, bottom left; *RR 69-282*, stamped, bottom left: *GEMINI G.E.L./ LOS ANGELES, CALIF.*
Gift of Paul F. Walter
1975-390

Earth Day, 1970
Color lithograph with collaged element on white wove paper
132.0 x 95.0 cm. (52 x 37⅜ in.)
Edition of 50
Based on the design for an offset lithographic poster (produced for the American Environment Foundation in celebration of the first Earth Day, April 22, 1970; printed in an edition of 300 signed and 10,000 unsigned prints; published by Castelli Graphics, New York City) using a larger format with the addition of a collaged element and without the date of April 22
Printed and published by Gemini G.E.L., Los Angeles
Signed, numbered, and dated in graphite, bottom left: *RAUSCHENBERG 29/50*

70; copyright and Gemini blindstamps, bottom left; workshop number on verso in graphite, bottom right: *RR 70-350*, stamped, bottom right: *Gemini G.E.L./ Los Angeles, Calif.*
Gift of the Friends of the Princeton University Art Museum
x1971-21

Surface Series From Currents, 1970
Portfolio of 18 screenprints (37 through 54) from the series *Currents*, 1970
Two-color screenprint on Aqua B 844 paper
89.0 x 89.0 cm. (35 x 35 in.) each image; 101.5 x 101.6 cm. (39⅞ x 40 in.) each sheet
Edition of 100
Printed by Adolf Rischner at Styria Studio, Inc., Glendale, California; published by Dayton's Gallery, Minneapolis, and Castelli Graphics, New York City
Each print signed, numbered, and dated in graphite, bottom right: *RAUSCHENBERG 76/100 70*; each print numbered on verso in graphite, bottom: *37 RR 1096, 38 RR 816, 39 RR1216, 40 RR 676, 41 1136, 42 RR636, 43 RR1176, 44 RR 716, 45 RR 1056, 46 RR 976, 47 RR 596, 48 RR 896, 49 RR 756, 50 RR 776, 51 RR 936, 52 RR 856, 53 RR 1016, 54 RR 556*
Gift of Arthur A. Goldberg
x1983-111 a-r

Poster for the Benefit of Congressman John B. Brademas's Re-election, 1973
Color photo-screenprint and applied masking tape on white wove paper
71.0 x 51.0 cm. (28 x 20 in.)
Edition of 100 and 21 artist's proofs
Printed by Styria Studio, Inc., New York City
Signed, numbered, and dated in graphite, bottom left: *RAUSCHENBERG AP 21/21 73*; Styria Studio blindstamp, bottom right
Gift of Herbert C. Schorr, Graduate School Class of 1963, and Mrs. Schorr
x1982-359

Labor's Centennial, 1881–1981, 1981
Color offset lithograph on smooth white wove paper
91.5 x 61.0 cm. (36 x 24 in.)
Edition of 100
Printed to celebrate the centennial of the AFL-CIO
Signed, numbered, and dated in graphite, bottom left: *RAUSCHENBERG/M.E. 59/100 x'81*
Gift of the AFL-CIO
x1982-46

Cliché-Verre: Hand Drawn, Light Printed, 1983
Offset lithograph on verso of transparent polyester sheet
58.2 x 45.7 cm. (23 x 18 in.) image;
63.5 x 47.5 cm. (25 x 18¾ in.) sheet
Edition of 1,000, with 200 signed proofs and 800 unsigned proofs
Printed by Bridget Smith; published and copyrighted by the Drawing and Print Club Founders Society, Detroit Institute of Arts, to celebrate the opening of the Schwartz Graphic Arts Galleries, Detroit Institute of Arts, July 12–August 21, 1983
Museum purchase, Art and Apparatus Fund
x1981-9

Recall, 1990
Color offset lithograph on Arches en tout cas heavy white wove paper
65.5 x 55.0 cm. (25¾ x 21⅝ in.) image; 81.3 x 56.0 cm. (32 x 22 in.) sheet
Edition of 40
Printed by Bill Goldston at Ivy Hill Corporation and Universal Limited Art Editions, West Islip, New York; published by the Whitney Museum of American Art in conjunction with the exhibition *Robert Rauschenberg: The Silk Screen Paintings, 1962–64*
Signed, numbered, and dated in graphite, top left: *RAUSCHENBERG 28/40 90*
Gift of James Kraft, Class of 1957
x1993-261

LARRY RIVERS
Bronx, New York 1923–2002
Southampton, New York

Untitled, 1973
From the portfolio *The New York Collection for Stockholm*, 1973
Edition of 300
Lithograph and color screenprint on white wove paper
22.7 x 30.4 cm. (9 x 12 in.)
Printed by Styria Studio, Inc., New York City; published by Experiments in Art and Technology, Inc., New York City
Signed, dated, and numbered in graphite, bottom right: *Rivers '73 252/300*; stamped on verso, bottom left: *COPYRIGHT BY LARRY RIVERS/ PRINTED AT STYRIA STUDIO*
Gift of Mr. and Mrs. James Regan
x1974-35 v

An Outline of History, 1975
From the *Kent Bicentennial Portfolio: Spirit of Independence*, 1975
Color lithograph and screenprint on white heavyweight handmade rag paper
81.9 x 104.8 cm. (32¼ x 41¼ in.)
Edition of 125
Printed by Styria Studio, Inc., New York City; published by Lorillard, a division of Loews Theaters, Inc., New York
Numbered, signed, and dated in yellow pencil, bottom right: *4/125 Rivers '75*; Styria Studio blindstamp, bottom left
Gift of Lorillard, a division of Loews Theaters, Inc.
x1976-288

JAMES ROSENQUIST
Grand Forks, North Dakota 1933

Spaghetti and Grass, 1965
Color lithograph on white handmade wove paper
70.2 x 43.2 cm. (27⅝ x 17 in.) image;
79.6 x 56.9 cm. (31⅜ x 22⅜ in.) sheet
Edition of 23 and 2 artist's proofs
Printed and published by Universal Limited Art Editions, West Islip, New York
Titled, numbered, signed, and dated in graphite, center: *Spaghetti and Grass 12/23 James Rosenquist 1965*; ULAE blindstamp, center left
(Glenn 5)
Museum purchase, Laura P. Hall Memorial Fund
x1974-6

Ten Days, 1973
From the portfolio *The New York Collection for Stockholm*, 1973
Color screenprint on smooth white wove paper
22.8 x 30.4 cm. (9 x 12 in.)
Edition of 300
Printed by Ali Rischner at Styria Studio, Inc., New York City; published by Experiments in Art and Technology, Inc., New York City
Signed and dated in graphite, center: *Rosenquist 1973*; numbered in graphite, bottom left: *252/300*; stamped on verso, bottom left: *Copyright 1973 by James Rosenquist/Printed at Styria Studio*
(Glenn 68)
Gift of Mr. and Mrs. James Regan
x1974-35 w

Black Tie, 1977
Color lithograph on rolled white Arches
Cover paper
93.0 x 187.5 cm. (36⅝ x 73⅞ in.)
Edition of 100, 20 artist's proofs,
7 hors commerce proofs, 8 workshop
proofs, and 1 right-to-print proof
Printed by Maurice Sanchez at Derrière
L'Étoile Studios, Inc., New York City;
published by Sidney Singer
Signed and dated in graphite, bottom
center: *James Rosenquist 1977*;
numbered and titled, bottom left:
91/100 Black Tie; blindstamp of a
man in a hat, bottom right
(Glenn 121)
Gift of Mario d'Urso
x1979-149

Coin Noir, 1977
Color lithograph and screenprint on
rolled white Arches Cover paper
93.3 x 188.0 cm. (36⅝ x 74 in.)
Edition of 100, 15 artist's proofs,
9 hors commerce proofs, and 1 right-
to-print proof
Printed by John C. Erickson at Aripeka
Ltd. Editions and Styria Studio, Inc.,
New York City; published by Sidney Singer
Signed and dated in graphite, bottom
right: *James Rosenquist 1977*; numbered
in graphite, bottom left: *91/100*; titled
in graphite, center left: *Coin Noir*; Styria
Studio blindstamp, bottom right
(Glenn 125)
Gift of Mario d'Urso
x1979-148

Derrière l'Étoile, 1977
Color lithograph on rolled white Arches
Cover paper
93.8 x 187.7 cm. (37 x 73⅞ in.)
Edition of 100 and 14 artist's proofs
Printed by Maurice Sanchez at Derrière
L'Étoile Studios, Inc., New York City;
published by Sidney Singer
Signed and dated in graphite, bottom
right: *James Rosenquist 1977*; numbered
in graphite, bottom left: *90/100*
(Glenn 120)
Gift of George Heyman
x1979-8

Violent Turn, 1977
Color lithograph on rolled white Arches
Cover paper
83.0 x 187.4 cm. (32⅝ x 73¾ in.)
Edition of 100, 20 artist's proofs,
and 4 hors commerce proofs
Printed by Maurice Sanchez at Derrière
L'Étoile Studios, New York City; published
by Sidney Singer
Signed and dated in graphite, bottom
right: *James Rosenquist 1977*; numbered
and titled in graphite, bottom left:
44/100 Violent Turn
(Glenn 127)
Gift of James Kraft, Class of 1957
x1993-264

While the Earth Revolves at Night,
1982
Color aquatint on white St. Cuthberts
Somerset Satin paper
59.8 x 41.0 cm. (23½ x 16⅛ in.) image;
85.0 x 66.2 cm. (33½ x 26 in.) sheet
Edition of 59, 12 artist's proofs,

1 printer's proof, 3 publisher's archive
proofs, 4 special proofs, and 1 right-
to-print proof
Printed by Charles Levine, Kenneth
Farley, and Patrick Foy at Gemini G.E.L.,
Los Angeles; published by Gemini G.E.L.
Numbered, titled, signed, and dated in
graphite, bottom: *5/59 While the Earth
Revolves at Night James Rosenquist
1982*; copyright and Gemini blindstamps,
bottom right; workshop number inscribed
on verso in graphite, bottom left:
JR82-3046, stamped, bottom left:
© *Gemini G.E.L., Los Angeles*
(Glenn 195)
Gift of Herbert C. Schorr, Graduate
School Class of 1963, and Mrs. Schorr
x1992-106

**Henry's Arrival on the Art World
Causes Gravity**, 1997
From *The Geldzahler Portfolio*, 1998
Color lithograph on Arches Cover paper
76.3 x 56.0 cm. (30 x 22 in.)
Edition of 75 and 15 artist's proofs
Printed by Universal Limited Art Editions,
West Islip, New York; published by the
Estate Project for Artists with AIDS,
West Hollywood, California
Signed and dated in graphite, bottom
right: *James Rosenquist 1997*; numbered
in graphite, bottom left: *35/75*
Museum purchase, Art and Apparatus
Fund
1998-284.8

EDWARD RUSCHA
Omaha, Nebraska 1937

Gas Pump Nozzle and Hose Study, 1962
Tempera, carbon transfer, and graphite on cream wove paper
27.9 x 13.7 cm. (11 x 5³⁄₈ in.)
Signed and dated in graphite, right: *Ed Ruscha 1962*; inscribed in graphite, bottom right: *BELL/IVORY/+/BELL/T.Z*
Museum purchase, Kathleen Compton Sherrerd Fund for Acquisitions in American Art and Fowler McCormick, Class of 1921, Fund
2006-19

Every Building on the Sunset Strip, 1966
Softcover book printed in offset lithography on white wove paper folded and glued in one continuous accordion page, in silver Mylar slipcase
18.0 x 14.4 cm. (7 x 5⁵⁄₈ in.) cover
First edition of 1,000 copies
Printed by Dick de Ruscha, Los Angeles; published by the artist
Signed on slipcase in pen and black ink, bottom: *Ed Ruscha*
(Engberg B4)
Museum purchase, gift of Alexander D. Stuart, Class of 1972
1997-90

***Mocha Standard**, 1969
Color screenprint on cream mold-made paper
49.6 x 93.8 cm. (19¹⁄₂ x 37 in.) image; 65.4 x 101.6 cm. (25³⁄₄ x 40 in.) sheet
Edition of 100, 3 artist's proofs, and 7 undesignated proofs
Printed by Jean Milant and Daniel Socha at the artist's studio, Hollywood, California; published by the artist
Numbered, signed, and dated in graphite, bottom left: *54/100 E. Ruscha 1969*
(Engberg 30)
Museum purchase, Laura P. Hall Memorial Fund
x1974-8

Vanish, 1973
Color lithograph on Arches paper
51.0 x 71.2 cm. (20 x 28 in.)
Edition of 50, 13 artist's proofs, 2 printer's proofs, 2 publisher's proofs, and 1 right-to-print proof
Printed by Ed Hamilton at Cirrus Editions, Los Angeles; published by Cirrus Editions and Brooke Alexander, Inc., New York City
Numbered, signed, and dated in graphite, bottom left: *17/50 Edward Ruscha 1973*
(Engberg 68)
Gift of James Kraft, Class of 1957
x1993-266

Open, 1974
From the series *Tropical Fish Series*, 1975
Color photo-screenprint with varnish overprint on Arches 88 paper
65.7 x 83.2 cm. (25⁷⁄₈ x 32³⁄₄ in.)
Edition of 56, 11 artist's proofs, 1 printer's proof, 3 publisher's archive proofs, and 1 right-to-print proof
Printed by John Roberts at Gemini G.E.L., Los Angeles; published by Gemini G.E.L.

Numbered, signed, and dated on verso in graphite, bottom right: *42/56 Edward Ruscha 1974*, workshop number in graphite, bottom left: *ER74-5092*, stamped, left: *copyright GEMINI G.E.L./ 8365 Melrose Ave., L.A., Ca. 90069*
(Engberg 79)
Museum purchase, Laura P. Hall Memorial Fund
x1977-127

America, Her Best Product, 1974
From the *Kent Bicentennial Portfolio: Spirit of Independence*, 1975
Color lithograph on Rives BFK paper
79.7 x 59.7 cm. (31³⁄₈ x 23¹⁄₂ in.)
Edition of 125, 5 artist's proofs, 2 printer's proofs, 2 printer's archive proofs, and 1 right-to-print proof
Printed by James Allen at Cirrus Editions, Los Angeles; published by Lorillard, a division of Loews Theaters, Inc., New York
Signed and dated on verso in graphite, lower right: *Edward Ruscha 74*; numbered in graphite, bottom left: *14/125*; workshop number in graphite, bottom right: *179C-ER74*
(Engberg 78)
Gift of Lorillard, a division of Loews Theaters, Inc.
x1976-289

GEORGE SEGAL
New York City 1924–2000
South Brunswick, New Jersey

Girl on a Chair, 1970
Plaster, wood, and paint
91.0 x 61.0 x 30.0 cm.
(35⁷⁄₈ x 24 x 11⁷⁄₈ in.)
Edition of 150 and 30 proofs
Published by Editions Alecto,
Shoeburyness, England
Signed and numbered, bottom right:
G Segal/121/150; Editions Alecto
monogram, bottom right
Gift of Richard Roth
y1978-48

Wall Relief: Torso, 1972
Plaster
79.5 cm. x 55.2 cm. (31¹⁄₄ x 21³⁄₄ in.)
Gift of the artist for the William C.
Seitz, Graduate School Class of 1955,
Memorial Collection
2000-254

Remembrance of Marcel, 1973
From the portfolio *The New York
Collection for Stockholm*, 1973
Phonograph record with photocopied
labels on both sides produced from a
3M Color-In-Color machine; white wove
paper folder with photo-screenprint
cover, *Dry Cleaning Store*
Record diam. 17.3 cm. (6⁷⁄₈ in.);
folder 17.9 x 17.9 cm. (7 x 7 in.)
Edition of 300
Published by Experiments in Art and
Technology, Inc., New York City; record
produced by Cook Laboratories, Inc.,
Norwalk, Connecticut; photograph on
cover and record labels by Walter
Russell; cover printed at Styria Studio,
Inc., New York City
Signed on verso of folder in pen and
black ink, bottom right: *G Segal*; numbered
in pen and black ink, bottom left:
252/300; inscribed in pen and black ink,
center: *With Segal it's not a matter of
the found object; it's the chosen object./
Marcel Duchamp*; stamped, bottom left:
*COPYRIGHT BY GEORGE
SEGAL/PRINTED AT STYRIA STUDIO*;
record labels titled, dated, and signed
in photocopy: *REMEMBERANCE OF
MARCEL/March 1973/GEORGE SEGAL/
©1973 By George Segal*; record incised:
CO6152ABS
Gift of Mr. and Mrs. James Regan
x1974-35 x

Two Figures: One Front, One Back,
1975
Number 11 from *The Blue Jean Series*,
1975
Color aquatint on Fabriano Rosaspina
paper
85.0 x 127.5 cm. (33¹⁄₂ x 50¹⁄₈ in.) image;
104.0 x 140.0 cm. (41 x 55¹⁄₈ in.) sheet
Edition of 46

Printed and published by 2RC Editrice,
Rome
Signed and dated in graphite, bottom
right: *George Segal 1975*; numbered
in graphite, bottom left: *39/46*; 2RC
Editrice blindstamp, bottom left
Gift of James Kraft, Class of 1957
x1993-270

GS1, 1978
Color lithograph on heavy cream wove
paper
75.8 x 55.9 cm. (29⁷⁄₈ x 22 in.)
Edition of 100 and 20 hors commerce
proofs
Printed and published by Ediciones
Polígrafa, Barcelona
Signed and dated in graphite, bottom
right: *G Segal 78*; numbered in graphite,
bottom left: *HC 4/20*
Gift of Professor Sam Hunter
x1984-344

GS3, 1978
Color lithograph on heavy cream wove
paper
75.8 x 55.9 cm. (29⁷⁄₈ x 22 in.)
Edition of 100
Printed and published by Ediciones
Polígrafa, Barcelona
Signed and dated in graphite, bottom
right: *G Segal 78*; numbered in
graphite, bottom left: *98/100*
Gift of Professor Sam Hunter
x1985-11

GS5, 1978
Color lithograph on heavy cream wove
paper
75.8 x 55.9 cm. (29⁷⁄₈ x 22 in.)
Edition of 100
Printed and published by Ediciones
Polígrafa, Barcelona
Signed and dated in graphite, bottom
right: *G Segal 78*; numbered in
graphite, bottom left: *65/100*
Gift of Professor Sam Hunter
x1985-12

GS6, 1978
Color lithograph on heavy cream wove
paper
75.8 x 55.9 cm. (29⁷/₈ x 22 in.)
Edition of 100
Printed and published by Ediciones
Polígrafa, Barcelona
Signed and dated in graphite, bottom
right: *G Segal 78*; numbered in graphite,
bottom left: *26/100*
Gift of Professor Sam Hunter
x1985-13

GS7, 1978
Color lithograph on heavy cream wove
paper
75.8 x 55.9 cm. (29⁷/₈ x 22 in.)
Edition of 100
Printed and published by Ediciones
Polígrafa, Barcelona
Signed and dated in graphite, bottom
right: *G Segal 78*; numbered in graphite,
bottom left: *6/100*
Gift of Professor Sam Hunter
x1984-343

**Abraham and Isaac: In Memory of
May 4, 1970, Kent State University**,
1979
Bronze
Cast by Johnson Atelier, Hamilton,
New Jersey
H. 210.0, l. 300.0, w. 120.0 cm.
(82⁵/₈ x 118¹/₈ x 47¹/₄ in.)
The John B. Putnam Jr. Memorial
Collection, Princeton University, partial
gift of the Mildred Andrews Fund
y1978-49

ANDY WARHOL
Pittsburgh, Pennsylvania 1928–1987
New York City

Blue Marilyn, 1962
Acrylic and screenprint ink on canvas
50.5 x 40.3 cm. (19⁷/₈ x 15⁷/₈ in)
Signed and dated on verso, top right:
Andy Warhol 1962
Gift of Alfred H. Barr Jr., Class of 1922,
and Mrs. Barr
y1978-46

Birmingham Race Riot, 1964
Screenprint on smooth white wove paper
From the portfolio *Ten Works by
Ten Painters*, 1964
50.8 x 61.0 cm. (20 x 24 in.)
Edition of 500, with no proofs
Published by the Wadsworth Atheneum,
Hartford, Connecticut; printed by
Sirocco Screenprinters, New Haven,
Connecticut, under the supervision
of Ives-Stillman, New Haven
Signed and dated on verso in blue ink,
lower right: *Andy Warhol 65*; portfolio
numbered on colophon in blue ink: *314*
(Feldman and Schellmann II.3)
Gift of Ileana and Michael Sonnabend
x1986-210.5

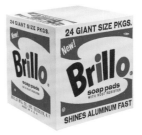

Brillo Box, 1964
Synthetic polymer and screenprint on
wood
43.4 x 43.6 x 35.8 cm.
(17 x 17¹/₈ x 14 in.)
Museum purchase, the Jean and Leonard
Brown Memorial Fund, and partial gift
of the Andy Warhol Foundation for the
Visual Arts
y1993-132

Flowers, 1964
Color offset lithograph on smooth white
wove paper
55.7 x 55.9 cm. (22 x 22 in.) image;
58.5 x 58.6 cm. (23 x 23 in.) sheet
Edition of approximately 300
Printed by Total Color, New York City;
published by Leo Castelli Gallery, New
York City, to coincide with an exhibition
by the artist at Leo Castelli Gallery,
November 21–December 17, 1964
Signed and dated in pen and black ink,
bottom right: *Andy Warhol 64*
(Feldman and Schellmann II.6)
Gift of Ileana and Michael Sonnabend
x1986-206

Liz, 1964
Color offset lithograph on textured
white wove paper
55.8 x 55.6 cm. (22 x 21⁷/₈ in.) image;
58.6 x 58.9 cm. (23 x 23¹/₈ in.) sheet

Edition of approximately 300
Printed by Total Color, New York City;
published by Leo Castelli Gallery,
New York City
(Feldman and Schellmann II.7)
Gift of Ileana and Michael Sonnabend
x1986-207

Marilyn, 1967
From the portfolio of 10 screenprints
Marilyn Monroe (Marilyn), 1967
Color screenprint on smooth white
wove paper
91.4 x 91.4 cm. (36 x 36 in.)
Edition of 250 and 26 artist's proofs
lettered A–Z
Printed by Aetna Silkscreen Products,
Inc., New York City; published by Factory
Editions, New York City
Initialed and dated on verso in graphite,
bottom left: *A.W. 67*; numbered
in graphite, bottom right: *33/250*
(Feldman and Schellmann II.28)
Museum purchase, Laura P. Hall
Memorial Fund
x1977-5

Marilyn Monroe (Marilyn), 1967
Color screenprint on smooth white
wove paper
From the portfolio of 10 screenprints
Marilyn Monroe (Marilyn), 1967
91.5 x 91.5 cm. (36 x 36 in.)
Edition of 250 and 26 artist's proofs
lettered A–Z
Printed by Aetna Silkscreen Products,
Inc., New York City; published by
Factory Editions, New York City
Signed on verso in graphite, bottom
left: *Andy Warhol*; stamped on verso,
bottom right: *30/250*
(Feldman and Schellmann II.31)
Gift of the Friends of the Princeton
University Art Museum
x1971-20

***Flash—November 22, 1963**, 1968
From the portfolio of 11 screenprints
Flash—November 22, 1963, 1968
Color screenprint on smooth white
wove paper

53.3 x 53.3 cm. (21 x 21 in.)
Edition of 200
Printed by Aetna Silkscreen Products,
Inc., New York City; published by Racolin
Press, Inc., Briarcliff Manor, New York
(Feldman and Schellmann II.40)
Promised gift

Pepper Pot, 1968
From the portfolio of 10 screenprints
Campbell's Soup I, 1968
Color screenprint on smooth white
wove paper
89.1 x 58.6 cm. (35 x 23 in.)
Edition of 250 and 26 artist's proofs
lettered A–Z
Printed by Salvatore Silkscreen Co., Inc.,
New York City; published by Factory
Additions, New York City
Signed on verso in pen and black ink,
bottom right: *Andy Warhol*; stamped,
bottom right: *30/250*
(Feldmann and Schellmann II.51)
Gift of Ileana and Michael Sonnabend
x1986-209

SAS Passenger Ticket, 1968
Color screenprint on smooth white
wove paper
67.8 x 123.7 cm. (26⅝ x 48¾ in.)
Edition of 250
Printed by Stig Arbam AB, Malmö,
Sweden; published by the Moderna
Museet, Stockholm, to coincide with an
exhibition by the artist at Moderna
Museet, February 10–March 17, 1968
Signed on verso in graphite, bottom
left: *Andy Warhol*
(Feldman and Schellmann II.20)
Gift of Ileana and Michael Sonnabend
x1986-208

Flowers, 1970
From the portfolio of 10 screenprints
Flowers, 1970
Color screenprint on smooth white
wove paper
91.5 x 91.5 cm. (36 x 36 in.)
Edition of 250 and 26 artist's proofs
lettered A–Z
Printed by Aetna Silkscreen Products,
Inc., New York City; published by
Factory Additions, New York City
Signed and numbered on verso in pen
and black ink, bottom right:
Andy Warhol X
(Feldmann and Schellmann II.68, II.67)
Gift of Herbert C. Schorr, Graduate
School Class of 1963, and Mrs. Schorr
x1979-95, x1979-96

Flowers, 1970
From the portfolio of 10 screenprints
Flowers, 1970
Color screenprint on smooth white
wove paper
91.4 x 91.4 cm. (35⅝ x 35⅝ in.)
Edition of 250 and 26 artist's proofs
lettered A–Z
Printed by Aetna Silkscreen Products,
Inc., New York City; published by
Factory Additions, New York City
Signed on verso in pen and black ink,
bottom right: *Andy Warhol*; stamped,
bottom left: *118/250*
(Feldman and Schellmann II.68, II.64)
Gift of James Kraft, Class of 1957
x1993-281, x1993-282

Electric Chair, 1971
From the portfolio of 10 screenprints
Electric Chairs, 1971
Color screenprint on smooth white
wove paper
90.0 x 121.5 cm. (35³⁄₈ x 47⁷⁄₈ in.)
Edition of 250 and 50 artist's proofs
numbered in Roman numerals
Printed by Silkprint Kettner, Zürich;
published by Bruno Bischofberger, Zürich
Signed in pen and blue ink, bottom left:
Andy Warhol; stamped on verso, bottom
right: *225/250*
(Feldmann and Schellmann II.80)
Gift of Graham Smith, Graduate School
Class of 1971
x1976-318

Electric Chairs, 1971
Portfolio of 10 color screenprints on
smooth white wove paper
90.0 x 121.5 cm. (35³⁄₈ x 47⁷⁄₈ in.) each
Edition of 250 and 50 artist's proofs
numbered in Roman numerals
Printed by Silkprint Kettner, Zürich;
published by Bruno Bischofberger, Zürich
Each signed and dated on verso in pen
and black ink, bottom left: *Andy Warhol
71*; each stamped, bottom right: *AP IX/L*
(Feldman and Schellmann II.74–.83)
Gift of Paul F. Walter
x1977-148 a-j

Mao, 1970
From the portfolio of 10 screenprints
Mao, 1970
Color screenprint on smooth white
wove paper
91.5 x 91.5 cm. (36 x 36 in.)
Edition of 250 and 50 artist's proofs
Printed by Styria Studio, Inc., New York
City; published by Castelli Graphics and
Multiples, Inc., New York City
Numbered and signed on verso in
graphite, bottom left: *a/p 17/50 Andy
Warhol*; Styria Studio stamp, bottom right
(Feldman and Schellmann II.90, II.98)
Gift of Herbert C. Schorr, Graduate
School Class of 1963, and Mrs. Schorr
x1979-97, x1979-98

Untitled, 1973
From the portfolio *The New York
Collection for Stockholm*, 1973
Xerox print on typewriter paper
Edition of 300, 25 artist's proofs, and
31 printer's proofs; each print unique
28.0 x 21.6 cm. (11 x 8¹⁄₂ in.)
Printed by Julie Martin, New York City;
published by Experiments in Art and
Technology, Inc., New York City
Signed and numbered on verso in black
ink, bottom left: *Andy Warhol 252/300*
(Feldmann and Schellmann II.89)
Gift of Mr. and Mrs. James Regan
x1974-35 cc

Untitled 12, 1974
From the portfolio *For Meyer Schapiro*,
1974
Color screenprint on Arches paper
48.3 x 40.7 cm. (19 x 16 in.) image;
75.8 x 56.3 cm. (29⁷⁄₈ x 22¹⁄₈ in.) sheet
Edition of 100, 13 artist's proofs, and
3 printer's proofs
Printed by Alexander Heinrici, New York
City; published by the Committee to
Endow a Chair in Honor of Meyer
Schapiro at Columbia University,
New York City
Numbered, signed, and dated on verso
in black ink, bottom center: *47/100
Andy Warhol '74*
(Feldman and Schellmann II.120)
Gift of the Albert List Family Collection
x1977-144

Mick Jagger, 1975
From the portfolio of 10 screenprints
Mick Jagger, 1975
Color screenprint on Arches Aquarelle
rough paper
110.0 x 73.3 cm. (43¹⁄₄ x 28⁵⁄₈ in.)
Edition of 250, 50 artist's proofs, and
3 printer's proofs
Printed by Alexander Heinrici, New York
City; published by Seabird Editions,
London
Signed in graphite, bottom right: *Andy
Warhol*; signed in red marker, bottom
left: *M. Jagger*; numbered in graphite,
bottom left: *249/250*
(Feldman and Schellmann II.139)
Gift of Carlton K. Coddington, Class
of 1938
x1987-31

*"Fips" Mouse, 1983
Synthetic polymer and silkscreen ink
on canvas
20.3 x 25.4 cm. (8 x 10 in.)
Promised gift

ANDY WARHOL and GERARD MALANGA
New York City 1943

The Thermofax Series, 1964–65
Thermal-development print with ink
additions
35.5 x 29.9 cm. (14 x 11 ³/₄ in.)
Museum purchase, gift of the National
Endowment for the Arts, a federal
agency, and a matching gift from the
Geraldine R. Dodge Foundation
x1983-10

TOM WESSELMANN
Cincinnati, Ohio 1931–2004
New York City

Study for Still Life, No. 22, 1962
Charcoal with black chalk on cream
wove paper
91.0 x 121.0 cm. (35⁷/₈ x 47⁵/₈ in.)
Signed and dated in charcoal, top center:
Wesselmann 62
Museum purchase, Laura P. Hall
Memorial Fund
x1971-6

Great American Nude #62, 1965
Liquitex polymer on plywood
111.0 x 152.4 cm. max.
(43³/₄ x 60 in.)

Dated and signed on verso in red marker,
right: *GAN #62/43" x 60"/1965/
Wesselmann/LIQUID POLYMER/PAINT
ON GESSO/ON NOVA PLY (U.S./
PLYWOOD)/LIQUITEX MATTE/VARNISH.*
Gift of Peter H. Sharp, Caroline M.
Sharp, and Randall A. Sharp
y1993-161

*Still Life #54, 1965
Grip-Flex on Uvex plastic
116.8 x 147.3 x 12.7 cm. (46 x 58 x 5 in.)
Edition of 3
Numbered, dated, and signed on verso
in red marker, center right:
*SL#54/1965/Wesselmann/
46" x 58" x 5"*; inscribed in black
marker, top right, text boxed: *#1
of/EDITION/OF 3*
Promised gift

*Fingertips with Cigarette, 1978
Watercolor and charcoal on J. Barcham
Green heavyweight mold-made
watercolor paper
55.9 x 76.2 cm. (22 x 30 in.)
Signed and dated in graphite, bottom
center: *Wesselmann 78*
Promised gift

Maquette for Dropped Bra, 1978
Liquitex on Bristol board
16.5 x 14.5 cm. (6¹/₂ x 5³/₄ in.)
Numbered, dated, and signed on verso
in graphite, center: *8" x 16'6"/78-35*
[encircled]/*Wesselmann 78 p* [letter
encircled]
Promised gift

*Dropped Bra (Big Maquette),
1978–80
Alkyd on aluminum
71.1 x 147.3 x 55.9 cm. (28 x 58 x 22 in.)
Inscribed on verso in black ink, bottom
left: *THE ESTATE OF TOM WESSELMANN*;
signed: *Claire Wesselmann EXECUTOR*;
stamped and engraved: *Wesselmann
No 8* [?]
Promised gift

*Smoker Study Sculpture, 1981
Alkyd on steel
27.9 x 81.3 x 33.0 cm. (11 x 32 x 13 in.)
Edition of 15 and 3 artist's proofs
Signed, dated, and numbered on verso
in black ink, bottom right: *Wesselmann
81 AP 1/3*
Promised gift

*Beach at Easthampton, 1989–91
Alkyd on steel
78.7 x 246.4 cm. (31 x 97 in.)
Inscribed on verso in black ink, top:
*L-32 TOM WESSELMANN 1989/91
BEACH AT EASTHAMPTON*; signed and
dated in graphite, center: *Wesselmann 91*
Promised gift

Study for Bedroom Painting #56,
1982
Pencil and thinned Liquitex on rag paper
101.6 x 152.4 cm. (40 x 60 in.)
Signed and dated in graphite, bottom
right: *Wesselmann 82*
Promised gift

*Study for Nude Edge with
Seascape, 1984
Oil on canvas
33.0 x 76.2 cm. (13 x 30 in.)
Signed on verso in black ink, bottom
center: *THE ESTATE OF TOM
WESSELMANN – Claire Wesselmann,
EXECUTOR*; titled and dated on verso of
wooden stretcher in black ink, top left
(partially hidden by frame): *STUDY FOR
NUDE EDGE/1984 OIL ON CANVAS*
Promised gift

***Monica Reclining in Chinese Robe**, 1985–99
Alkyd on steel
12.1 x 43.2 cm. (4³/₄ x 17 in.)
Edition of 6 artist's proofs
Signed, numbered, dated, and titled on verso in black ink: *Wesselmann AP 4/6 TOM WESSELMANN 1985/99 MONICA RECLINING IN CHINESE ROBE EDITION ALKYD ON CUT OUT STEEL 4 3/4 x 17"*
Promised gift

***Monica Sitting, Robe Half Off**, 1986–90
Alkyd on steel
29.2 x 16.5 cm. (11¹/₂ x 6¹/₂ in.)
Edition of 25
Numbered and signed on verso in graphite: *11/25 Wesselmann*; titled and dated in black ink: *STEEL DRAWING EDITION/1986/90/MONICA SITTING, ROBE HALF OFF/11 1/2" x 6 1/2"/11/25*
Promised gift

Still Life with Orange and Tulip
1986–92
Alkyd on steel
26.0 x 31.1 x 5.75 cm.
(10¹/₄ x 12¹/₄ x 2¹/₄ in.)
Edition of 25
Signed, dated, titled, and numbered on verso in black ink, bottom right: *Wesselmann/WESSELMANN 1986/92/ STILL LIFE WITH ORANGE/AND TULIP EDITION 19/25/10 1/4 x 12 1/4 x 2 1/4/ ALKYD ON CUT OUT STEEL*
Promised gift

***Still Life**, 1988
Porcelain
47.6 x 50.8 cm. (18³/₄ x 20 in.)
Edition of 299
Signed in black ink, bottom right: *Tom Wesselmann*
Promised gift

Maquette for Fast Sketch Still Life with Fruit and Goldfish, 1989
Liquitex on Bristol board
35.6 x 43.2 x 3.2 cm. (14 x 17 x 1¹/₄ in.)
Signed and dated in black ink, bottom right: *WESSELMANN 89*
Promised gift

Delphinium and Daisies, 1989–92
Alkyd on steel
132.0 x 40.0 cm. (52 x 15³/₄ in.)
Signed and numbered on verso in graphite, top: *WESSELMANN 15/25*
Promised gift

Monica Sitting, Elbows on Knees, 1990
Lithograph on white Rives BFK paper
83.0 x 66.5 cm. (32⁵/₈ x 26¹/₈ in.) image; 152.8 x 86.3 cm. (60¹/₈ x 34 in.) sheet
Edition of 75, 12 artist's proofs, 2 printer's proofs, and 1 right-to-print proof
Printed by Bruce Porter at Trestle Editions, New York City; published by Parasol Press Ltd., New York City, for the Brooklyn Academy of Music Foundation
Signed and numbered in graphite, bottom center: *Wesselmann 7/75*
Gift of James Kraft, Class of 1957
x1993-284

Landscape II, 1991
Porcelain
45.1 x 60.0 cm. (17³/₄ x 23⁵/₈ in.)
Promised gift

Maquette for Seascape with Cumulus Clouds, 1991
Liquitex on Bristol board
11.4 x 41.91 cm. (4¹/₂ x 16¹/₂ in.)
Signed, dated, and titled on verso of frame in black ink, left: *D91117/TOM WESSELMANN 1991/MAQUETTE FOR SEASCAPE WITH/CUMULUS CLOUDS/ LIQUITEX ON BRISTOL BOARD/ 4 1/2 x 16 x 1/2"* on 21 1/2 x 12 1/2; inscribed in graphite, center left: *A*
Promised gift

Still Life with Apple, Orange, and Radio, 1991
Color screenprint on paper
76.2 x 93.4 cm. (30 x 36³/₄ in.)
Edition of 100
Signed in graphite, bottom right: *Wesselmann 73/100*
Promised gift

***Still Life with Blonde**, 1999
Color screenprint on white wove paper
76.2 x 94.0 cm. (30 x 37 in.)
Edition of 12 artist's proofs
Signed and numbered in graphite, bottom right: *Wesselmann AP 11/12*
Promised gift

Maquette for Kate's Beauty, 2001
Liquitex on Bristol board
22.5 x 24.5 x 1.9 cm. (8⁷/₈ x 9⁵/₈ x ³/₄ in.)
Signed and dated in black ink, bottom right: *Wesselmann 01*; signed, dated, and titled on verso of frame in black ink, center: *TOM WESSELMANN 2001/ D014 MAQUETTE FOR KATE'S BEAUTY/ 8 7/8 x 9 5/8 x 7/8 on 16 x 17"/ LIQUITEX ON BRISTOL BOARD*
Promised gift

BIBLIOGRAPHY

References are provided below for selected sources that address the Pop art movement in general as well for those devoted to artists whose work is represented in the collection.

GENERAL WORKS

Francis, Mark, ed. *Pop*. With a survey by Hal Foster. New York, 2005.

Frith, Simon. *Art into Pop*. New York, 1987.

Lippard, Lucy, ed. *Pop Art*. New York, 1966; rev. 1970.

Livingstone, Marco. *Pop Art: A Continuing History*. London, 1990; rev. 2000.

Madoff, Steven Henry, ed. *Pop Art: A Critical History*. Berkeley, 1997.

Mamiya, Christin J. *Pop Art and Consumer Culture: American Super Market*. Austin, Tex., 1992.

Russell, John, and Suzi Gablik, eds. *Pop Art Redefined*. New York, 1969.

Taylor, Paul, ed. *Post-Pop Art*. Cambridge, Mass., 1989.

Whiting, Cécile. *A Taste for Pop: Pop Art, Gender, and Consumer Culture*. Cambridge, 1997.

ALLAN D'ARCANGELO

Ferrari, Silvia, ed. *Allan D'Arcangelo, Retrospettiva*. Exh. cat., Galleria Civica, Palazzina dei Giardini, Modena. Milan, 2005.

JIM DINE

Beal, Graham W. J., et al. *Jim Dine, Five Themes*. Exh. cat., Walker Art Center, Minneapolis. New York, 1984.

Carpenter, Elizabeth. *Jim Dine Prints, 1985–2000: A Catalogue Raisonné*. Exh. cat., Minneapolis Institute of Arts. New York, 2002.

Celant, Germano, and Clare Bell. *Jim Dine: Walking Memory, 1959–1969*. Exh. cat., Solomon R. Guggenheim Museum. New York, 1999.

Feinberg, Jean E. *Jim Dine*. New York, 1995.

Glenn, Constance W. *Jim Dine Drawings*. New York, 1985.

Krens, Thomas, and Riva Castleman. *Jim Dine: Prints, 1970–1977*. Exh. cat., Williams College Museum of Art. Williamstown, Mass., 1976.

Livingstone, Marco. *Jim Dine: The Alchemy of Images*. New York, 1998.

Shapiro, David. *Jim Dine: Painting What One Is*. New York, 1981.

ROBERT INDIANA

Kernan, Nathan. *Robert Indiana*. New York, 2003.

Love and the American Dream: The Art of Robert Indiana. Exh. cat., Portland Museum of Art, Maine. 1999.

Robert Indiana. With statements by the artist and an introduction by John W. McCoubrey. Exh. cat., Institute of Contemporary Art, University of Pennslyvania. Philadelphia, 1968.

Robert Indiana: Retrospective, 1958–1998. Exh. cat., Musée d'Art Moderne et d'Art Contemporaine. Nice, 1998.

Ryan, Susan Elizabeth. *Dream-Work: Robert Indiana Prints*. Baton Rouge, 1997.

——. *Robert Indiana: Figures of Speech*. New Haven, 2000.

Sheehan, Susan, et al. *Robert Indiana Prints: A Catalogue Raisonné, 1951–1991*. New York, 1991.

Tobin, Robert L. B., and William Katz. *Robert Indiana*. Austin, Tex., 1977.

Weinhardt, Carl J., Jr. *Robert Indiana*. New York, 1990.

JASPER JOHNS

Bernstein, Roberta. *Jasper Johns*. New York, 1992.

Boudaille, Georges. *Jasper Johns*. New York, 1989.

Castleman, Riva. *Jasper Johns: A Print Retrospective*. Exh. cat., Museum of Modern Art, New York. Boston, 1986.

Crichton, Michael. *Jasper Johns*. Exh. cat., Whitney Museum of American Art. New York, 1994.

Field, Richard S. *The Prints of Jasper Johns, 1960–1993: A Catalogue Raisonné*. West Islip, N.Y., 1994.

Francis, Richard. *Jasper Johns*. New York, 1984.

Johnston, Jill. *Jasper Johns: Privileged Information*. New York, 1996.

Kozloff, Max. *Jasper Johns*. New York, 1968.

Orton, Fred. *Figuring Jasper Johns*. Cambridge, Mass., 1994.

Rosenthal, Mark. *Jasper Johns: Work since 1974*. Exh. cat., Philadelphia Museum of Art. Philadelphia, 1988.

Rosenthal, Nan, et al. *The Drawings of Jasper Johns*. Exh. cat., National Gallery of Art. Washington, D.C., 1990.

Varnedoe, Kirk, and Roberta Bernstein. *Jasper Johns: A Retrospective*. Exh. cat., Museum of Modern Art. New York, 1996.

ALEX KATZ

Beattie, Ann. *Alex Katz*. New York, 1987.

Felix, Zdenek, and Carter Ratcliff. *Alex Katz Cutouts*. Hamburg, 2003.

Katz, Vincent, ed. *Alex Katz: Erfundene Symbole/Invented Symbols*. Positions in Contemporary Art 2. Ostfildern-Ruit, Germany, 1997.

Kuspit, Donald. *Alex Katz: Night Paintings*. New York, 1991.

Maravell, Nicholas P. *Alex Katz: The Complete Prints*. New York, 1983.

Marshall, Richard. *Alex Katz*. Exh. cat., Whitney Museum of American Art. New York, 1986.

Sandler, Irving. *Alex Katz: A Retrospective*. New York, 1998.

ROY LICHTENSTEIN

Adelman, Bob, and Calvin Tomkins. *The Art of Roy Lichtenstein: Mural with Blue Brushstroke*. New York, 1984.

Alloway, Lawrence. *Roy Lichtenstein*. New York, 1983.

Coplans, John, ed. *Roy Lichtenstein*. New York, 1972.

Corlett, Mary Lee. *The Prints of Roy Lichtenstein: A Catalogue Raisonné, 1948–1997*. 2d rev. ed. New York, 2002.

Cowart, Jack. *Roy Lichtenstein, 1970–1980*. Exh. cat., Saint Louis Art Museum. New York, 1981.

——, ed. *Lichtenstein: Sculpture & Drawings*. Exh. cat., Corcoran Gallery of Art. Washington, D.C., 1999.

Fitzpatrick, Robert, and Dorothy Lichtenstein, eds. *Roy Lichtenstein: Interiors*. New York, 1999.

Lobel, Michael. *Image Duplicator: Roy Lichtenstein and the Emergence of Pop Art*. New Haven, 2002.

Rose, Bernice. *The Drawings of Roy Lichtenstein*. Exh. cat., Museum of Modern Art. New York, 1987.

Waldman, Diane. *Roy Lichtenstein*. Exh. cat., Solomon R. Guggenheim Museum. New York, 1969.

——. *Roy Lichtenstein*. New York, 1971.

——. *Roy Lichtenstein*. Exh. cat., Solomon R. Guggenheim Museum. New York, 1993.

CLAES OLDENBURG

Axsom, Richard H., and David Platzker. *Printed Stuff: Prints, Posters, and Ephemera by Claes Oldenburg. A Catalogue Raisonné, 1958–1996*. New York, 1997.

Celant, Germano, et al. *Claes Oldenburg: An Anthology*. Exh. cat., Solomon R. Guggenheim Museum. New York, 1995.

Claes Oldenburg: Multiples in Retrospect, 1964–1990. New York, 1991.

Lee, Janie C. *Claes Oldenburg Drawings, 1959–1977; Claes Oldenburg with Coosje van Bruggen Drawings, 1992–1998*. Exh. cat., Whitney Museum of American Art. New York, 2002.

Oldenburg, Claes. *Claes Oldenburg*. Exh. cat., Museum of Modern Art, New York. London, 1970.

Rose, Barbara. *Claes Oldenburg*. Exh. cat., Museum of Modern Art. New York, 1970.

ROBERT RAUSCHENBERG

Crow, Thomas, et al. *Robert Rauschenberg: Combines*. Exh. cat., Museum of Contemporary Art. Los Angeles, 2005.

Hopps, Walter, et al. *Robert Rauschenberg: A Retrospective*. Exh. cat., Solomon R. Guggenheim Museum. New York, 1997.

Hunter, Sam. *Robert Rauschenberg*. New York, 1999.

Joseph, Branden Wayne. *Random Order: Robert Rauschenberg and the Neo-Avant-Garde*. Cambridge, Mass., 2003.

Kotz, Mary Lynn. *Rauschenberg: Art and Life*. New York, 1990.

Mattison, Robert S. *Robert Rauschenberg: Breaking Boundaries*. New Haven, 2003.

Steinberg, Leo, et al. *Robert Rauschenberg*. Cambridge, Mass., 2002.

Tomkins, Calvin. *Off the Wall: A Portrait of Robert Rauschenberg*. New York, 2005.

Turrell, Julia Brown, et al. *Rauschenberg Sculpture*. Exh. cat., Modern Art Museum. Fort Worth, 1995.

LARRY RIVERS

Harrison, Helen A. *Larry Rivers*. New York, 1984.

Hunter, Sam. *Larry Rivers*. New York, 1971.

Rose, Barbara, and Jacquelyn Days Serwer. *Larry Rivers: Art and the Artist*. Exh. cat., Corcoran Gallery of Art, Washington, D.C. Boston, 2002.

JAMES ROSENQUIST

Glenn, Constance. *Time Dust, James Rosenquist: Complete Graphics, 1962–1992*. New York, 1993.

Goldman, Judith. *James Rosenquist*. New York, 1985.

Hopps, Walter, and Sarah Bancroft. *James Rosenquist: A Retrospective*. Exh. cat., Solomon R. Guggenheim Museum. New York, 2003.

Tucker, Marcia. *James Rosenquist*. Exh. cat., Whitney Museum of American Art. New York, 1972.

EDWARD RUSCHA

Benezra, Neal, et al. *Ed Ruscha*. Exh. cat., Hirshhorn Museum and Sculpture Garden. Washington, D.C., 2000.

Engberg, Siri, and Clive Phillpot. *Edward Ruscha: Editions, 1959–1999. Catalogue Raisonné*. Exh. cat., Walker Art Center. Minneapolis, 1999.

Hickey, Dave, and Peter Plagens. *The Works of Edward Ruscha*. Exh. cat., San Francisco Museum of Modern Art. New York, 1982.

Rowell, Margit, and Cornelia Butler. *Cotton Puffs, Q-tips, Smoke and Mirrors: The Drawings of Ed Ruscha*. Exh. cat., Whitney Museum of American Art. New York, 2004.

GEORGE SEGAL

Friedman, Martin, and Graham W. J. Beal. *George Segal: Sculptures*. Exh. cat., Walker Art Center. Minneapolis, 1978.

Hunter, Sam, and Don Hawthorne. *George Segal*. New York, 1984.

Livingstone, Marco. *George Segal Retrospective: Sculptures, Paintings, Drawings*. Exh. cat., Montreal Museum of Fine Arts. Montreal, 1997.

Tuchman, Phyllis. *George Segal*. New York, 1983.

Van der Marck, Jan. *George Segal*. New York, 1975.

ANDY WARHOL

Bastian, Heiner, ed. *Andy Warhol: Retrospective*. Exh. cat., Tate Modern. London, 2001.

Baume, Nicholas, ed. *About Face: Andy Warhol Portraits*. Hartford, Conn., 1999.

Coplans, John. *Andy Warhol*. Greenwich, Conn., 1970.

Doyle, Jennifer, et al. *Pop Out: Queer Warhol*. Durham, N.C., 1996.

Feldman, Frayda, and Jörg Schellman, eds. *Andy Warhol Prints: A Catalogue Raisonné, 1962–1987*. 4th ed. rev. and expanded by Frayda Feldman and Claudia Defendi. New York, 2003.

Frei, Georg, and Neil Printz, eds. *The Andy Warhol Catalogue Raisonné*. New York, 2002.

Koestenbaum, Wayne. *Andy Warhol*. New York, 2001.

McShine, Kynaston, ed. *Andy Warhol: A Retrospective*. Exh. cat., Museum of Modern Art. New York, 1989.

Michelson, Annette, ed. *Andy Warhol*. Cambridge, Mass., 2001.

Printz, Neal. *Andy Warhol: Death and Disasters*. Exh. cat., Menil Collection. Houston, 1988.

Warhol, Andy, and Pat Hackett. *POPism: The Warhol '60s*. New York, 1980.

TOM WESSELMANN

Eccher, Danilo, and Slim Stealingworth [Tom Wesselmann]. *Tom Wesselmann*. Exh. cat., Flora Bigai Arte Moderna e Contemporanea, Venice, and Pietrasanta, Lucca. Milan, 2003.

Glenn, Constance. *Tom Wesselmann, The Early Years: Collages, 1959–1962*. Exh. cat., Art Galleries, California State University. Long Beach, 1974.

——, and Mary-Kay Lombino. *Tom Wesselmann: The Intimate Images*. Exh. cat., University Art Museum, California State University. Long Beach, 2003.

Hunter, Sam. *Tom Wesselmann*. New York, 1994.

Sheppard, Ileen. *Tom Wesselmann: Drawings*. Exh. cat., Queens Museum. Flushing, N.Y., 1987.

Slim Stealingworth [Tom Wesselmann]. *Tom Wesselmann*. New York, 1980.

PHOTOGRAPHY CREDITS

Individual works of art appearing in this book may be protected by copyright in the United States of America or elsewhere, and thus may not be reproduced in any form without the permission of the copyright owners. Every effort was made to obtain official permission to reproduce the works illustrated in this volume. In some cases, permission to reproduce was conditioned upon publication of a credit line or notice of copyright, as follows:

COVER

Art © Estate of Roy Lichtenstein/ photo Bruce M. White

ROBERT INDIANA: "A PEOPLE'S PAINTER"

All art by Robert Indiana © 2006 Morgan Art Foundation Ltd./Artists Rights Society (ARS), New York; figs. 2, 10: courtesy Paul Kasmin Gallery; figs. 4–5, 11–15: Bruce M. White; fig. 6: Geoffrey Clements/art © Ellsworth Kelly; fig. 8: art © The Museum of Modern Art/Licensed by SCALA/Art Resource, New York and Artist Rights Society (ARS); fig. 9: Geoffrey Clements

GROUNDING THE FIGURE, RECONFIGURING THE SUBJECT: THE CUTOUTS OF ALEX KATZ

All art by Alex Katz © Alex Katz/Licensed by VAGA, New York; fig. 1: Sarah Wells; fig. 2: courtesy Robert Miller Gallery, New York; fig. 3: Christopher Burke Studio; figs. 5, 8–9: Alex Katz Studio; figs. 6–7: Bruce M. White; fig. 10: Bruce M. White/art © Ed Ruscha

ROY LICHTENSTEIN: WIT, INVENTION, AND THE AFTERLIFE OF POP

All art © Estate of Roy Lichtenstein; fig. 5: Robert McKeever; figs. 6, 8, 10: Bruce M. White; fig. 7: Rudolph Burckhardt

CLAES OLDENBURG: MONUMENTAL CONTINGENCY

All art © Claes Oldenburg and Coosje van Bruggen; figs. 5, 11, 13: Bruce M. White; fig. 8: Fred W. McDarrah, New York; fig. 12: Attilio Maranzano; fig. 14: Douglas M. Parker, Los Angeles; fig. 15: courtesy Paula Cooper Gallery; figs. 16–17: courtesy Pace Wildenstein

ANDY WARHOL: SURFACE TENSION

All art except figs. 1, 6 © 2006 Andy Warhol Foundation for the Visual Arts/Artists Rights Society (ARS), New York; fig. 1: photo © Rheinisches Bildarchiv; fig. 8. digital image © The Museum of Modern Art/Licensed by SCALA/Art Resources, New York

"LIKE A ROUSSEAU AMONG THE CUBISTS": TOM WESSELMANN'S UN-POP PROCEDURES

All art by Tom Wesselmann © Estate of Tom Wesselmann/Licensed by VAGA, New York; fig. 3: photo © Sheldon Memorial Art Gallery; fig. 4: image © 1988 The Detroit Institute of Arts/art © 2006 The Willem de Kooning Foundation/ Artists Rights Society (ARS), New York; fig. 5: photo © Museum of Modern Art, licensed by SCALA, Art Resource, NY/art © Dedalus Foundation, Inc. /Licensed by VAGA, New York; fig. 6: image © Metropolitan Museum of Art/art © 2006 The Willem de Kooning Foundation/ Artists Rights Society (ARS), New York; fig. 8: image © Metropolitan Museum of Art; fig. 9: Jim Strong, Inc.; fig. 11: Jamison Miller; fig. 15: Jeffrey Sturges; fig. 16: Geoffrey Clements

CHECKLIST OF THE COLLECTION

All photographs by Bruce M. White unless otherwise noted. All art by Jim Dine © Jim Dine/Artist Rights Society (ARS), New York; all art by Robert Indiana © 2006 Morgan Art Foundation Ltd./ Artists Rights Society (ARS), New York; Jasper Johns, *Pinion* and *Decoy II* © Jasper Johns and U.L.A.E./Licensed by VAGA, New York, and *Target* © Jasper Johns/Licensed by VAGA, New York; all art by Alex Katz © Alex Katz/Licensed by VAGA, New York; all art by Roy Lichtentstein © Estate of Roy Lichtenstein; all art by Claes Oldenburg and Coosje van Bruggen © Claes Oldenburg and Coosje van Bruggen; Robert Rauschenberg, *Shadow Play* © Robert Rauschenberg and U.L.A.E./Licensed by VAGA, New York, all other art by Rauschenberg © Robert Rauschenberg/Licensed by VAGA, New York; all art by Larry Rivers © Estate of Larry Rivers/Licensed by VAGA, New York; all art by James Rosenquist © James Rosenquist/Licensed by VAGA, New York; all art by Edward Ruscha © Ed Ruscha; all art by George Segal © The George and Helen Segal Foundation/Licensed by VAGA, New York; Andy Warhol, *Brillo Box, Flowers, Liz, Electric Chairs, Mao, Untitled, Mick Jagger, The Thermofax Series* © 2006 Andy Warhol Foundation for the Visual Arts/Artists Rights Society (ARS), New York, *Pepper Pot* © 2006 Andy Warhol Foundation/ ARS, New York/TM Licensed by Campbell's Soup Co. All Rights Reserved; all art by Tom Wesselmann © Estate of Tom Wesselmann/Licensed by VAGA, New York, *Still Life with Apple, Orange, and Radio* courtesy Maxwell Davidson Gallery

INDEX

Note: Pages on which illustrations appear are indicated by italics.

A

Abramson, J. A., 116, 134nn.7 & 10
Alloway, Lawrence, 41, 51n.2, 61, 75, 134n.2
Arnheim, Rudolf, 50
Austin, J. L., 23

B

Barr, Alfred, 23–24, 83
Barthes, Roland, 34n.16, 70, 109
Baudrillard, Jean, 100
Bell, Larry, 103
Blackburn, Robert, 37
Bruggen, Coosje van, 86–92; with Oldenburg: *Blueberry Pie, Flying. Scale B 2/3*, *90*, 92, 144; *Blueberry Pie, Flying. Scale C I–VI 2/3*, *91*, 92, 144; *Dropped Bowl with Scattered Slices and Peels*, *87*, 89; *Proposal for a Colossal Monument in Downtown New York City*, 92, *93*, 144; *Study for a Sculpture of 1992, Version Four*, *87*, 89, 144; *Valentine Perfume 2/2*, *89*, 144
Bryson, Norman, 66

C

Clark, Carmen, 19, 34n.2
Clark, Earl, 19, 34n.2
Cole, Thomas, 24; *The Voyage of Life*, 26
Coplans, John, *Serial Imagery*, 65
Cowart, Jack, 55
Creeley, Robert, 35n.33
Crow, Thomas, 29, 34n.16

D

D'Arcangelo, Allan, *Side View Mirror*, *137*
Demuth, Charles, 24; *I Saw the Figure 5 in Gold*, 25
Denby, Edwin, 39, 42, 52n.22
Dine, Jim, 94n.2, 113, 118, 121, 128; *The Art of Painting No. 2*, *137*; *Etching, Self-Portrait (primary colors)*, *137*; *Five Paintbrushes (second state)*, *138*; with Padgett, *Oo La La*, *138*; *A Tool Box*, *137*; *The Venice Night*, *138*
Duchamp, Marcel, 41, 65, 76, 92; *Trebuchet (Trap)*, 95n.22

E

Ernst, Max, *The Master's Bedroom*, 95n.1

F

Ferenczi, Sándor, 103
Fitzpatrick, Robert, 68

G

Gallant, Aprile, 19
Glaser, Bruce, 63
Greenberg, Clement, 29, 38–39, 41, 104
Guys, Constantin, 42

H

Hamilton, Richard, 68, 134n.2, 136n.41

I

Indiana, Robert (Robert Clark), 14–35, 113, 128, 134n.5; *Ahab*, 21, *22*; *The American Art*, 29; *American Art Since 1960*, 139; *The American Dream #1*, 15, *17*, 23–24, 34n.10; *Art (1992)*, 29, *31*, 139; *Art (2000)*, 29, *32*, 33, 139; "Autochronology," 22–23; *The Big Four*, 25; *The Bridge*, 19; *The Bridge (print)*, 19, *20*, 139; *The Cardinal Numbers*, 25; *Chief*, 21; *Colby Art Tondo*, *14*, 29, *30*, 138; *The Demuth American Dream #5*, 25; *A Divorced Man Has Never Been the President*, 15; *Duncan's Column*, 22; *Eat/Die*, 15, *16*, 34n.2; *Election (Electi)*, 15–16, 34n.5; *Eternal Hexagon*, 138; *Exploding Numbers*, 25; *The Figure Five*, 25; *FUCK*, 33; *Good Time Charley*, 140; *Hole*, 21–22; *An Honest Man Has Been President: A Portrait of Jimmy Carter*, 15; *Liberty '76*, 138; *LOVE*, 15–16, *17*, 29, 33; *Love Is God*, 33; *Nine*, 26; *One*, 26; *Peace Escapes Once Again*, 15, *18*, 139; *Philadelphia LOVE*, 138; *Six*, 26, *28*, 139; *The Slips*, 22; *The Small Demuth Diamond Five*, 25; *Soul*, 21; *Terre Haute*, 22; *Two*, 21, 26, *27*, 139; *The X-5*, 25
Irisis, Dot, 118

J

Johns, Jasper, 19, 21, 23–24, 29, 75, 111n.3, 136n.38, 136n.40; *Coathanger*, 97; *Decoy II*, *140*; *The Figure 5*, 25; *Flag*, 23, *24*, 135n.22; *Flashlight*, 97; *Light Bulb*, 139–40; *No*, 139; *Painted Bronze (Ale Cans)*, 29, 97, *98*, 100; *Painting with a Ball*, 140; *Pinion*, *139*; *Target with Plaster Casts*, 23; *Target*, *140*; *Targets*, 139; *White Flag*, 23

K

Kaprow, Allan, 76–77, 83, 94n.7; *Assemblage, Environments, and Happenings*, 77–78; *18 Happenings in 6 Parts*, 94n.7; "The Legacy of Jackson Pollock," 77
Karp, Ivan, 128
Katz, Ada, 38, 40–42, 49, 51n.2
Katz, Alex, 36–53, 128; *Ada (Weather Vane Model)*, 41; *Ada, Ada*, 38; *Anne*, 45, *46*, 50, 141; *Birches*, 53n.39; *The Black Dress*, 42; *Blue Series, Ada and Edwin*, *40*; *Boy with Branch I*, *140*; *Dana*, *141*; *Frank O'Hara*, 39, 40; *George Washington Crossing the Delaware*, scenery for, 44; *Henry Geldzahler*, *141*; *Jessica*, 45, *47*, 48–49, 141; *Maxine*, 44; *One Flight Up*, 44, 45, 49; *Standing Legs*, *49*; *Swamp Maple*, *48*; *Vincent*, *140*; *Vincent and Vivien*, 53n.37; *Vincent with Open Mouth*, *140*; *Washington*, *141*; *The Wedding Dress*, *36*, 42, *43*, 141
Kelly, Ellsworth, 19, 25; *Atlantic*, *21*
Kennedy, Jacqueline, 105–10
Kennedy, John F., president, 15, 34n.5, 105–10, 111n.19
Kennedy, Robert, 108, 111n.21
Koch, Kenneth, *George Washington Crossing the Delaware*, 44
Kooning, Willem de, 38–39, 51n.11, 97–98, 113, 117–28, 135n.26; *Easter Monday*, *119*; *Merritt Parkway*, *117*, 132; *Woman IV*, *124*
Kozloff, Max, 23, 29
Kramer, Hilton, 24, 41, 44
Krauss, Rosalind, 75, 100

L

Lichtenstein, Roy, 15, 33, 54–73, 94n.2, 104, 113, 118, 128; *Apple with Gray Background*, 72n.19; *Brushstroke*, 61, 62, 63, 72n.19, 142; *Brushstroke V*, 59, 60–61, 63, 142; *Brushstrokes*, 57; *Finger Pointing*, 143; *Fish and Sky*, 141; *Haystack #4*, 65, 141, 143; *Haystack #5*, 65, 142; *Interior*, 69, 70, 143; *Interior with African Mask*, 68; *Masterpiece*, 55, 56; *Mural with Blue Brushstroke*, 58, 60; *Nude*, 142; *Ritual Mask*, 68; *Roto-Broil*, 55, 56, 61; *Sandwich and Soda*, 141; *Still Life*, 143; *Still Life with Lobster*, 54, 63, 64, 142; *Still Life with Red Jar*, 66, 67, 142; *Untitled (Still Life with Lemon and Glass)*, or *Untitled 5*, 142; *Wall Explosion I*, 60; *Yellow and Green Brushstrokes*, 58

Lobel, Michael, 61–63

Longo, Robert, 45

Loran, Erle, 55, 65

M

Malanga, Gerard: with Warhol, *The Thermofax Series*, 153

Matisse, Henri, 38, 66, 113, 136n.35

Memling, Hans, *Portrait of a Young Man*, 121, 132

Mondrian, Piet, 63, 65, 113, 116, 130, 135n.22

Monet, Claude, 65–66

Morris, Robert, 37, 51n.4

Motherwell, Robert, *Elegy to the Spanish Republic*, 118

Muschinski, Patty, with Oldenburg, *Snapshots from the City*, 79

O

O'Doherty, Brian, 116

Oldenburg, Claes, 34n.10, 41, 63, 74–95, 104, 113, 128; *B Tree (for Alfred Barr)*, 83, 86, 143; *Banana Monument*, 83; *The Bedroom Ensemble*, 81, 83; *Blueberry Pie, Tipped Up, and Spilling*, 144; with van Bruggen, *Blueberry Pie, Flying. Scale B 2/3*, 90, 92, 144; with van Bruggen, *Blueberry Pie, Flying. Scale C I–VI 2/3*, 91, 92, 144; with van Bruggen, *Dropped Bowl with Scattered Slices and Peels*, 87, 89; *Feasible Monument for a City Square*, 86; *Hats Vesuvius*, 143; *M. Mouse (with) 1 Ear (equals) Tea Bag, Blackboard Version (1965)*, 143; *Mouse Museum*, 84; *Pepsi-Cola Sign*, 80; *Picasso Cufflink*, 143; *Pie à la Mode*, 89, 92; *Placid Civic Monument*, 84, 85; *Profiterole*, 74, 82, 144; with van Bruggen, *Proposal for a Colossal Monument in Downtown New York City*, 92, 93, 144; *Proposed Colossal Monument to Replace the Washington Obelisk*, 84, 85; *Proposed Monument for the Intersection of Canal Street and Broadway, New York*, 83, 84, 85; *Small Monument for a London Street*, 85, 86; with Muschinski, *Snapshots from the City*, 79; *Stars*, 94n.4; *The Store*, 77–78, 80, 81, 89; *The Street*, 78, 79, 81; with van Bruggen, *Study for a Sculpture of 1992, Version Four*, 87, 89, 144; *Three Hats*, 143; with van Bruggen, *Valentine Perfume 2/2*, 88, 89, 144

Orton, Fred, 23–24

P

Padgett, Ron: with Dine, *Oo La La*, 138

Perl, Jed, 41

Perrault, John, 39

Pollock, Jackson, 38, 63, 75–78

R

Ratcliff, Carter, 44

Rauschenberg, Robert, 19, 21, 41–42, 52n.9, 75, 94n.2, 104, 135n.19, 136n.38; *Cliché-Verre: Hand Drawn, Light Printed*, 146; *Earth Day*, 145; *Labor's Centennial, 1881–1981*, 145; *Poster for the Benefit of Congressman John B. Brademas's Re-election*, 145; *Recall*, 146; *Sack*, 145; *Shadow Play*, 144; *Surface Series from Currents*, 145

Rivers, Larry, 51n.9; *An Outline of History*, 146; *Untitled*, 146

Rose, Barbara, 75

Rosenberg, Harold, 53n.38, 56, 111n.3

Rosenblum, Robert, 24, 55, 57

Rosenquist, James, 19, 29, 34n.10, 41, 94n.2, 113, 128; *Black Tie*, 147; *Coin Noir*, 147; *Derrière l'Étoile*, 147; *Henry's Arrival in the Art World Causes Gravity*, 147; *Spaghetti and Grass*, 146; *Ten Days*, 146; *Violent Turn*, 147; *While the Earth Revolves at Night*, 147

Rosenthal, Mark, 86

Ruscha, Edward, 49, 134n.2; *America, Her Best Product*, 150; *Every Building on the Sunset Strip*, 148; *Gas Pump Nozzle and Hose Study*, 148; *Mocha Standard*, 49, 50, 148; *Open*, 148; *Vanish*, 148

Ryan, Susan, 22–23, 25, 33

S

Seckler, Dorothy Gees, 29, 33

Segal, George, 40; *Abraham and Isaac: In Memory of May 4, 1970, Kent State University*, 150; *Girl on a Chair*, 149; *GS1*, 149; *GS3*, 149; *GS5*, 149; *GS6*, 150; *GS7*, 150; *Remembrance of Marcel*, 149; *Two Figures: One Front, One Back*, 149; *Wall Relief: Torso*, 149

Selley, Claire, 123

Selz, Peter, 56

Seurat, Georges, 42; *Les Poseuses*, 42

Sherman, Hoyt L., 72n.21

Stealingworth, Slim (Tom Wesselmann), 117–19, 132, 136n.35

Stein, Gertrude, 117

Steinberg, Leo, 123–28

Stevenson, Adlai, 85

Swenson, Gene, 15, 35n.21, 75

T

Tomkins, Calvin, 55

W

Warhol, Andy, 34n.16, 37, 51n.2, 63, 65, 94n.2, 96–111, 113, 128; *Birmingham Race Riot*, 150; *Blue Marilyn*, 108, 109, 150; *Brillo Box*, 98, 99, 100, 104, 150; *Electric Chair*, 152; *Electric Chairs*, 152; *"Fips" Mouse*, 100, 102, 153; *Flash—November 22, 1963*, 96, 107, 108–9, 110, 151; *Flowers (1964)*, 151; *Flowers (1970)*, 151; *Flowers (1970)*, 151; *Liz*, 150; *Mao*, 152; *Marilyn*, 151; *Marilyn Monroe (Marilyn)*, 151; *Mick Jagger*, 152; *Orange Car Crash, 14 Times*, 106, 109; *Pepper Pot*, 101, 151; *POPism*, 103, 105; *Round Jackie*, 109, 110; *SAS Passenger Ticket*, 151; *Since*, 105–8; with Malanga, *The Thermofax Series*, 153; *Untitled*, 152; *Untitled 12*, 152

Wesselmann, Tom, 112–36; *Beach at Easthampton*, 122, 153; *Big Nude*, 117; *Delphinium and Daisies*, 154; *Dropped Bra (Big Maquette)*, 130, 131, 153; *Fingertips with Cigarette*, 115, 153; *Great American Nude #1*, 123; *Great American Nude #62*, 153; *Great American Nude #100*, 123; *Landscape II*, 154; *Little Bathtub Collage #1*, 128; *Maquette for Dropped Bra*, 153; *Maquette for Fast Sketch Still Life with Fruit and Goldfish*, 154; *Maquette for Kate's Beauty*, 154; *Maquette for Seascape with Cumulus Clouds*, 154; *Monica Reclining in Chinese Robe*, 127, 154; *Monica Sitting, Elbows on Knees*, 154; *Monica Sitting, Robe Half Off*, 126, 154; *Portrait Collage #1*, 121; *Smoker Study Sculpture*, 114, 153; *Still Life*, 120, 154; *Still Life #15*, 116; *Still Life #20*, 130, 132; *Still Life #36*, 130; *Still Life #54*, 112, 130, 133, 153; *Still Life with Apple, Orange, and Radio*, 154; *Still Life with Blonde*, 128, 129, 154; *Still Life with Orange and Tulip*, 154; *Study for Bedroom Painting #56*, 153; *Study for Nude Edge with Seascape*, 124, 125, 153; *Study for Still Life, No. 22*, 153; *Sunset Nude with Matisse Odalisque*, 132. See also Stealingworth, Slim

Wilmerding, John, 26

John Wilmerding is Christopher Binyon
Sarofim '86 Professor of American Art in the
Department of Art and Archaeology, Princeton
University. A distinguished authority on American
art, he was formerly deputy director of the
National Gallery of Art in Washington, D.C.

Hal Foster is Townsend Martin '17 Professor
of Art and Archaeology and chairman of the
department at Princeton. A cultural critic and
theorist, he is co-author of *Art Since 1900:
Modernism, Antimodernism and Postmodernism*.

Johanna Burton, **Kevin Hatch**, **Suzanne
Hudson**, **Alex Kitnick**, **Julia E. Robinson**, and
Diana K. Tuite have recently received their
Ph.D. or are current doctoral candidates in
the Department of Art and Archaeology at
Princeton University.

Distributed by Yale University Press for the
Princeton University Art Museum

96 color and 45 black-and-white illustrations

Cover illustration:
Roy Lichtenstein, American, 1923–1997
Still Life with Red Jar, 1994, detail
Screenprint on Lanaquarelle watercolor paper;
53.3 x 48.9 cm.
Princeton University Art Museum, promised gift

Cover design by CoDe. New York Inc.